DRAWN TO ART

A Nineteenth-Century American Dream

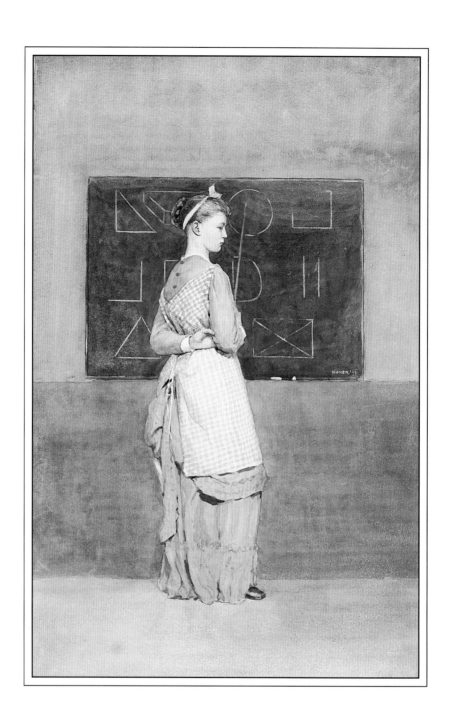

DRAWN TO ART

A Nineteenth-Century American Dream

DIANA KORZENIK

WITH A FOREWORD BY RUDOLF ARNHEIM

UNIVERSITY PRESS OF NEW ENGLAND

HANOVER AND LONDON, 1985

UNIVERSITY PRESS OF NEW ENGLAND

BRANDEIS UNIVERSITY
BROWN UNIVERSITY
CLARK UNIVERSITY
UNIVERSITY OF CONNECTICUT
DARTMOUTH COLLEGE

UNIVERSITY OF NEW HAMPSHIRE
UNIVERSITY OF RHODE ISLAND
TUFTS UNIVERSITY
UNIVERSITY OF VERMONT

LIBRARY OF CONGRESS CATALOGING-IN-PUBLICATION DATA

Korzenik, Diana, 1941–
 Drawn to art.

 Bibliography: p.
 Includes index.
 1. Art appreciation—Study and teaching—United
States—History—19th century. I. Title.
N7477.K63 1985 707'.074 85–9225
ISBN 0–87451–339–1

Published with the assistance of the J. Paul Getty Trust.

Jacket illustration and frontispiece: Los Angeles County Museum of Art, *Blackboard 1877*, Winslow Homer, Jo Ann and Julian Ganz, Jr., Collection.

This critique of art instruction was Winslow Homer's contribution to the lively debates about art applied to industry. Ironically, Homer used Walter Smith's drawing exercises—popularized at the centennial—as an occasion for exploring the very psychological aspects of art that Smith had rejected.

For my mother
and
in memory of my father

Let us stop talking for the present proudly and complacently about "our American art." We have no such thing as yet, in any sense that should make us the least proud. . . . No school of art ever yet arose to nobleness upon any such basis as that upon which our popular art rests, nor even can.

—*Boston Evening Transcript* (January 6, 1870, front page)

I have been repeatedly honored by the presence of young students from America who work with me on botanic microscopy for one or more terms. In such cases I have observed the average of students from America drew better than those of Europe of the same age. . . . Soon will the United States surpass us in Art as well as in Science if we do not arouse ourselves with new energy.

—*Instruction in Drawing* Dr. Arnold Dodel (1889)

CONTENTS

FOREWORD

When I read the manuscript of Diana Korzenik's book I experienced
something like the happy revelation she had herself when she first
opened the boxes of the Cross archives. For me, the captivating life
story of North American artists living, learning, and aspiring, away
from the metropolitan centers, had a special, almost exotic flavor, not
altogether different from what we experienced as youngsters in the
"old country" when we read, in German, about the trappers and the
Indians in the stories of James Fenimore Cooper.

For most readers of this book the story will be less romantic, but
I dare say that they, too, are in for some eye-opening surprises.
Korzenik's account supplements our knowledge of two great topics,
the history of art and of art education in America. Art education as
we know it has been essentially a piece of imported pedagogy, domi-
nated by the weighty figures of Herbert Read and Victor Lowenfeld
and backed by a century of European professional literature. Pro-
fessor Korzenik, herself thoroughly experienced in art education, has
known that this is not the whole story. The discovery of the Cross pa-
pers enables her to illustrate a rather characteristically American way
in which the desire to draw pictures was nurtured informally and
practically in small workshops all over the country.

At the same time, this colorful excursion into the vernacular art
practice and training should have a bearing also on our image of
American art. It should help to lead us down from the peaks of stan-
dard art history to the valleys where art has its humus. It uncovers
roots of North American art that seem to me to support and explain
certain aspects of what we have come to recognize as typical of many
of this country's painters and sculptors. In spite of all the interna-
tionalization that tends to obliterate local differences, there remain in
American art certain special traits, derivable not simply from the
course of official art history but from the mores of the craftsmen and

tradesmen in country and town. I have the impression that this con-
nection between the mentality of the daily life outside the big cities
and of the art in the galleries and museums is closer over here than it
is in Europe. There are reflections of popular taste and popular con-
cerns in the romantic landscapes of the nineteenth century, in the so-
cially inspired murals of the 1930s, and then again in the more recent
pop art and neorealism, which broke so unexpectedly through the de-
corous respectability of abstractionism. For this reason it seems to me
that anybody interested in the sources of art, especially the art of
North America, will be pleasantly enlightened by this richly docu-
mented chronicle.

In a more general sense, the story of the Cross family raises again
the questions of how applied commercial art relates to the indepen-
dent standards of the fine arts and how art training in schools com-
pares with learning by doing in the workshops of the practitioners.
These questions have been so endlessly talked about in theory that
the discussion cannot but profit from the tale of bravery and optimism
told in this book.

A fortunate coincidence has put this revealing material in the
hands of the right person. Topic and author suit each other tempera-
mentally. From the time when Diana Korzenik arrived at Harvard to
continue her training and to apply her practical experiences as an
artist and teacher to work in the psychology of the arts, I knew that
here was a "natural," a person thoroughly possessed by her curiosity,
her vocation, her trust in the mission of art. There was no such thing
for her as pure theory. The need to know grew from the need to learn
and to teach, and art derived its justification from what it could do for
the average person. This sprightly union of theory and practice, of
person and product, of individual and society has made her teaching
and writing so attractive. It adds the breath of life to the story she has
saved for us from oblivion.

RUDOLF ARNHEIM

ACKNOWLEDGMENTS

This book has become an occasion for focusing on many of my concerns. Though it is about our nation's life, it is intimately related to my personal life. Acknowledgments therefore must begin with my parents, whose preoccupation with art—and law and politics—provided me with the protections and the challenges analogous to those documented here. They, and formal teachers, addressed my needs as they oriented me to the world.

The particular form that this work has taken is the result of three thoroughly original scholars with whom I had the pleasure of studying in my adult years: Wolfgang Stechow, Meyer Schapiro, and Rudolf Arnheim. They each in their different ways gave me the courage to invent my own way of looking at how art grows within its culture.

My students at Massachusetts College of Art have also been my teachers. Properly, I should credit all the students in my years of teaching the history of art education.

I have depended upon many individuals and institutions throughout the research for this book. The findings of several scholars helped me chart the territory: Lawrence Cremin of Columbia University Teachers College, Margery Cohn of Harvard's Fogg Art Museum, Neil Harris of the University of Chicago, Paul Marks of the Massachusetts Board of Regents, and Peter Marzio of the Museum of Fine Arts, Houston. In addition, John Baker at Massachusetts College of Art and George Rawick of the University of Missouri at St. Louis, who read this work in its early stages, influenced my pursuit of certain themes. The Boston Public Library's Sinclair Hitching, Janice Chadbourne, and Paul Swenson, the Archives of American Art's Robert Brown, and the Boston Athenaeum's Donald Kelley also provided essential assistance, by helping me uncover marvelous and useful documents. The accuracy of details is due to the enthusiastic pursuit of obscure information by Dorothy Rothe of the Malden (Massachusetts)

Historical Society, Morton Vose of the Vose Archival Project, Betty Lessard of the Manchester Historical Association, and, of course, to the continually appreciative Ben Hopkins, chief librarian and keeper of the archives of the Massachusetts College of Art.

In addition to this being a public history, it is also a private revelation of two families. I gratefully acknowledge the trust and generosity of the descendants of Joseph and Deborah Cross: Rhoda Cross, her son, Ed, and his wife, Betty, and their children; and the descendants of Walter and Isobel Smith: Nora Sheath, Madeline Smith, Gerwin Prince, Geoffrey Golden, Vivien Gilbert, and Martha King. The relationships developed with these families will extend beyond the course of this research.

Words appear on these pages thanks to the efforts of several people. Jane Hankins deftly typed the rough drafts. The many subsequent revisions were painstakingly word-processed by Argie Staples. The many drafts she received were my responses to two editorial readings that were of inestimable value: those of Pam Painter and my sister, Ruth K. Franklin. I thank them both for their appreciative and critical suggestions. Finally, Karen Kennedy helped me solve problems that required her printmaker's precision.

Good friends gave intellectual and emotional support throughout this project. They know how important they have been. I feel special gratitude to Evie Davis, Kathryn Kirshner, and Susan Quinn, who encouraged my pursuit of the objects and ideas in this book; and to my writers' group (Caryl Rivers, Bernice Beresh, Janet Robertson, Barbara Ehrlich White, Carolyn Toll, Phyllis Karas, Diane Cox, and Sally Steinberg) for helping me through each stage of making this a book. Many friends and colleagues will recognize themselves and their children here. Our lives together are in this work. From the first day we all met, everyone at the University Press of New England has shared with me their personal curiosity and enjoyment of this material. This is a precious bonus for any author. I thank you all.

Boston, Massachusetts D.K.
April 1985

DRAWN TO ART

A Nineteenth-Century American Dream

INTRODUCTION

The recent and ongoing rediscovery of nineteenth-century American artists has revealed that we scarcely have categories for the diversity of people who worked throughout that century. At midcentury, well before the Civil War, a generation of rural children felt rumblings from the big cities about something called art. Events conspired to make these young people into a generation of artists, most of whom remain unknown to us today. The existence of these artists and our ignorance of them fascinate me. We need a way to understand them.

In no sense may these people be classified as folk artists. Unlike their counterparts in the first half of the century who had few images to inspire them, these artists of the middle and latter half of the century were surfeited by images created by the new technologies, which allowed for mass production of lithographs and wood engravings. As young people, these artists learned all they could from advertising, the illustrated press, and *The American Drawing-Book* by John G. Chapman. They seized every opportunity they had to study art in their own hometowns. Their efforts, which may have included house painting, sign painting, and wood engraving, ultimately proved limited. When they got all they could at home, they took off, congregating in major cities, looking for others who might help them find better

1

opportunities for art instruction and for work that used their art skills.

What did all these productive young people think they were do-
ing? What did drawing mean to their parents, and how had they
talked about it with their children? How did students think of drawing
when they took out their sketchbooks in art classes? What were their
teachers trying to give them? Ample evidence survives today to sug-
gest answers to these questions. Clues are in the earliest pamphlets,
catalogues, and how-to-draw books perhaps passed along from one
artistic neighbor to another. Later in the century, well-financed in-
stitutions for formal art instruction such as museums, art schools, and
the public schools joined the mission of igniting the nation's art spirit,
and they, too, produced a treasury of records, paraphernalia, guide-
books, and art curricula.

The shards that remain shock us. This century in which Americans
felt they were without any art proves to be one possessed by the pas-
sion for learning to draw. This single activity took on the intensity of a
dream, capturing and compressing many needs and wishes that en-
compassed the whole culture. If the dream of learning to draw is to
make sense to us today, we must exert some effort in reconstructing
its meaning. It seemed to me that if only it were possible to interpret
the meaning and hope of drawing in one particular life, I could ani-
mate otherwise rather dry generalizations. Without such detail, the
passion for learning to draw would be as devoid of meaning as a
deeply felt dream retold days later, after the intensity of the feelings
is gone. A fortunate discovery let me test my ideas.

Interpreting the changing promise of art study in the history of
American art education has been the focus of my research for more
than ten years. My search was prompted by questions that preoccupy
me still: Why did so many people in the nineteenth century want to
learn to draw? Why did the image of the artist appear so frequently in
nineteenth-century advertising, on trade cards and product labels?
Why was the artist at the easel so common an image in materials for
children? Why did coffee, tea, and even sewing-machine producers
distribute free little drawing books for children? Why are vast sums of
money from private, state, and federal sources spent on art instruc-
tion? Over time, largely through flea markets augmented by libraries,
I found how-to-draw books and other seemingly trivial art-related ob-

jects that offered me clues to how and why Americans came to be educated in matters of art.

People who haunt flea markets know that eventually one finds what one is looking for. The purposeful searching eye can bring forth from masses of unsorted rubble that one thing that expands, redefines, or rounds out a facet of a collection. Success is even more likely because no one remains anonymous for long. Dealers note and cater to the interests of buyers and contact them if anything surfaces that even vaguely resembles something they have sold to them before.

One dealer, Roberta Carr, and I share a fascination with the history carried within the objects. Even if it does not exactly pertain to my special interest, she occasionally contacts me to tell me news of a recently discovered treasure. In December 1981, a card from her invited me to her home, then inundated with drawings, paintings, prints, books, and paper documents salvaged from masses of furniture and other household objects being organized for sale at auction. I learned that she had acquired five cardboard boxes of different shapes and sizes, the contents of which all related to some people named Cross who were part of Kilburn & Cross, a nineteenth-century Boston engraving and printing business whose success crested and then precipitously declined in the last quarter of the nineteenth century. The actual Kilburn & Cross wood blocks, test impressions made by printing these wood blocks on paper, and final proofs were there along with books, drawings, watercolors, and family mementos. "You've got to see these to believe it!"

At Roberta's home in Concord, New Hampshire, shelves normally containing old books were concealed behind four-by-eight-foot gray, Homosote panels. Bright lights were directed toward these panels, on which she had pinned tiny radiant watercolor landscapes of New Hampshire scenery from this collection. Some paintings were fully developed with layers of delicate colors; others at different stages of completion revealed ground colors that are invisible to the viewer of finished paintings. One, The Old Man of the Mountains at Franconia Notch, was a site immediately recognizable to me. Looking more closely, I saw that each painting and drawing was a specific place, dated and labeled by its exact location.

My eyes, always searching for art instruction paraphernalia, were

diverted from the walls of watercolors to the floor, on which were un-rolled diplomas from the Boston Evening Drawing Classes as well as school assignment drawings that were the prerequisite for obtaining the diploma. The drawings were examples of a specific tradition with which I was familiar, a type required of students who attended college where I teach, Massachusetts College of Art in Boston, one hundred years ago, when it was known as the Massachusetts Normal Art School. On the floor beside these diploma drawings were little yellow art instruction books, published in Britain between 1850 and 1900 but popular among aspiring artists in the United States. They taught how to paint flowers and faces and how to do anatomy drawing. Near them, a large gray volume contained a wood-engraved pictorial cata-logue and history of New York's 1853 Exhibition of Industry of All Nations.

In other piles were oil-painted flower pictures, more instructional books, proofs pulled from wood-engraved advertisements and photo-graphs. A stack of old leather-bound books included an album in which carefully cut engravings had been pasted. On top of that were several lavish editions of *Washington* illustrated by Kilburn & Cross. Crucial to my interests were eight small, irregular cream-colored pieces of paper marked with childhood drawings of ducks, trees, seals, and people, dated around 1868. Rarely does children's artwork of that century survive.

It was immediately apparent that I had found what I was looking for. All my earlier research and flea-marketing expeditions led me to appreciate what was here. I had been getting ready to write my book on nineteenth-century American art instruction before I found these papers. My fascination was with the impact of social class on artistic opportunity. I had collected evidence that a different kind of art had been taught to the poor than to the affluent. This split, which left its impression on American art ever since, needs to be understood if de-mocratization of art is ever to be more than a dream. The Cross pa-pers appeared and presented me with lives of exactly the right period (1850–1900), to pursue the questions that intrigued me.

With these real Cross people I felt I could grasp issues that have eluded others. Biography promised to help me focus on the fact that every person who draws was once a child. Each Cross child had

scribbled and depicted things of the world and had only a particular set of educational opportunities. Each child's life was constrained by the family's economic and social class. The Cross children permitted me to study the particular hope attached to becoming a highly skilled wood engraver and the vulnerability that accompanied it.

This study, however, needed more than the Cross biography. Biography is a provisional way of scanning artistic substance, but it does not alone treat the historical question in artists' lives, which is always the nature of their relation to what has preceded and what will follow them.[1] My prior research and flea-marketing already provided the texture, the context, for interpreting the period. To understand the nineteenth-century educational situation, the historian Lawrence Cremin claims, one must consider the influence of the press, innumerable voluntary associations and, perhaps of least importance, schools. Through the Cross family, I could gain a fine-grain filter for examining contributions of the press, voluntary associations, and schools to crucial events. The family enabled me to see the interested adults, attractive opportunities, and awkward facts of childhood and adolescence that are too readily masked retrospectively by adult mastery and professionalism.

Mesmerized by the Cross collection, I decided to return to Concord to organize the papers in Roberta's possession into workable categories. Doing this, I discovered that the work of three separate artists were saved together: Joel Foster Cross and Henry Cross, brothers, and Emma Cross, their sister. The lives of Henry and Emma, at least, seemed traceable through a good many years. Some objects remained unclassifiable. Watercolors by both noted and unknown people provided no clues as to their relationship to the Crosses. One huge leather-bound album in which 1860s wood engravings had been meticulously pasted offered no information as to its initial owner nor to the purpose for which it had been assembled. One portrait, reputed to be of one of the Cross brothers, provoked me to speculate about the relationship its artist, watercolor painter Henry Herrick, might have had with the sitter. Even with all the gaps, however, that inventory persuaded me that here was a rare collection of childhood drawings, student artwork, and source books that had miraculously remained together with the adult artwork that grew from it.

The family that originally owned this collection hoped a museum or historical society would acquire it so that some researcher might begin work on it. I was asked to talk with a museum director about the value I saw in the collection. As I was persuading him, I realized how much I wanted to work with these materials myself. Although I was determined never to do such a thing, while negotiations were still in progress, I nonetheless bought the collection.

I felt that I had adopted a child and had an enormous responsibility from which I could not turn. My knowledge could certainly help me start, but I was sure I had a great deal more to learn in order to take proper care of my new charge. The telephone number of the collection's former owners served me as Dr. Spock serves new mothers. One knows that, when necessary, there is someone to whom one may refer one's questions. Had it not been for that telephone number, I never would have been foolhardy enough to think I could have pieced together this story.

My priority was to establish the identity of the people from whose lives these shards remained. When were they born, and how did art ever enter their lives? I knew nothing. Very shortly, I met a stone wall. There just was not enough here. Photographs became my major frustration because they did not tell me who was who and where it was they were standing, sitting, boating, or sketching. With a list of questions in hand, I telephoned the Cross family who had owned these things and was fortunate to be invited to talk with them at their old farmhouse in Merrimack, New Hampshire.

During our first meeting, a Sunday afternoon in mid-May 1981, a rush of information was offered. The Bible that had been with the family since the eighteenth century provided the dates of birth, marriage, and death that I needed. My interest in that Bible seemed to make the family more talkative and curious about its own history. Betty Cross disclosed that there were things other than the Bible that they had not sold, and from another room she brought out a tall pile of oblong sketchbooks. I was stunned and am now even more grateful that there was more artwork to explain the significance of all the Cross memorabilia.

"So much time . . ." Ed Cross said to me. "So much time was spent on each of these drawings. . . . Why? Why in the world would

anyone spend all his time doing this?" Ed's question referred to his great-uncle, Henry Cross, who had produced the majority of the no longer boxed artwork. In writing this book, I have chosen to consider his question, which was a variation of my own: Why would anyone who had grown up on a farm in the nineteenth century ever choose to spend his life making drawings? That question led to others: What did drawing promise? What was going on in the culture that made drawing so important? Were the efforts rewarded or disappointed? Where did all this work lead the people who made the drawings?

The process of gathering information has taken years, and much of that time was spent in the Cross family's home. They made their home mine. We shared many meals between my reading and rereading their old trunkful of family documents, letters, and newspapers. Around Thanksgiving 1982, the old farmhouse, emptied the year before by public auction, was finally sold. With the Crosses, when they signed on its sale, I shared a sense of severing ties with the past. When they moved into a new, antique-style farmhouse, one downstairs room was devoted to the family archive; it was considered a family room, though hardly in the conventional sense. Family memorabilia have been framed and hung on the walls around a desk, there for future study of the nearby trunk filled with precious papers. This room is my work-room, I have been assured, whenever I want to use it.

That this book exists is due to the Cross family members, who were so generous to me, and of course, to Roberta Carr, who introduced me to them.

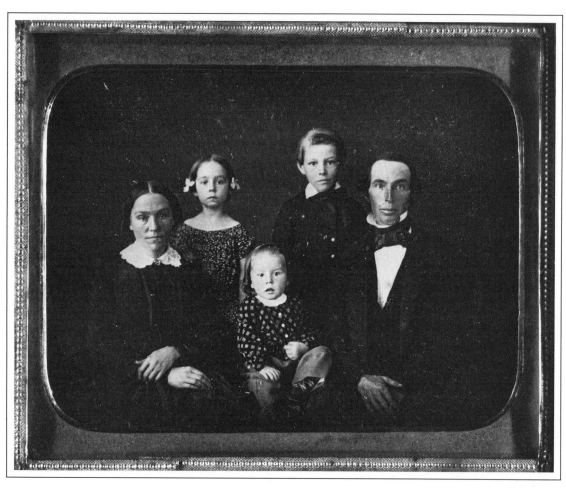

Daguerreotype of Cross Family circa 1854
Cross Family Collection.

CHAPTER 1

NEW MILLS

On the facing page is a daguerreotype from about 1854. It is one of innumerable images that have survived from the nineteenth century. Such pictures show us what people wore, how they were groomed and perhaps the furniture on which they sat, but nothing shows the dreams in their minds. We know that each era had its passions. Many are well documented. But who would suspect that this earnest, hard-working farming family of Manchester, New Hampshire, would be preoccupied—in time—with ideas about art? Yet that was the case.

Artists in a New Mill City

The bounty of papers that were saved along with this daguerreotype enable us to know the thoughts of these people and the future they were to reap. Here begins an account of a New England "Everyman's" family and the children's eager pursuit of art study—a widely shared passion and source of prosperity for their century.

Henry Clay Cross and his two siblings, Joel Foster and Emma, all artists-to-be, can first be seen with their parents in the oldest surviving family photograph for which they carefully posed. The mother, sitting to the far left, and the father, to the far right, frame the boundaries of the family group. Both look younger than their thirty-seven years because the blurring and silvering of the image have increased over time. The daguerreotype itself was a symbol of the new technology whose promise could only benefit the growing family.

Deborah Perry Wilder Cross looks out calmly, waiting as the pho-
tographer does his work. Everything is in its place. Her dark hair is
parted in the middle and pulled tightly back. Her hands are posed
like those of the Mona Lisa, the fingers of one hand curving over the
opposite wrist. Her dress is dark, lightened only toward her face by
the white lace collar. Emma, the only daughter, stands somewhat be-
hind her, neck erect and taut, reminding us of one of today's pre-
cocious little ballet students. Her hair too is parted down the middle
and pulled tight, tied with bright ribbons at her ears, accentuating
the fact that she is a very grown-up five-year-old. Her dark dress and
white lace collar echo her mother's. She stares still and seriously at
the camera, remembering that she must not move. Emma's older
brother, Joel Foster Cross, stands beside her. Nine years old and con-
siderably taller than his sister, his serious, almost sad, slim face ex-
presses little interest in being part of this long process of being pho-
tographed. Foster, as he was called, stands behind his father, Joseph
Cross, who looks the proverbial dour New Englander, firm and immo-
bile, due less, perhaps, to his temperament than to the requirements
of the photographer. He prepared for this picture by dressing in a
dark suit with a high-collared white shirt and a rather dressy bow tie.
Right in the middle of the formal group, three-year-old Henry Clay
Cross sits cross-legged on a couch between his parents, staring out
wide-eyed at the camera. Henry opens his mouth as if fascinated by
the photographer in front of him. Dressed somewhat less formally for
this photograph than are the others, with a lightly dotted dark sweater
edged by a ruffled shirt collar showing a bit at the neck, Henry is very
much the center of attention, a position he retained throughout his
childhood.

In family lore, Deborah Cross is credited with bringing the aes-
thetic and cultural element to the family. Her love was flower cultiva-
tion, and throughout her life she was known for her skills in what
was then called floriculture. "Those who have been recipients of her
courtesy, will testify to her love of flowers and her success in their
cultivation."[1]

Deborah Cross was born in the western part of New Hampshire, in
the town of Peterborough, into a family that already had nine chil-
dren. She was born rather late in her parents' lives, which reached

back into the eighteenth century; he was born in 1779, just after the signing of the Declaration of Independence, and she five years after. The Wilders were fortunate to live long lives. Both lived to know all three Cross grandchildren. Deborah's father, Abel Wilder, survived to see Henry become six; his wife, also Deborah, lived well up through the first year of the Civil War and saw Henry reach the age of ten.

When Deborah married Joseph Cross, he was a dark-haired, hazel-eyed, five-foot-eight-inch-tall, twenty-seven-year-old, whose spirit was far more good-humored than the dour man suggested by the daguerreotype. When Joseph became a parent, he delighted in telling fantasy stories to the children and in calling their attention to the miracles of nature. Joseph Cross seems to have contributed as much to the children's aesthetic sensibility as did his wife. He left ample evidence through his letters that he shared with his wife the pleasure of natural beauty and was absorbed with giving verbal form to his visual observations.

The Cross side of the family came from Swanzey, New Hampshire, even farther west than Peterborough. In the 1820s, when Joseph was just a child, his father, Benjamin Cross, was the local schoolteacher. Swanzey's district six school was probably in their home. In those days, the teacher was, perhaps, the son of one of the farmers of the district who knew a little more than his elder pupils. His wages were those of a farm laborer: board plus ten or twelve dollars a month. The qualification for becoming a teacher was the ability to do any sum.

Generally the teacher was very young, sometimes not more than sixteen years old, but if he possessed the due expertness at figures, if he could read the Bible without stumbling over the long words, and without mispronouncing more than two thirds of the proper names, if he could write well enough to set a decent copy, if he could mend a pen, if he had vigor enough of character to assert his authority and strength enough of arm to maintain it, he would do.[2]

A tiny cream paper note in the Cross descendants' possession proudly recorded that Benjamin Cross received six dollars for each nine-week period of teaching. This enabled the family in 1826 to be the first in their town to purchase a stove. But by 1841, the exodus of the male Crosses began. Benjamin took his son Joseph east, leaving Swanzey for Manchester, which as recently as 1810 had been known

as Derryfield. Two other sons, Ira and Levi, came along at about the same time. Ira stayed on and ultimately became mayor of the city of Manchester. Levi acquired property out on Mammoth Road, but had to forfeit it when he was unable to pay the taxes. He returned to western New Hampshire and settled in Peterborough, first working as a weaver and in time becoming a mill agent. No records survive to inform us about the Cross women, who presumably stayed behind.

Early records show that initially Benjamin Cross and his son Joseph owned no land. Joseph built up his assets through investing in 150 shares of lumber as stock-in-trade at Fitts Mill. By 1852, the time of Henry's birth, Joseph had already owned his own farm for four years and had sixteen acres with a house, a horse, and two cows.

The year that the Joseph Crosses started a family was also the year that Manchester was chartered: 1846. Joel Foster was their only child for four years, years in which the family is reported to have lived in Hookset, just north of Manchester. Play for Joel Foster probably meant following along after his parents, doing or trying to do whatever they did around their home. He learned farming by imitating his parents and then by taking on small responsibilities. As he made himself useful, his parents came to rely on his contribution to the family's work.

In New England, the sons of farmers begin to make themselves useful almost as soon as they can walk. They feed the chickens, they drive the cows, they bring in wood and water, and soon come to perform all those offices which come under the denomination of "chores." By the time they are eight or nine years old, they frequently have tasks assigned to them, which are called "stints" and not till they have done their stint are they at liberty to play.[3]

In his early years, he had few, if any, children with whom to play. Alone, he could chase butterflies and search for hens' nests, but the prospect of siblings promised him companionship. In so rural a situation, it is hard to exaggerate how Emma and Henry would enrich his life. But Joel Foster was soon to find out that another job accompanied the work that he learned to do for his parents. He was responsible for teaching Emma and Henry about planting, haying, and caring for Nellie the cow, and he undertook that assignment as soon as they were able to learn.

Emma, born when Foster was four, was named after her mother's

sister, Emmalina, who had just died at age thirty-three. Foster and Emma's early interests centered on the home places where they watched their parents at work. One busy work space that the children observed was the kitchen, where growing things were transformed into meals. Fire, water, and air conspired with produce from the earth to supply needs for the family's table. Both Mr. and Mrs. Cross cooked. Joseph Cross was to become known for his cooking invention, a pot called the Model Baker, which conserved the nutrients and moisture in the baking process. Not only was the kitchen warm with human activity and the presence of parents, but it had the warmth of the stove that provided comfort through the long New Hampshire winters.

Henry was born to Deborah and Joseph Cross on July 7, 1852, when Joel Foster was six and a half and Emma Augusta just two. The family lived then in its newly acquired dark-shuttered white farmhouse. Called Shady Nook Farm, it was built on a hill and was reached by a circling roadway from the area's major street, Mammoth Road. At the time of Henry's birth, the midsummer foliage of overarching shade trees created a safe and sheltered space for the young family.

Circumstances of a baby's moment of birth, family and community crises, pressures, and pleasures all leave their impression on the life that is to develop. But the new Cross baby bore the mark of the time of his birth also through the name he was given. He was called Henry Clay Cross after the United States senator, Henry Clay, who had died only days before on June 29. Though Clay had failed to win his party's presidential nomination in 1844, he was an admired national leader. As a southern former slaveholder, he was uniquely able to persuade Americans of the evils of slavery and its threat to the unity of the country.

The Crosses, like many, responded to the moral arguments against slavery. They were inspired by the sense of justice implicit in Clay's words in a letter concerning the future of slavery written to Richard Pindell in 1849:

". . . if the principle of subjugation, founded upon intellectual superiority, be true, and be applicable to races and to nations, what is to prevent its being applied to the individual? And then the wisest man in the world would have a right to make slaves of all the rest of mankind!"[4]

Through the naming of their child, the Crosses expressed the hope that the changing American society would bring a rearrangement of opportunity so that no "wisest man" could have the right to make slaves of the rest of mankind.

The New Manchester

When Joseph Cross and his father arrived in 1841, Mammoth Road was a vestige of old Derryfield, renamed Manchester but not yet a chartered city. Though the rolling hills visible from Shady Nook Farm hardly suggested it, by the time of Henry's birth in 1852, everything had changed. Manchester was a chartered, growing city whose center of activity had shifted diagonally to the opposite end of town, leaving Shady Nook Farm neglected off in the remote northeast corner of the newly incorporated city.

Mammoth Road itself had been the center of controversy. It had been planned to extend from the most northerly edge of the city due south through the city toward Lowell and on to Boston, Massachusetts, the result of efforts by the old stagecoach companies, which in 1830 persuaded the town to build the road to increase travel from New Hampshire's capital city, Concord, through Derryfield, and on into Massachusetts. But six years of argument followed, and no thoroughfare had been completed. Other travel routes had proved more convenient, and Mammoth Road became almost deserted; in some parts it lacked enough traffic to keep the grass from growing over it. The new Manchester city government finally resolved in 1836 that the road improvement should be discontinued.

The site of town meetings had been the old Presbyterian Meeting House on Mammoth Road. In conjunction with the initial upgrading of the road, the town government had decided in 1831 to repair and alter the second floor of its old meetinghouse to prepare it to serve as the town's first publicly financed schoolroom, but after $243 were expended on improvements, that plan, too, was canceled. The last blow to the old village center was the discontinuation of the Mammoth Road post office in 1840.

The Cross family was caught in a shifting tide. Because of the geographical location of their farm, they identified with the old-timers and the old town center, which was now defunct. But the date of Joseph's arrival, 1841, suggests that he departed from his hometown

of Swanzey, New Hampshire, precisely to benefit from the new opportunities of the boomtown. Perhaps it was at that time that the land became less desirable and therefore cheaper.

The amalgamation of the new city of Manchester and the dissolution of the old town center at Mammoth Road made life difficult for the Cross parents and neighbors, who were now far from shops, tradespeople, and the life of the new city. Every detail of the new city was planned by a few men who called themselves the Amoskeag Manufacturing Corporation, incorporated back in 1831, whose purchase of three thousand acres of the old sandbanks at the eastern shore of the Merrimack River in 1834, with further land and water privileges on both sides of the river, was essential to its building a new industrial city. Amoskeag could hardly be blamed for destruction of agriculture. Nothing could grow on their chosen site; a sandbank was just the place to start manufacturing. Even Harriet Martineau, an English traveler and writer who echoed American fears of mill development in her travels through America, could not object to manufacturing developed on land unsuitable for agriculture. "If there is poor land, and good mill seats, abundant material . . . and talent for the construction and use of machinery; there should manufacturing spring up."[5]

Once the Amoskeag Corporation was established, it built the first of its great mills on fourteen acres of the river's eastern shore. This was Stark Manufacturing Company, incorporated in 1838 and named after Manchester's revolutionary war hero, John Stark. Following that, workers' housing was built. In 1839, a second mill was built for Stark, and another, which included a machine shop, for the Amoskeag Corporation itself.

Old-timers did not observe all this with equanimity. There was overt rivalry between the new village people and the old settlers. At the close of the town meeting session in 1840, Justice Frederick G. Stark, grandson of John Stark, scolded: "You are a set of interlopers who have come here to get a living upon a sand bank. And a damned poor living you'll get, let me tell ye!"[6] In that meeting, however, the citizens of the new village won and elected their candidates for selectman. Years later, Justice Stark's prediction was recalled as being woefully incorrect.

The earliest city directory, dated 1844, records both Joseph, then

age twenty-three, and his father, Benjamin Cross, working as watch-
men for the Amoskeag Corporation, and provided with room 3 at cor-
poration housing. In four years time Joseph would maintain two
sources of income, one at home on the farm and the other down at the
corporation. This was not an uncommon pattern. In fact, workers
were often jacks-of-all-trades and had flexible and multiple jobs.
When seasonal work demanded more of their time at the farm, they
could cut back on their hours at the corporation. If the corporation
needed them to be working into the night, it could assure them a
place to rest their heads. The Herrick family, living just across Mam-
moth Road from the Cross family, had a similar arrangement with the
corporation.

As the Cross men traveled back and forth from the corporation to
the farm, they carried stories of the changes they witnessed and
rumors of things to come. More and more workers came to the city
for employment, and with them came their families. Their children
needed schools, and the city, which up to 1841 had no publicly sup-
ported schoolhouses, suddenly had to supply them. The town saw to
it that the new schools received what they called liberal appropria-
tions, though these hardly appear so, considering the salaries. In the
1850s, that a master or head teacher received only seven hundred
dollars a year and most teachers received only five dollars weekly did
not prevent people from boasting that few towns in New England had
a superior system of common schools.

The abandonment of the newly refurbished second-floor school-
room of the Mammoth Road meetinghouse was justified because the
Amoskeag and the city had new plans for improved schools. As part
of its grand scheme, Amoskeag agreed to provide land for schools,
which it considered community benefits. The Amoskeag Corporation,
retaining ownership, provided a parcel of land at the corner of Chestnut
and Lowell streets on which the town could build a high school. Next
South Grammar School, formerly convened in a chapel on Concord
Street, was granted a plot on Park Street. Of course, no school was
built out near Mammoth Road, since that location was outside the
boundaries of the Amoskeag Corporation's plan.

The only public facility located on Mammoth Road was the work
farm, established by the city government in 1846. Indigent and help-

less individuals were housed in the now dilapidated old tavern stand of Captain Ephraim Stevens, surviving from the days when Mammoth Road was the traffic center of town. For an initial purchase price of six thousand dollars for 106 acres on Mammoth Road, City Farm was established; with virtually no costs other than a superintendent's salary and the purchase of some farming tools, it solved the perennial problem of how best to remove misfits from the community.

Far from Mammoth Road, the new village became the site for everything that enhanced urban life. The Manchester Lyceum welcomed famous itinerant public lecturers. Manchester Athenaeum's museum and reading room, established in 1844 thanks to large donations from the Amoskeag Corporation, Stark Mills, and the Manchester Print Works, increased its library from about seven hundred books to almost three thousand in about ten years.

Religious life also was taken into account by the Amoskeag Corporation. Just as land was provided for school construction, so it was for churches, many of which sought new buildings. Those that antedated the mills had outgrown their old accommodations. Other churches were needed for workers whose denominations never before gathered in Manchester. By 1850, of the eleven churches clustering at the new village's center, most were on Amoskeag-owned property.

The appearance of the churches were matters of pride. One Episcopal church boasted that it had tempered the walls with a tint and had painted the illusion of grained wood on them. The Catholic Society started its ambitious architectural program in 1844, aspiring to create, "the most beautiful church in the state. They also intended to improve it externally by building a tower."[7] The church's unsafe construction and a population increase justified building a new church, which by 1856 was duly appreciated: "Certainly our Catholic community deserved well of our citizens for contributing their share of ornamental buildings to our young city."[8] Their aesthetic interests were somewhat enviously and condescendingly admired.

Everything was changing, even the distribution of wealth. Adults recalled the days when,

[their] father's neighbors were all hard working farmers—men who worked their own farms—who were nearly all equal in wealth, and to whom the idea of social inequity, founded upon an inequality of possessions, did not exist even as an idea. Wealth and want were alike unknown.[9]

New Hampshire had been a poor state until the great manufacturing towns sprang into existence:

Some articles which forty years ago, were quite destitute of pecuniary value now [1855] afford an ample profit. Firewood, for example . . . could seldom be sold at any price. It was usually burned up on the land on which it grew, as a worthless encumbrance. Firewood now in the city of Manchester, sells for six dollars a cord, and at any point within ten miles of Manchester, for four dollars a cord. Forty years ago farmers had little surplus produce, and that little had to be carried far, and it brought little money home.[10]

With the rearrangement of life in Manchester, adults and their children must have come to expect that anything was possible. As if in answer to their doubts, *The (Old) Farmer's Almanac* of 1852, the year of Henry Cross's birth, made these changes into metaphors for human possibilities celebrating the moral contributions of the new American inventions: "We may all learn great lessons from the prominent discoveries of the times: from the locomotive, punctuality; from the telegraph, brevity, and speaking to the point; from the daguerreotype, quite composure."[11] With cautious optimism, the changes taught that opportunity was to be expected.

Landscape versus Mills

For some who thought about art, "improvements" even became symbols of artistic possibilities. As Emerson urged: "It is in vain that we look for genius to reiterate its miracles in the old arts; it is its instinct to find beauty and holiness in new and necessary facts, in the field and roadside, in the shop and mill."[12] Worldly improvements promised new matter for art. Years before the Crosses coped with changes in Manchester, the prominent American painter Thomas Cole wrestled with transformations he witnessed along the Hudson River.

Like Manchester, New York's Hudson River landscape was also changing, but the Hudson was no sandbank. The hemlocks, which beautified the scenery, also provided tannin, an element vital to the processing of leather. For convenience, tanneries were built in that wilderness as early as 1816. By midcentury, hemlocks had almost entirely vanished and, with them, the wooded landscape that had drawn people to it.

Even in the eighteenth century, the village of Catskill was known as The Landing, prophetic of the commercial shipping town it was to

become. By 1836, sole leather, lumber, butter, wool, hay, and potash were shipped to New York from its twelve wharves. Catskill's over twenty thousand residents and its significant commerce made this former rural town one of the three major cities of New York State. Only the panic of 1837 thwarted the further development of the area, which was linked with projected canals and rail routes and had been intended to rival New York City for inland trade.

Catskill's artist, Thomas Cole, so devoted to nature's wildness, also confessed his excitement. Of Rochester, New York, he wrote:

Here is a large and handsome town that has risen in the midst of wilderness almost with the rapidity of thought. . . . But for the appearance of newness the traveler would imagine that it would have been the work of ages. Bridges, aqueducts, warehouses, and huge mills which are the castles of the United States are standing over the rushing waters and in future ages they shall tell the tale of the enterprise and industry of the present generation.[13]

The artist struggled to reconcile the paradise of nature with the power and promise of improvements. By 1836, Cole's paradise, with tanneries along Catskill Creek and its tributaries for twenty-seven miles, was dense with sixteen gristmills, twenty-six sawmills, eight fulling mills, seven carding machines, one woolen factory, two ironworks, one trip-hammer, two paper mills, and a brewery. The artist found himself in mourning for more than the hemlocks.

Just two years after Amoskeag purchased its acres of sandbank in New Hampshire, Thomas Cole published his essay entitled "American Scenery" in the January 1836 issue of *The American Monthly Magazine*, which was initially presented as a lecture, part of the proceedings of New York City's American Lyceum, a voluntary association of distinguished friends of education formed only five years before. The American Lyceum meetings, convened at City Hall, dealt with ideas meant to instruct and encourage teachers and promote education in the common schools. Cole's session concerned the impact on people of growing industrialism. He told his audience that he worried about then-current trends:

In this age, when a meager utilitarianism seems ready to absorb every feeling and sentiment, and what is sometimes called improvement in its march makes us fear that the bright and tender flowers of the imagination shall all be crushed within its iron tramp, it would be well to cultivate the oasis that yet remains to us, and thus preserve the germs of a future and a purer sys-

tem. . . . The spirit of our society is to contrive but not to enjoy—toiling to
produce more toil—accumulating in order to aggrandize. The pleasures of
the imagination, among which the love of scenery holds a conspicuous
place, will alone temper the harshness of such a state.[14]

Cole believed landscape could serve Americans in place of the
cultural heritage they felt they lacked: "Poetry and painting sublime
and purify thought, . . . and *rural nature* is full of the same quicken-
ing spirit—it is, in fact, the same exhaustless mine from which the
poet and the painter have brought back such wondrous treasures."[15]

Americans needed to be helped to value and see their own land-
scape. Those who went to Europe saw landscape there and then
closed their eyes at home, he contended. "Nature has spread for us a
rich and delightful banquet. Shall we turn from it? We are still in
Eden; the wall that shuts us out of the garden is our own ignorance
and folly."[16]

Cole argued that American landscape "is a subject that to every
American ought to be of surpassing interest . . . its beauty, its magnifi-
cence, are all his."[17] Noting that even the most refined communities
seemed to have an apathy to beauties of external nature, Cole argued
that everyone would benefit by "cultivating a taste for scenery."[18]
Painting itself was a means of instruction, a transformation of nature
for moral purposes.

Though by 1840 Cole was acknowledged as America's leading
landscape painter, and so honored by a solo exhibition at the National
Academy of Design, and though he advocated the educational virtues
of observation and painting, he had not yet taught. But the suggestion
that he teach must have struck Cole just at the right moment, because
when Daniel Wadsworth, founder of Hartford's Wadsworth Athe-
naeum, kindly wrote a letter of introduction to Thomas Cole for a
young prospective student, Cole agreed to take him on. No sooner
had he accepted the eighteen-year-old student than he received this
note: "My highest ambition lies in excelling in the art. I pursue it not
as a source of gain, or merely as an amusement. I am sensible of the
unusual advantage I enjoy in being allowed to look to you sir as an
instructor."[19] The note was signed with the soon to be well-known
name of Frederick Edwin Church.

Church's father, an affluent Hartford banker, objected to his son's

desire to become a painter. Painting and inventing, both interests of Frederick, seemed beneath his class and akin to the work of a mechanic.

Years before, he had worried less about his son's interests. He had even arranged for him to have drawing lessons with two Hartford drawing teachers, Alexander H. Emmons and Benjamin H. Coe. But as Frederick Church approached adulthood, his continuing interest in painting grew more threatening to his father. Nonetheless, his parents approved of his study with Mr. Cole, which began June 4, 1844.

At Catskill, young Church was welcomed at the simple column-lined wide front porch of Cole's large brick house called Cedar Grove. From the elegant doorway, ornamented with clear leaded glass, Cole could orient Church to the places where they would work. To the left of the house, he could point out a small, white, shingled building that had served as his studio until his new, larger one, over to the right of the large vegetable and flower garden, was ready.

The property ran from the edge of his road all the way down to the Hudson River. Cole shared the privileges of his position there, in every sense, with young Frederick Church. They toured the property and talked about the forms of trees and plants in nature, then returned to the studio to draw. Cole taught by drawing pencil or ink examples from nature—a selected cliff or ridge, a gnarled tree root, a cut stump—and then inviting his student to emulate his hand. Young Church absorbed each new idea and made it his own. Cole admired his student's achievements and said that young Church had "the finest eye for drawing in the world."[20] After the first year at Catskill, Cole judged Church's paintings fit to be exhibited in the National Academy of Design's 1845 exhibition in New York City. In 1846, after completion of his second year at Catskill, Church set off on his own.

Individual biographies can be deceptive. One master teaches another, and with some transformation due to temperament and mission, tradition is carried on; but Cole and Church were part of a much larger story. At this time, many Americans wanted to learn to draw. The wishes Cole expressed in his American Lyceum lecture became the American dream. Though Cole neither lived long enough to do more teaching (he died of pneumonia in 1848), nor desired to teach the multitudes, many Americans awaited art instruction. Cole's hopes

for his nation shaped generations who saw the appreciation of land-scape and learning to draw it as the fulfillment of their personal and political dreams all combined.

Art for
Employment
✼

Art—drawing in particular—came to symbolize concerns quite different from those of Cole and his young student. Drawing itself became the means for unifying the useful and the ornamental in art, an avenue by which industrialization could be integrated into culture. For some, art education had nothing to do with fine art or the savoring of American landscape. It promised work, employment. At mid-century, a new idea grew in popularity in America: that knowing how to draw was indispensable for manufacturing or, in fact, for any fabrication. The lesson had been learned from France, Germany, and England where useful art was seen to contribute to human comfort and the perpetuation of an historical memory. Each nation's government promoted art and a system of training its artists. Perhaps because of America's ties to many things English, perhaps because England saw herself as just a newcomer to the international arena of industrial art, Americans paid special attention to the British art schools whose system of instruction was developed for art labor.

Industrialization brought about new ambitions, and the fulfillment of these ambitions was to take place on an international scale. As early as the late eighteenth century, Manchester's Samuel Blodget, envisioning that his city "shall be the equal of the great manufacturing city of Manchester, England,"[21] directed citizens' energies to international competition. International competition did make Manchester prominent. As of 1851, the Amoskeag Manufacturing Corporation already had been designated as "finest in its class" in the international display of industrial products at London's Crystal Palace exposition. Its samples of denim, cotton flannels, tickings, and sheet-ings earned it a bronze medal with a sculpted relief of Queen Victoria and Prince Albert.

Americans were proud that the English found American products prizeworthy. This success set a precedent. In 1853, the new American president, Franklin Pierce, whose New Hampshire roots made him particularly sensitive to the significance of industrial exposi-tions, opened a spectacular international manufacturing exhibition in

the United States. The New York extravaganza, called The Exhibition of Industry of All Nations, was inspired, of course, by London's exposition; it marked the formal entry of America into the competitive international market of aesthetic industrial production. The New York exhibition was intended to teach Americans how Europeans transformed American raw materials into mass-produced, highly marketable aesthetic objects. The hope was that Americans would acquire the skills to do their own artistic production here. Though Americans had little confidence in their ability to compete with the British and the Europeans, they longed to improve.

The New York exposition was a lavish public act aimed at inspiring change in American life. The authors of the exhibition record, B. Silliman and C. R. Goodrich, assured readers that an art spirit existed in American culture and that this exhibition would promote its emergence. In their view, art labor meant money. The cultivation of an art spirit was another way of saying America could anticipate prosperity.

These authors were not alone in stating their case. William Minifie, a Baltimore teacher of architectural and mechanical drawing, prepared an address for the Maryland Art Institute in which he publicized the shocking economic facts from the *Report on Commerce and Navigation* made to Congress in 1852. He reported that every year, $11 million left the United States for the purchase of textiles, decorated ribbons, woolens, and dress goods. From Britain alone, the United States imported 36 million tons of textile goods, including printed calicoes, silk goods, worsted and mixed fabrics. Minifie complained that too many American dollars were paid to artists abroad for skilled work that could be performed here. "I would call upon our manufacturers as the persons most directly interested, to be foremost in the good work. Let them start such schools for both sexes with liberality and then call upon our statesmen and capitalists for aid." [22]

This art education had nothing to do with what Cole and Church were doing. Neither the education of painters and sculptors nor even of independent designers was at issue, but that of "the workman, by whose skill it is fashioned and by whose intelligence or ignorance, it is to be made or marred." [23] Art education promised to create skilled art labor. Americans who admired the British products were re-

minded that art labor was a recent thing in Britain, the result of art schools established there only since 1836, when it was resolved that "measures for the promotion of artistic education amongst the manufacturing classes ought to be at once taken and that the Government ought to assist."[24] British art labor's success was expected to be contagious, "to attract attention here and induce wealthy and influential and liberal citizens to provide similar schools for the instruction of our own artisans."[25]

In the 1850s, there was such excitement about learning to draw that independent artists were encouraged to hold classes even before governments had time to establish them. Just after the New York exhibition, a worker in the drafting department of the Amoskeag was encouraged by his friend, the Unitarian minister Reverend Francis LeBaron, to teach a drawing class two nights a week. His class, which he considered charity work, was for boys who aspired to be workers in the mills. "In the same room is a class of young ladies who are learning crayon drawing. The influence of the young ladies is quite amusing in its effect on my scholars. They dare not speak above a whisper."[26] The teacher, John Rogers, later to become a popular American sculptor, precisely shows the economic value of the skills he taught in notebooks he kept in the years 1854–1855. His drawings show machines designed and fabricated at the Machine Shop at the Amoskeag: warpers, centrifugal pumps, hoisters, looms, lathes, planers, furnaces, and nappers for cotton flannels. Through drawing, Rogers could indicate relationships between the parts of a machine and the path of its moving elements. Architectural ornament could be shown in exact scale and position far more specifically than words could convey. For machines such as these to be built, drawings had to be made and people had to learn how to make them. It appeared then that anyone who knew how to draw had it made.

The ideal was to have many people learn what Rogers knew. Rogers was a maverick whose skills were scarce in the nation at that time. Manchester was the beneficiary of his unusual situation. Rogers's family, though of the upper class, did not have the money to send their son to Harvard, so instead of receiving the classical education that was typical of his class, he attended Boston's English High School. There he received a general comprehensive education that

included instruction in drawing. Rogers took the regular drawing classes under Edward Seager, and he studied drawing because everybody at English High School did. His high school drawings, "though adequate representation of things seen, . . . were no better, no worse, than most of the work of a host of amateurs stimulated by the introduction of art education in nineteenth century schools."[27] Nevertheless, the drawing skills that Rogers mastered he brought with him to the Amoskeag, where people immediately saw their value.

It was of drawings such as John Rogers's and his students' that Silliman and Goodrich dreamed, as they wrote of the American art spirit that would emerge when

artists abandon the silly notion . . . that easel pictures in oil and works in marble are the only objects of their attention. . . . It will be a happy day for modern art when the genius of the artist and the skill of the artisan are again, as of yore, found in one person.[28]

Art instruction hoped to deliver this happy day. Art labor offered the dream of opportunity that every man would be able to be employed and to contribute to the good of the country. New York's exposition was a first step in a young nation's march for art education.

A child growing up at this time heard the message that becoming an artist was a pursuit that could benefit the nation and assure one employment. Never before had families heard these arguments. Confusing though these notions may have been to the farming and working families, they inspired interest. There was little to contradict the enticements. "The masses in the United States have no knowledge of art for the plain reason that they have had no opportunity to instruct themselves in it."[29] Growing up in New England in the 1850s, children such as Foster, Emma, and Henry Cross could not escape the lure of art study. Their situation was not unlike children of today who are urged to study computers. Drawing was seen as indispensable to industry, a life raft that would keep them afloat regardless of economic turbulence.

CHAPTER 2

FIRST PEOPLE

The unexpected isolation of Shady Nook Farm had little impact on the new infant, Henry Cross. He slept, cried, and smiled as every baby does, slowly adapting to life around him. In time, he showed interest in activities that involved the other members of the family. When he could crawl, he kept close to Foster, who helped his father milk the cows and gather the animals' hay and cereals.

As Emma helped her mother, she acquired a knowledge of flowers, which she was to treasure for life. She learned the shape, size, color, scent, blooming time, and cultivation of every flower that grew at Mammoth Road. When Henry learned to walk, the flowers were at just the right level for him to observe them. Their names, shapes, and their care became the objects of his interest and affection; this pleased his father, who had every intention that both his boys would grow up to be farmers.

At midcentury, the study of horticulture was credited with far more than just teaching the child the work of the farmer. It also was believed to cultivate children's temperament and affections, to teach them to love home, and to restrain them from the corruption of evil associates.

What we cultivate with such solicitude and visit often and wait for with much expectation, we almost invest with life and sensibility and treat with

the kindness we show a friend. It is no unusual thing for children under the influence of this principle, to mourn over a dying plant with a tenderness of sorrow which others fail to exhibit at a neighbor's funeral.[1]

Above all, horticulture was valued for its moral influence on growing children and thought to be particularly conducive to pious sentiments, for "It is God who paints the flowers of the fields and clothes all nature with manifold beauty."[2] Since Foster, Emma, and Henry were born into a farming family, there was no question that they would benefit from all the advantages of horticulture.

The moral influence of horticulture extended to the drawing of flowers. When the children came in from the garden, they settled down to draw, perhaps at a kitchen table, "the flowers of the fields." This family's meager resources were not spent on paints, but the family ledger shows that the children did have paper and pencils. At this time, Foster and Emma could have drawn recognizable flowers and Henry's early scribbles could confidently have been called flower or tree.

Labor on the farm was so essential and so little outside help could be obtained that most farmers' boys could not be spared to go to school. The Crosses, however, saw to it that their boys attended school regularly. For them, both education and farming were serious work. Emma also learned to farm and did much of the work the boys did. She was equally respected for her intelligence. Letters show that her family did everything to promote her education. Her love of words and stories was encouraged, and she was directed to study and learn at least as much as her brothers, and perhaps even more. She was expected to excel.

Both parents could read and write, and they stressed these skills in the education of all three children. The children learned to follow their elders' example, whether reading the huge leather-bound family Bible inherited from the Wilder family or the local newspapers the *Manchester Democrat*, *Stars and Stripes*, and *Ladies' Enterprise*, which joined each separate house to the other and connected all to the life of the world. Most frequently they read Manchester's *Daily Mirror & American*, full of the names and news of neighbors, spelled in neatly printed letters.

Family life required its own pastimes. One popular one was making copies in imitation of pictures on drawing cards, decks of lithographed

animals, birds, flowers, cottages, or human figures. Children's pastimes were often also work. Taught to sew at four or five, they could emulate sewing ideas in magazines such as *Peterson's* and *Godey's*. *Peterson's* provided a pattern for Lady Pincushion, which performed the utilitarian service of a pincushion and doubled as a not very huggable doll. Bookmarks, watch pockets, pen wipers, needlehooks, and pincushions were within most children's sewing repertoire. Any toys they had probably were made by themselves or were purchased from local toy carvers.

Across the Street
❦

In this rural, forsaken corner of Manchester, two kindly older people were important to the Cross family: Israel Evans Herrick and Martha Trow Herrick, who owned the farm across the road. Having moved south to Manchester from Hopkinton, via Concord and Nashua, New Hampshire, the Herricks acquired their farm in 1842. They had six children—five boys and one girl—the oldest of whom, Ann, was born in 1818. That would have made her exactly the same age as Mr. and Mrs. Cross. Inevitably, parental feelings toward Deborah and Joseph Cross led the Herricks to take a special interest in the Crosses and their children.

Mr. Herrick, a country merchant and lumber dealer, worked as a lumber surveyor for the new city of Manchester. His English progenitors, who had been on this side of the Atlantic for over two hundred years, settled in 1629 in Salem, Massachusetts. Mrs. Herrick, a product of "the best education," had attended a private church boarding school at Charlestown, Massachusetts. Jedidiah Morse, the school's director, was a historian and author and the father of Samuel F. B. Morse. Mrs. Herrick's art training there taught her skill with the pen and brush so that she could do watercolor painting in the manner of miniatures using the tiniest brushes. Years later, in a newspaper interview her son Henry recalled that in 1832, when he was eight, he was already studying art under her tutelage, and "studying with a purpose." Mrs. Herrick enjoyed teaching her son and introduced him to the new invention that was making such a stir, cake watercolors. Both mother and son selected the same subject matter for painting: birds and flowers. Years later, her son still treasured her schoolgirl paintings, which he said remained "fresh and clear."

As a little girl, Emma often crossed the road to visit Mrs. Herrick, and she probably talked about flower pictures. With a little prompting, Mrs. Herrick would have shown her the flower paintings she had made years before. If Mrs. Herrick still kept those cake watercolors, Emma would have enjoyed moistening them to release their lovely colors.

Although no longer the major traffic route, Mammoth Road still welcomed travelers. Most important was one who periodically came all the way from New York City to visit his parents, the Herricks. Henry Walker Herrick, born August 23, 1824, in Hopkinton, New Hampshire, was said to be one of those brilliant people born under the shadow of great Mount Kearsarge. He had lived with his parents at Mammoth Road but two years, from 1842 to 1844, the first two years they had this farm. In those years, both father and son worked for the Amoskeag Corporation, and teen-aged Henry, presumably self-taught, was sufficiently proficient to sell his wood engraving and designing services to the city government and the Amoskeag.

Henry Herrick, as he turned twenty, became restless and ambitious for more art training. Fortunately, Samuel F. B. Morse, who founded New York's National Academy of Design in 1829, spent time in the area of Manchester as well as Concord, New Hampshire, in the 1830s. Since Mrs. Herrick had studied with Morse's father and was herself an accomplished watercolor painter, Morse was likely to have visited their home. Tales of New York's important artists and the financial opportunities awaiting them provided the perfect incentive for young Herrick's departure from Manchester. In 1844, he took off to study at the National Academy of Design in New York City.

Most of the students at the National Academy were from homes closer to New York. The connection to the Morse family would have helped young Herrick feel somewhat more at home, but New York itself soon diverted him from any discomfort. It was just then becoming an exciting place to be an artist.

There have been few moments when it was better to be a painter in this country than in the years just before the Civil War. In that golden era of prosperity and cultural nationalism, painting in America finally evolved into an authentic movement with well-defined and in turn well-realized aims that were peculiar to the New World needs. The artist was called upon to play a

vital role in national life: he could help to unify the citizens of all quarters of the land, he could inspire patriotism, and he was paid well for his services.[3]

Henry Herrick enrolled for his first session at the academy in November 1844. He joined the antique class, where students developed their skills by copying forms of plaster casts of classical sculpture in order to qualify for the life class, to which Herrick reported he soon was promoted. The registration book at the National Academy shows Herrick's name and date of entry only to the antique class. In fact, no life class was recorded between 1843–1849. But records are not the ultimate authority. The academy was being criticized at this time for its methods of supervising and teaching students and may have neglected its class lists and records of promotion. It was years later that Herrick described his own education, so there is room for error on both sides.

Herrick needed to make money and also craved more contact with the busy world of New York City. Only six months after he arrived in the city, he got his first wood engraving job, engraving illustrations of Felix O. C. Darley's drawings for D. Appleton & Company, Publishers. A long and close working relationship developed between Herrick and Darley. Meanwhile, Herrick's list of publishers expanded to include Harper & Brothers, the American Tract Society, and Carter Brothers.

In 1849, after five solo years of professional advancement, Herrick married a former New Hampshire schoolteacher, Clarisa Parkinson (also known as Clara). Their early married life was spent in Brooklyn, then a city separate from New York, where they had their first four children.

Each of Herrick's successes earned him yet another job. Fellow engraver Benson J. Lossing, who also had been a student at the academy, recommended Herrick for a teaching post at the New York School of Design for Women, newly organized in 1852. The all-women's school then located on Broadway at the corner of Broome Street was headed by Miss Cordelia Chase, a fellow native of Hopkinton, New Hampshire, who offered the teaching position to Herrick. He accepted the job, and through it, a mission emerged that endured the rest of his life. In his first teaching job, he learned that drawing and engraving had special value in the lives of his young women stu-

dents: Their success in their work made them highly employable. When Herrick became principal of the School of Design for Women in 1856, he had already become a passionate advocate for women's right to an art education, a radical and threatening position at a time when even among male wood engravers competition was keen.

While he directed the school, Herrick continued to maintain his private office. There he executed designs for books and periodicals as well as bank notes for the American Bank Note Company. He came into the school only for specified critique hours every day, having prepared his senior students to train the neophytes.

Newspapers report that prominent New Yorkers Horace Greeley and Peter Cooper took an interest in Herrick's work at the school and spoke publicly on behalf of the women wood engravers he had trained. Herrick remained head of the school until 1858, when it was incorporated into the Cooper Union, founded in 1859. Since both Peter Cooper and Henry Herrick shared a commitment to providing art instruction for the working class, the aims of their institutions were complementary. When he came home, this visitor to Mammoth Road was to have a profound effect on the Cross children.

When Henry Herrick and his family made their trips to Manchester to visit his parents, they brought tales of their New York adventures. The Cross children were fascinated by this famous man who came to sit with them while they drew. He had drawn and engraved some of the pictures in their very own storybooks—*Robinson Crusoe*, *The Rescued Boy*, and *The Fireside Storybook*. Mr. Herrick's profession influenced the children to think of their own drawings as more than idle scribbles. The children probably watched Mr. Herrick draw. One day he took out a rectangle of wood on which he drew his own son, Allan, playing with Henry Cross. The panel, dated 1860, actually titled on the front, *Let's Make a Fire*, may have been so named by the children who served as its models.

All children draw and use whatever tool is available to make their mark. By the late 1850s, the Cross children would already have started to draw. Herrick probably encouraged them, presumably influenced by the then-popular British art theorist John Ruskin, whose *Elements of Drawing* was first published in London in 1857. Ruskin

Art Lessons

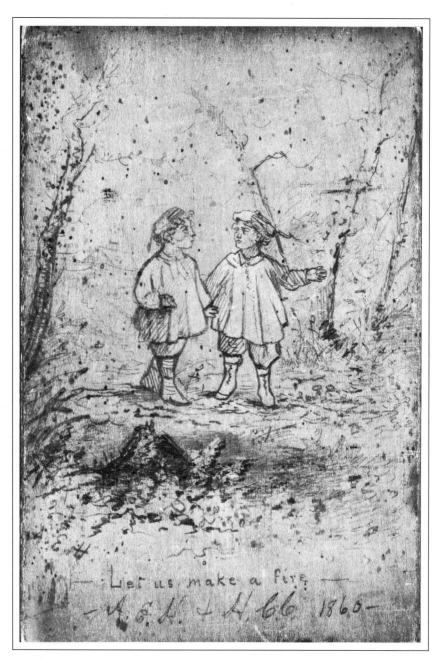

Pencil drawing on wood panel shows Henry Cross and Allan Herrick in 1860. Though initialed and dated in Henry's adult handwriting, the lettering "Let us make a fire" and the drawing style suggest Herrick's hand. Henry Cross was preoccupied with family history. He backdated and organized whatever bits of his childhood he could find.

encouraged children even to draw war pictures, such as children still make today:

If it has talent for drawing, it will continually be scrawling on what paper it can get; and should be allowed to scrawl at its own free will, due praise being given for every appearance of care, or truth, in its efforts. . . . It should have colors at command; and, without restraining its choice of subject in that imaginative and historical art, of the military tendency, which children delight in, (generally quite as valuable, by the way, as any historical art delighted in by their elders,) it should be gently led by the parents to try to draw, in such childish fashion as may be, the things that it can see and likes,—birds, butterflies, or flowers or fruit.[4]

Not only did Henry Herrick encourage the children to draw, but he must have shown them a book intended to show all Americans how they could learn to draw, Chapman's *American Drawing-Book*. This was one of many books for which he had drawn and engraved pictures. In 1858, after eleven years of the publication of its chapters as separate manuals, the New York publisher J. S. Redfield collected these into a single beautiful volume, just in time for Herrick to share it with his young protégés. Mr. Herrick's visits enriched the Cross children's lives, creating situations that were *Parents Magazine*'s very ideal: "Take an interest in your child's enjoyments. . . . The great difficulty with most parents is, that they are unwilling to devote time to their children. . . . Let the parent, then, find time to train up the child in the way he should go."[5]

Artists of every era, recalling their childhoods, savor intimate critical moments with an individual like Mr. Herrick, who showed such an intense interest in and love for pictures that the child recognized the passion and suddenly saw what he or she would be. To dream of becoming an artist, the young child needs examples. Mothers and fathers, neighbors, pictures, storybooks, and local teachers suggest to children that art exists. Critical impressions are formed early. For instance, well before meeting Thomas Cole, young Frederick Church was said to have had considerable talent in landscape painting and a strong desire to pursue that art. He had, as we know, already received instruction in drawing and painting from two Hartford artists, Benjamin H. Coe and Alexander H. Emmons, and although his biographer claimed they had "little to do with what their able pupil eventually became,"[6] this seems hardly to have been the case.

Coe was the most prolific producer of instructional landscape drawing books. He advised students on the drawing of trees thus: "Though, in foliage, a rigid accuracy is not required, as in drawing the human figure, yet the student who attempts it without a thorough knowledge of forms may soon expect to find himself entangled in its intricate masses."[7] Despite his copying method, the teacher's goal was to have students compose from nature: "It is good practice, after copying a picture, to lay it aside and draw again from recollection. This will serve to fix the form of the objects in the mind, and will be highly useful as a first step in drawing from nature."[8] Coe's teaching established landscape as the paramount subject matter for all his students, and Church pursued landscape painting for the rest of his life.

Artist William Dunlap, author of the earliest history of American art, recalled that but for the enthusiasm of an artist mother and an interested neighbor he would never have known about art. On the interested neighbor, Dunlap dealt at length:

It must have been the delight he took in watching the growth of the mental faculties, which caused this benevolent old man to devote so much attention to a child, and doubtless, he felt gratified by the attachment of a child. . . . The happy hours passed with him in his garden, or in walking with him . . . when I was placed by the side of the gentleman at the stand or a table where he sat with his books, when after going upstairs to the book-closet and bringing down such volumes as struck my fancy, I received his explanations of the pictures or the pages; if these visits were passed over I should omit the record of the happiest moments of childhood, and of hours which expanded my intellect, and laid the foundation for my love of books and pictures.[9]

After separation from his aged friend, Mr. Barstow, Dunlap recalled:

Books and pictures became the companions of my leisure, and I had as much time to bestow on them as I pleased. I had acquired the use of India ink and became attached to copying prints. I was encouraged by admiration. . . . My eyes became satisfied with light and shadow and the excitement of color was not necessary to my pleasure.[10]

The interests of adults have always been nourished by the child who craved education. In just this way, a neighboring New Hampshire farmer, sea captain and jovial friend, enjoyed young Horace Greeley's intellectual curiosity:

The captain had seen the world, possessed the yarn spinning faculty, and besides, being himself a walking travelers library, had a considerable col-

lection of books, which he freely lent to Horace. His salute to Horace was not "How do you do Horace?" but "Well, Horace, what's the capital of Turkey?" or "Who fought the Battle of Eutaw Springs?" or "How do you spell Encyclopedia, or Kamtschatka, or Nebuchadnezzar?" The old gentleman used to question the boy upon the contents of the books he had lent him and was again and again surprised at the fluency, the accuracy and the fullness of his replies.[11]

So the Cross children hungered for Father Herrick, as he was called, to show them his storybook illustrations and to tell them how they were made. Since many were made by Herrick and his friends from both New York and Boston, the children understood that each picture was made by a particular someone. The process of picture making came alive as Herrick explained what he thought made some pictures excellent and what made some inferior.

Too often the influence of simple early experiences is overlooked. Genius has nothing to do with the import and pleasure of early art experience. As teacher, author, and art crusader John Rubens Smith urged Americans in 1831:

"To arrive at a satisfactory result in our studies, nothing is required but a good inclination and docile disposition: dismiss all high flown metaphysical disquisitions on genius, ambition, invention, etc. They have nothing to do with this stage of the art, any more than a genius for learning to read, a genius for learning to write, or a genius for learning plain arithmetic. The many elaborate researches into and descriptions of the nature of genius, seem more calculated to raise a mist in the mind to the destruction of common sense, than to stimulate rational exertion."[12]

Despite the political and economic rhetoric on the value of learning to draw, for Foster, Emma, and Henry the dream of becoming artists could catch hold and lead to action only because they were already prepared. They already were doing something that was almost, but not quite yet, the thing of which they dreamed. Many people like the Crosses already were deeply involved with seeing, working in, and appreciating their landscape. The difference was that they were observing it as farmers, not as art connoisseurs. The farm family had looked at and noted the small and significant visible changes in the landscape upon which they depended for their livelihood.

Seeing Lessons

These descendants of Europeans who had boarded ships to become farmers on North American soil had to become astute observers of the earth and the climate's effect on it. They contended with steep hills

and innumerable unwanted rocks and marshes through icy winters and steaming summers. Since they grew part of what they needed to live, they became attentive to the smallest changes in color, texture, and shape that could indicate the health or vigor of a crop. Many like them, even if they could not read, would recognize conditions in growing plants and animals. What they judged as edible became the meals they ate. They literally lived or died based on the judgment of their eyes.

The children's eyes were trained as they worked alongside their parents. The parents taught the children to look at, notice, and respond to whatever would improve their efforts, so that the children could actually further the family's work. Today, we know that all young children learn through their senses. Whatever they do actively promotes their learning about size, weight, and distance. The more they handle and do, the more they understand. For children of the midnineteenth century, both their psychological development and the agricultural society itself required that they learn by responding to different appearances and textures of objects.

These same children, who could recognize conditions of the soil and of plants and animals on the farm, were also taught to adapt that skill to working with cloth. Even at a time when textiles were still largely imported from England, children learned to cut and sew the cloth to form shirts and skirts. As they grew older and their clothes wore out, those same good eyes transformed the worn garments into subtly calculated visual patterns to adorn beds as quilts or floors as rugs. By the time the youngsters had grown to adulthood, they had an intimate acquaintance with color, shape, texture, line, and pattern.

Americans had developed good eyes through observing their plants and their livestock, through cutting and sewing their own clothes, quilts, and rugs. The Cross children required only some instruction to redirect their observational skills from farming to pictures. They were prepared to make use of the opportunities of their century.

CHAPTER 3

IN AND OUT OF SCHOOL

So much has survived of the Cross family's life in the attic boxes and the descendants' own archives that the few remaining gaps are tantalizing. The lack of evidence tempts me to invent this scenario to provide continuity to the next bit of data that does exist. That the Crosses actually owned Chapman's *American Drawing-Book* when the children were young cannot be proven; it was not among the books I saw, but a good portion of the family's library was sold well before their other possessions. Without evidence, the following scene is pure invention:

The afternoon chores done, all three Cross children converged in the Shady Nook Farm kitchen to practice their drawing. Once inspired by Mr. Herrick, they carried on even without him at a bumpy old dented kitchen table, which only moments before was used for cutting up the fish for the codfish chowder. While their mother stood nearby stirring the chowder, boiling corn, and brewing coffee, the children drew and chattered, shifting quickly from one topic to another, stimulated by the anticipation of dinner, the memory of the color of a newly opened flower, or the novelty of an unfamiliar coach that passed down Mammoth Road. At this stage, their drawing skills permitted them to show the things they talked about. By 1856 or so, Henry was able to hold a pencil. Though Foster and Emma already

Chapman's Lessons

had had more years than he to practice making lines stand for things, he worked very seriously along with them.

When they did not draw, they pored over Mr. Herrick's copy of *The American Drawing-Book*, which made drawing into very serious business. Even the picture on the book's cover suggests this: An elegantly dressed female art student is shown seated at an ornate table on which she has set her desk easel, a unit that contains a drawing board that can be lifted from the frame and propped up and fixed at an angle by a supporting rod. On the floor beside her drawing table is a folding wooden rack on canisters, the container for a large black portfolio full of her finished drawings.

Lest Chapman lose most of the book's prospective customers, he is quick to reassure students that even without all those trappings they can proceed to learn to draw: "It is a matter of little importance what instrument is employed in the beginning . . . a piece of charcoal or chalk and the barn-door have served many. . . . He should early learn to consider his tools as of secondary consideration."[1]

The author also reassured readers on another matter: They should learn to draw whether or not they ever intended to become professional artists. Drawing was presented as a set of skills analogous to those of writing—simply useful and necessary for expressing ideas and observations. Lest parents became anxious seeing their children poring over his tome, Chapman comforted,

Who ever has hesitated to teach a child to write, because it was not intended that he should be an author? Drawing opens inexhaustible sources of utility as well as pleasure, practices the eye to observe and the hand to record the ever varying beauty with which nature abounds, and spreads a charm around every object of God's beautiful creation, unfelt and unknown to those who have failed or neglected its cultivation.[2]

The Cross parents, and many others like them, saw that their children's enthusiasm for drawing could be both a useful and a spiritual effort.

The scene in the Cross kitchen was repeated in many households. Anticipating parents' objections, Chapman interlaced drawing instructions with advice for parents who scrutinized the book's pages over the shoulders of their young. Every other phrase seems designed to placate a skeptical parent. After telling the tale of Giotto, the Ital-

First page of *The American Drawing-Book* by John Gadsby Chapman, published by J. S. Redfield, New York, in 1847. Engraved by Howland.

ian peasant boy who so perfectly drew a circle that the pope commissioned him to work in Rome, Chapman says,

Fathers and teachers, call not your boys idle fellows when you find them drawing in the sand. Give them chalk and pencil—let them be instructed in design. "But," you say, "I do not want my boy to become an artist." Depend upon it, he will plough a straighter furrow, and build a neater and better fence.[3]

Just as children were traditionally urged to think before they spoke, Chapman reminded them to "Think before you draw. Now is the time to school your hand in the habit."[4] Parents would have appreciated Chapman's attitude not least because it saved paper. Just as they did not want idle chatter to clutter the house with noise, parents did not want many bits of paper collecting without benefit of skills and discipline.

Chapman's exercises helped children perfect habits of accurate judgment. He taught them to make straight lines parallel to one another at equal distances, a technique that trained the eye and the hand. This was especially useful to anyone planning to become a wood engraver, since parallel lines called tinting are the basis of all wood-engraved forms. Though as yet the children knew little of the wood engraver's work, these exacting skills would have seemed desirable and probably led them to notice tinting in the wood engravings of their own storybooks.

Eager children had no patience for pages of text proclaiming the benefits of drawing. Their interest began with the section entitled "Primary Instructions in Drawing," whose frontispiece was drawn and engraved by Mr. Herrick. The word *drawing* is elegantly framed by vines lacing in and out of a beautifully drawn pencil, pen, and holder for chalks. From the pencil's point, a vine tendril sweeps down and cups a figure of a young boy drawing. His work demands that he not stare at his sketchbook, but gaze at a distant model in nature that is the reference for his picture.

Contrary to the example set by that drawing boy, the exercises in Chapman's book demand that the student start his practice by tracing straight lines, eliminating the habit of making small, hesitant strokes. The ideal line should be firm and decisive. Such directions hardly seem suited to children under ten, but they were vigilantly obeyed

PRIMARY INSTRUCTIONS

IN

DRAWING.

A FACILITY of hand is one of the first requisites in drawing, whatever instrument be employed, whether Pencil, Pen, Brush, or Modelling tool. Many are by nature endowed with a certain mechanical dexterity, or happy readiness with the fingers, to whom this facility is of easy acquirement; and all possess it, to a certain degree, or they could not be taught to write, which, in the beginning, is nothing more than the *drawing* of certain conventional forms, without any distinct idea of an object beyond the imitation of such forms. The first "pot-hook and hanger," is, clearly, *Drawing*. If the pupil has improved upon this humble beginning, so as to write a fair hand, he already, perhaps unconsciously, possesses an acquirement that will not only make easy his first essays in drawing, but essentially serve nim, however far he may extend its pursuit. Should this useful accomplishment have been neglected, he can not do better than practise his hand in the careful imitation of good specimens of penmanship, or place himself under the instruction of some good writing-master. The use of the pen has been too much overlooked by draughtsmen, especially by amateurs. It produces a certain line, and induces an early habit of care and accuracy, from the fact that it can not be easily erased. Many are falsely captivated by the spirited dash of a master, who overlook the means by which that ease and freedom have been acquired. It is the result of accuracy and labor; and to imitate the end, we should not shrink from the beginning. Let us lay well the foundation, before we begin the structure. He who starts with the black-lead pencil in one hand, and the Indian rubber in the other, will find, however convenient the latter may be, that he will soon fall into a loose and slovenly habit, of which it will be difficult to

Drawn and engraved by Henry Walker Herrick for *The American Drawing-Book* by John Gadsby Chapman.

and performed as precisely as writing exercises. The student started at the upper left-hand top of the page and filled the whole top line before going below to start the next line. Children were to progress from lines to the application of these to flat forms, which were to be used in making familiar objects—fence gates, tables, boxes, and steps.

Though little in Chapman's book admits to the interests or abilities of children, at one point he acknowledges that the aim of the beginner is simply to draw a horse that shall not be mistaken for a man. After the practice of merely making lines, the farm children must have been relieved when Chapman finally permitted them to draw from leaves. Now they could make use of their knowledge of form and draw the shapes they knew. In drawing leaves, Chapman instructed that all appearances of straight lines and angles should be avoided. "There are none in the original, and there should be none in its representation."[5]

Now Foster, Emma, and Henry go out the kitchen door, snip sprigs from their favorite plants, and bring them back inside to lay them down next to their drawing book. Even if they intended to draw the leaves as they appeared, their lack of practice and skill had to result in a simple form that only approximated the complexity of the original. The Cross children were content if their leaves were not mistaken for something else. One thing led to another. The practice of drawing the leaf led to combining leaves and inventing their own plants, or of copying plants from engravings in their own picture books.

The children continued their plant drawings on their own. They did not have to follow Chapman's schedule and proceed to the drawing of faces, hands, or feet. Early on, drawing became their play and their work. Though I have speculated about Chapman's, it would have been just one of innumerable resources around their home that could serve their purposes. That they drew at home for themselves and made themselves their own teachers is a fact. The many surviving drawings are evidence. Here, the children were really in charge.

Schoolwork

School was something else. Farm families like the Crosses aspired to get from education something quite different from the subtle work they already could accomplish with their eyes and their hands. People who went to schools wanted skills they did not already have; they

wanted to learn to write, do sums, and read. That excellent penmanship was a high priority is evident in his father's frequent criticism of Foster's writing. "I should be very much more pleased if you would take more pains in your penmanship. I think you would find it greatly to your advantage to do so. Emma will soon be ahead of you unless you try to improve in your handwriting."[6] Schools were devoted to the mastery of written symbols—expressing ideas in writing and understanding other people's ideas by reading. The anticipated goal more than compensated for students' sensory deprivation, the suppression of their interests and pleasure in the work of their hands.

Historically, schooling has always removed children from the protection of their homes, introducing them to wider circles of people and experiences. In the case of the old New England dame school, the mission was accomplished even if the child simply left the family's own home to go to that of the teacher. Early in the century, the schoolhouses that did exist were rough, unpainted, unornamented boxes, uninterrupted except for windows and a door. They were frequently overcrowded with students who ranged from young children to young adults. School began at nine, and the teacher heard each pupil read. He listened to each one four times a day, twice in the morning and twice in the afternoon, and all children whose turn to read it was not wrote or read on their own. For practice in writing, students repeated a copy of a phrase the teacher set in their notebooks, such as "Procrastination is the thief of time" or "Contentment is a virtue."

By 1856, when Henry Cross had just come of school age, an entirely public school system was in place in the city of Manchester. Now, with the help of the Amoskeag Corporation, teaching was carried on in new buildings designed and built especially for education. By 1856, Foster and Emma had already been attending the public schools. The tales they brought home helped Henry prepare for the experiences ahead. They described different kinds of schools and how a student progressed from one kind to another. Manchester's nine school districts now comprised five levels of schooling. Ideally, children of age four started off in the primary school, where they were taught to read. Students who learned to read progressed to the middle school. Between these two schools was a third, the intermediate

school, for slow children who did not yet read but were too old either to start or to remain within the primary school. Mastery of reading in the middle school enabled one to progress on to the grammar school.

Only one-quarter of the children who started in the primary school, however, even entered the grammar school. Farm or other work obligations, ill health, and inability to read conspired to keep numbers low. Therefore, only two grammar schools were needed for those who continued on from the eleven primary schools. North Grammar and South Grammar each had a master who served as a principal and head teacher, supervising a staff of several assistant teachers. Completion of grammar school, which was certified by the master, was a respected achievement as well as a prerequisite for eligibility for high school. Few chose to continue, and of the initial primary school population, only 10 percent remained to complete their high school studies.

The city's ambition is suggested by its speedy creation of a public education system as early as 1841. Once several new schoolhouses were in place, people were pressed to decide what these new schools were for. Nearby Massachusetts had wrestled with the problem in the 1830s and 1840s and could supply some possibilities. The secretary of Massachusetts's State Board of Education, Horace Mann, by then a national education leader, had faced enormous difficulties in his efforts to establish Massachusetts's public school system. When he took on that job in 1837, he found the schools in shambles. He decided that new buildings were needed and that the minimally skilled teachers were in need of more education themselves.

Most of all, curriculum ideas were essential, and he provided these for his state and, unofficially, for the nation through his editorship of the *Common School Journal*. The journal did not merely recommend certain subjects of study; it actually taught teachers how to proceed through the lesson. One such discussion covered the drawing curriculum of a Prussian teacher, Peter Schmid, whom Mann observed on his tour of European schools. Actual drawing lessons were published step by step, with illustrations, to enable American teachers to emulate Schmidt's method. Between 1838 and 1848, Mann's published curricula set the standard for the common schools, a standard that Manchester would study and model its own schools on.

In 1852, in the midst of Manchester's rapid development of school

programs, the Manchester Lyceum invited Horace Mann as a visiting lecturer. Mann was between jobs, just retired from his position as secretary of education in Massachusetts and about to go west to become president of Antioch College. He was at the peak of his fame. The Crosses and many local parents must have poured into the lyceum to hear his words. Mann inspired these families, who could never afford to send their children to private seminaries or academies, to believe their children would be "improved," at least in their reading and writing studies, by their education in the common schools.

Mann's audience, citizens of a changing city, was well aware that schools suffered discipline problems, truancy, and inadequate funding, all of which threatened the opportunity of education.

In those days urban and country teachers were often compelled to fight for the right of way and sooner or later, the test was reasonably sure to come, as to whether the new teacher could fight as well as teach, and frequently the fighting preceded the teaching.[7]

Also, the population was increasing, thanks to waves of immigrant workers who moved into the city as well as to improved health conditions. Life expectancy at the end of the nineteenth century was 50 percent greater than at the beginning, which meant more school children survived their early years.

The realities were quite dismal, and schools could hardly promise the creation of a perfect society. The failures of schooling were attributed to parents who, with their own minimal education and long work hours, were hardly in a position to improve matters. Horace Mann's lecture preceded by one year the mill workers' strike of 1853, when workers protested the fourteen-hour workday.

People worried that schools were haunted by "a rapidly increasing class of idle, ignorant and vicious non-producers. . . . If from our boasted public schools, we are each year letting loose an army of ignorant children . . . the time is coming when this will compel attention."[8]

The crowds of children felt the strains of their society in their school days. The childhood schooling in the 1850s is well described from memoirs of another New England artist of Henry's age and background:

The discipline there was strict and the punishment severe for any misbehavior or failure on the part of the pupils; though the teaching was effi-

cient. There was no discipline or watchfulness given pupils at recess time or before or after school hours. Much of the pupil's education however was obtained out of doors. The older boys and girls being teachers of the younger ones in all points where their parents would have preferred them to have been ignorant. There the most perverted ideas of morals and behavior were freely expressed and eagerly listened to until the "little innocents" became more versed in evil than their parents or teachers had any suspicion of. The bigger boys would go to the school yard and there insult and annoy any Irish or foreign children who passed until fights were common and sometimes serious, for the insulted ones learned to come around with sticks and stones with which to meet their tormenters. Our bigger boys would meet their victims with this doggerel: "Paddy whacker, Chew Tobacca, if you die it is no matter!" This was at the time of "know nothing" excitement when all the Catholics were under suspicion of being secretly working under orders from the Priesthood to overcome the liberty of Protestants and free thinkers generally. No doubt many of the older pupils heard much at home or from the daily newspapers to inspire them with enmity toward all Catholics and strangers.[9]

Education was a privilege and a problem. The schools were to feel every change and every strain in the community. People wrote articles in the Manchester newspapers, held meetings, and talked among themselves; something had to be done to meet the pressing needs in the schools. If a way could be found to help the "vicious nonproducers" to become self-supporting wage earners, it was agreed the schools would be providing a great service to the community.

The school leaders struggled to find an answer. Perhaps new skills should be taught in addition to those of reading, writing, and ciphering. Drawing might help, Horace Mann suggested in the *Common School Journal*, permitting as it did the active child more physical activity than any other schoolwork. Drawing could release the tension that otherwise might be directed toward shooting spitballs and might teach obedience and work skills that could be useful to future laborers. Drawing could prove useful to all students, even the most unwilling. So the Manchester public schools decided to teach drawing.

School systems learned about new curricula via publications advertised and distributed through commercial catalogues, as well as through the *Common School Journal*. Growing demand for school curricula made companies vie with one another for products. In 1855, the catalogue of Boston booksellers Ide & Dutton, advertised a volume that, though first printed back in 1827, had been reprinted in

many editions and taught just the sort of drawing that suited the public schools: William Bentley Fowle's *The Eye and the Hand: Linear Drawing*. The catalogue claimed that Fowle's book was intended "to provide practical lessons for training those important organs," and proved more suitable to schools than the host of available amateur drawing manuals. In this book, drawing looked like geometry. Dutton announced:

The object of this little volume is to furnish regular and systematic lessons such as teachers unacquainted with drawing may use with advantage and such as all children may and ought to learn. The work is devoted to that portion of the art which is subject to fixed rules and which lies at the foundation of drawing, considered as a science.[10]

This advertisement revealed the worries of the public schools. School committees wanted order; any kind of system and sequence was better than none; teaching could not depend on teachers who were assumed to be without intelligence, interests, and abilities; lessons with "fixed rules" were insurance against variations in abilities of both teachers and students.

Fowle's book, an adaptation of an earlier French drawing manual, was ideally suited to the aims of the Manchester public schools. The introduction to the 1866 edition gives its history and explains that the French manual by M. Francoeur resulted from Napoleon's request for a curriculum from his bureau of instruction. "When Napoleon was Emperor of France, he established a national system of education and one of the earliest studies was Drawing; not fancy drawing, which is hardly subject to any fixed rules . . . but that portion of the art which is subject to rules."[11]

Fowle, a teacher in Boston's Monitorial School, anticipated what was appropriate. He had large numbers of students to be educated at little expense, so he had to simplify his curriculum to such a degree that monitors, who were themselves still students, could teach it. Fowle used his experience as his guide and stayed safely with simple, measurable rules of geometrical drawing, using only circles, triangles, cylinders, and pyramids as the bases of his instruction.

Fowle's books first appeared, leather-bound, with many steel engravings. Though they were later issued in a less costly hardback format, schools needed even cheaper books that every child could hold,

see up close, and even copy. Here enter William Bartholomew, water-color artist from Grafton, Vermont, and a drawing teacher for the Boston public schools, whose instructional drawing materials were adopted well beyond the borders of Massachusetts. Bartholomew's first drawing lessons appeared in 1853, followed by a series of num-bered workbooks, in which a child viewed an image on one page and then drew his best replica of that image on the page opposite. Bartholomew's examples were an amalgam of romantic, rather En-glish bits of landscape from the early amateur drawing books and the purely geometrical drawing that appeared in Fowle's book. When Bartholomew pictured the side of a house, he showed a single plane that was textured with boards so it looked more like a house than a mere geometrical shape. He acknowledged: "With young pupils the pleasure of drawing is so great, that they are inclined to give little attention to truthfulness of form, the basis of art. To correct this error, the teacher should insist on their making a complete and careful drawing. . . ."[12]

The pleasure of drawing was indeed so great that many children found it impossible merely to render the form correctly. Pages in stu-dents' surviving sketchbooks ornament a house with, for example, trees, animals, and people, although only a plain geometrical house was printed as the example on the opposite page.

In 1859, Bartholomew produced *Linear Perspective Explained*, fol-lowed in 1860 by five sets of what he called Progressive Drawing Cards. With that, drawing cards, old family home amusements, were adapted to schools; children held their own cards and made their cop-ies on a paper or slate before them. Each of Bartholomew's twelve-card sets had assignments pertaining to the particular image, mixing elements of landscape drawing with the elements of geometrical drawing. A student perfected straight lines by drawing a straight picket stuck into the ground or improved his triangles by drawing a triangular unit of fencing. Bartholomew's instructions stressed giving the drawings character, by which he meant preserving the qualities of, for example, brick, stone, or boards without having to render every detail. Bartholomew's manuals and drawing cards, published in Boston, enjoyed prestige in Manchester, where all Massachusetts's

Fences, gates, wells, and windows are basic forms in Bartholomew's
Progressive Drawing Cards. This set, first in a series of five, consists of twelve
cards. Boston's Cyrus G. Cooke published this series in 1860.

educational ideas were admired. The schools adopted the geometrical, straightforward exercises prescribed by Bartholomew.

When Bartholomew's drawing books became Manchester's drawing curriculum, Manchester was on its way toward fulfilling the promise of the great New York Exhibition of Industry of All Nations. Here was drawing that looked like preliminary drafting, so useful for developing the skilled labor needed by the industrial mills right outside the schoolhouse door. Bartholomew's instruction promised to reverse the shocking outflow of American dollars to foreign skilled art laborers. William Minifie had already stated the case: Drawing should start in childhood, and government should continue to supply art training through the young person's education in order for the nation to be serving its own best interests.

The Amoskeag Corporation, which had given the land to the Manchester public schools and shaped virtually all opportunities that were offered in their community, could appreciate Minifie's words: "I would call upon our manufacturers as the persons most directly interested, to be foremost in the good work." [13] Drawing was education that would pay off, busying unwilling students' idle hands and perhaps even preparing them for work in the mills.

Self-Instruction
〰️

Schools could hardly solve all the problems. In the effort to avoid curricula that would reveal any individual differences, particularly any individual excellence, the system, in fact, catered to the lowest human expectations. School policy aimed low. The capacities of neither the teachers nor the students were believed capable of inspiration. As people debated about what the schools should provide, the best-intentioned public leaders found themselves trapped. The aspirations and needs of different social classes no longer could be ignored. After a brief time, families with means continued to educate their children at academies and seminaries at their own expense. As people acknowledged that different types of schools taught students in different ways, it became obvious that many of the things people wanted to learn they had to teach themselves outside of school. The book market eagerly expanded to provide how-to manuals for self-instruction.

Though students sought the skills taught in the schools, it was not clear how these meager achievements would ever enable ordinary

Americans to realize the aspirations of which they dreamed. The skills of ciphering, reading, and writing were a long way, it must have seemed, from what Americans imagined to be the polish and eloquence of European culture.

The more people learned of reading and writing, the more they must have craved to learn to draw. With the aid of one of the hundred and forty-five how-to-draw manuals published in America between 1820 and 1860, often reprinted in several editions, drawing came to be accepted as a general skill that could be learned as early as writing, and that people could teach themselves. With drawing, at least one could describe one's own house or horse, or plan the planting of one's garden. A young person could feel more powerful drawing from observation than when copying "Procrastination is the thief of time." Drawing became a quick and efficient way of getting one's thoughts on paper. Drawing assisted words. As people drew, they could feel themselves rise on the social ladder.

The more people aspired to education, the more they aspired to know about "art." Readers were attentive as newspapers reported the success of each new canvas of Frederick Church. In 1858, when Church returned to the falls to do some more sketching after his vastly publicized success with his painting, *Niagara*, *Harper's Weekly* reported that a group of onlookers watched the artist closely. "Then with an air of mingled contempt and commiseration as if the poor artist might well give up his attempt, 'Pshaw! You ought to see CHURCH's Niagara,' 'I painted it,' was the smiling reply."[14] These tourists felt themselves to be art cognoscenti. They identified their own meager pictorial accomplishments with Church's, not quite understanding what Church had achieved. The burgeoning world of illustrated books and the pictorial press, the plethora of instructional drawing manuals, and the hunger for education and self-improvement all conspired to persuade a young person of the value of studying about art and particularly learning to draw.

As more and more people noticed and saved the images that surrounded them, they found they were not satisfied merely to look at pictures; they developed an appetite for learning to make them. Publishers responded to this interest. Today, looking back, we can see how the proliferation of manuals, cards, and books for drawing instruc-

tion paralleled the growth of popular illustrated books and periodicals. Through the first half of the nineteenth century, English drawing manuals were imported, but American variants of these were also printed in vast numbers. Many of the 145 American manuals available to the Cross' generation assured the aspiring draftsman that drawing was just like farming; both required that a person know how to make a straight line. Drawing manuals were designed to teach diligent students how to draw the forms that they observed in nature. Drawing skills, it was argued, were essential to the carpenter, the shipbuilder, and the mechanic. Every effort was made to distinguish this work from the schoolgirl's flower drawing manuals, such as those imported from England. Whatever the many attractions to drawing may have been, its utility served to conceal the pleasure people found in it.

As the quality of printing improved, so had the quality of the drawing manuals, and ever more beautiful images enticed the student to persist. Benjamin H. Coe, that Hartford art teacher who gave Frederick Church his early art lessons, also provided lessons for the nation at large. At the time Frederick Church moved to New York State to study with Thomas Cole, Coe published a *New Drawing Book of American Scenery*. At about that time, he also published *First Lessons in Perspective*. Throughout the early 1840s, various editions of *Easy Lessons in Landscape Drawing* appeared in hard-covers with full-page lithographed illustrations. These volumes indicate the hunger of Americans for visual instruction. Coe's books continued to be published into the 1850s, feeding the increasing appetite for learning to draw.

No single artist-author could satisfy this booming market. The 1840s saw the publication of drawing cards for children to copy, published under the name of Jacob Abbott, a popular children's storybook author and illustrator. Also from Hartford came a small drawing book, *Self-Instructor No. 1, Child's First Book*, by Josiah Holbrook. New York publisher J. S. Redfield produced Chapman's book, but Boston also contributed its share to this growing market. Benjamin F. Nutting, a Boston painter, lithographer, and drawing teacher, produced in 1848 the first of his popular sets of *Initiatory Drawing Cards*, depicting houses, gates, and trees bordering rivers.

Most manuals were for home use, but some were developed by

teachers in schools. In Boston's first comprehensive high school, Boston English High School, drawing was regarded as essential to the practical course of study that was an alternative to the classical preparation for Harvard and Yale. The school's drawing teacher, Edward Seager, whom we know as the teacher of John Rogers, was one of the many artist-teachers who contributed to the outpouring of popular drawing manuals. Seager's *Progressive Studies of Landscape Drawing* (1847) would not, of course, have been expected to make great profits on sales to the English High School students alone. Seager and all the other producers of instructional drawing books knew the surge of out-of-school interest in these books. Well into the 1860s, they knew that masses of publications of art instruction books would be purchased by learners of all ages who craved personal self-improvement.

The creators of drawing manuals had their fingers on the pulse. They spent most of their days in their studios teaching drawing classes to students who eagerly sought them out. They understood and exploited the growing sophistication in American printing. They may even have realized that the invention of printable pictures was of even greater importance than that of movable type, revolutionizing as it did people's notion of information and of what they, themselves, were capable of conveying. The quality of printed pictures and the artist-teacher's persuasion touched everyone: "Let them look back on their own life and see what they have lost for want of this cultivation. . . . Without the faculty of just perception imparted by a knowledge of design, we walk through life blindfolded."[15]

The various drawing manuals designed for home use retained their popularity up to the Civil War years. Perhaps because, of all skills, drawing could be seen most visibly to improve with practice and one stage of study could be compared to another, drawing skills became a metaphor for other types of learning and self-improvement. In this spirit, Joseph Cross applauded in his letters his children's progress in drawing. Drawing was one of those useful things his children could learn, and he praised them at each step of their achievements.

CHAPTER 4

READING AND WRITING
THROUGH THE WAR YEARS

Slavery Had there been no Amoskeag Corporation, Foster, Emma, and Henry Cross would have had only minimal formal schooling in that one crowded second-floor room renovated at the Mammoth Road meetinghouse. Nothing in the Cross papers suggests that the family could have afforded to send the children to private academies. Only the benevolence of the city and the corporation enabled the Cross children to trek three or four miles to their various primary and grammar schools to benefit from formal instruction. For many other families, the growth of public schools never produced an adequate alternative to the education available at the academy. Families that could afford to do so continued to pay to educate their children, and private academies thrived in nineteenth-century New Hampshire. Early in the century, there were already twenty-five such institutions, the best known being Phillips Exeter Academy.

Students attended these academies even from outside the state of New Hampshire, and one such student, who attended Phillips Exeter, was the son of Abraham Lincoln. Politics and his son's presence in the state motivated Mr. Lincoln to travel there in March 1860. The

54

state's capital, Concord, received him for an afternoon speech. Then he took the iron horse south to rain-drenched Manchester, to be greeted by a crowd at Smyth Hall that probably included the Cross parents.

The Manchester audience heard their former mayor, Frederick Smyth, who now presided over the local Republican club, introduce Lincoln as the president-to-be. The honored guest then talked about the abolition of slavery. His excited audience would not let him stop. When Mr. Lincoln continued, "I never saw a disunionist in principle," a Reverend Mr. Gage rose from his seat in the audience to say, "Sir, you behold one." This unanticipated remark gave the nervous audience a chance to observe Lincoln's mind and teaching skills at work. The audience called for the Reverend Mr. Gage to be removed, but Lincoln protested, "No, this is the man I wanted to meet here. What did you say, sir?" opening a debate between the two men, in which it was agreed, even by Reverend Mr. Gage, that Lincoln had won.[1]

At an informal reception that followed, people got an opportunity to look at the famous Mr. Lincoln. Throngs of admirers relished this opportunity to see the man in the flesh. Until then, they had seen him only in wood-engraved or lithographed paper images. Satisfied that this man did exist, Manchester's citizens took to the rainy roads to return home. If the Crosses were among them, they had a long way to go, departing from the gaslit downtown area, traveling off to dark, quiet Mammoth Road.

Lincoln spent that might at the City Hotel in downtown Manchester and requested an impromptu tour of the mills the next morning. A young E. P. Richards, with grimy face and dirty hands, was asked to serve as his guide. When introduced, Mr. Richards said, "My hands are hardly fit to take yours, Mr. Lincoln," to which Lincoln is reputed to have offered one of his classic replies: "Young man, the hand of honest toil is never too grimy for Abe Lincoln to clasp."[2] They toured together for two hours. At Manchester Mills, agent Waterman Smith offered Lincoln a sample of his mill's production—a dozen pairs of socks. Lincoln carried them unwrapped under his arm even as he went off to the train to leave the city.

After Lincoln's departure, slavery remained a topic of reading and

conversation. Perhaps due to the fact that the Amoskeag Paper Mill produced a ton of paper daily, Manchester always had ample sources of news. Even back in the early days of the 1840s, Manchester already had six newspapers reporting national and local affairs. Libraries, both the Athenaeum and the Merrill Circulating Library, made current books available. For those who could not read or who preferred the sociability of the human presence, there was the Manchester Lyceum, where from twelve to fifteen visiting lecturers a year debated matters on public affairs. An additional forum, the New Lyceum, was also formed specifically to establish a course of lectures on the subject of slavery.

In Manchester, slavery was no abstract issue. It was central to the citizens' concerns. Manchester's manufacturing was dependent on the availability of cotton picked by southern slave labor; the fact that the mill's production diversified just before the war suggests the managers' anxiety about the uncertainty of continuing profitable cotton production. To protect itself against the possible loss of cheap cotton, Amoskeag developed shops for coffee grinders, gas fixtures, and pump suppliers. Back in 1852, one newspaper reported that "there was but one real obstacle to the continued prosperity and progress of the city— the obstacle is abolitionism."[3]

Through the decade that followed, every forum—newspapers, lecture halls, even theater productions such as Harriet Beecher Stowe's *Uncle Tom's Cabin*—became the occasion for intense debate. Manchester's own local labor tensions must have intensified feelings. The labor riot of 1855, in which Manchester's workers refused the increase from an eleven-hour to a fourteen-hour workday, must have seemed not unlike a slave rebellion and presumably increased the laborers' identification with the slaves.

Lincoln was inaugurated as president on March 4, 1861, and Manchester's Republicans fired 100 guns in celebration. Shortly thereafter, on April 13, 1861, the Civil War began. Perhaps inspired by Lincoln's visit only a year before, Manchester's citizens immediately responded to his call for volunteers. By April 27, 131 Manchester volunteers headed to Concord to form the First New Hampshire Regiment. After a short training period, the men were mustered into service in May 1861.

This time the Manchester mills converted themselves into manufacturers of goods needed for war. In April 1861, the Manchester Print Works produced four thousand dozen flags, each with the thirteen stripes and thirty-four stars. The Amoskeag Machine Shop and Mills got a contract from the War Department for the manufacture of rifled muskets. From fifteen hundred to two thousands rifles a month were produced. Other shops got other contracts. Manchester's mills appeared to be transformed into an armory. Government guards around the mills kept all Manchester citizens aware of the war, though the actual conflicts took place on remote battlefields.

The families of volunteers suffered personal and financial losses. In May 1861, the city government appointed the Manchester Relief Committee, which voted to pay $1.50 per week to the wife of each volunteer. As the war continued, the city offered larger amounts of money. By 1862, the city was paying a bounty of $75.00 for each man who enlisted in the battery of one of the older regiments. As yet there was no draft.

The daily life of the Cross family was gradually altered by the war. The changing needs were reflected in the family's only surviving ledger, that of 1861–62, where expenditures were recorded: pencil and paper, $.15; a slate $.25; shoes for Emma and Foster, $1.00 for each pair; and that month's rare purchase, a set of engraver's tools, $3.38. Past his fifteenth birthday, Foster had proven himself mature enough to have his own wood-engraving tools, just like Mr. Herrick's, which made those wonderful book illustrations. Foster's interest in wood engraving justified this expenditure, which exceeded the cost of *two* pairs of shoes.

In the same ledger, an entry of March 1862 records the purchase of Joseph Cross's army vest, which he bought in preparation for his going to war with the Eleventh Regiment of New Hampshire Infantry Volunteers. Deborah Cross, who had lost her father in 1858, now suffered the death of her mother on July 30, 1862. Though Grandmother Wilder was past seventy-eight, the timing of her death must have tested Deborah Cross's strengths. She needed all her resources to prepare herself for the separation from her husband. By the time Joseph Cross went off to war on August 29, 1862, he had already taught his chil-

Mr. Cross Enlists

dren how to do the work of the farm, and he expected them to follow through on their jobs when they were not at school, being helpful to their mother.

A year and a half after the outbreak of the war, Joseph Cross enlisted, deeply committed to the Union cause. Early in his long wartime correspondence, he assured his family, "Were it not for the feelings I have for you and my happy home, I should feel there was no sacrifice I could make for my country that would be too great to make."[4] That he waited so long to enlist was probably due to his age. At forty-three, he was far older than others in the regiments. In 1863, traveling through Mississippi, Mr. Cross recalled how the men in his regiment thought of the old man: "There has [sic] a number of men in our company told me they wondered when they saw me at Concord, what I enlisted for. They selected me for the first man to fill the grave."[5] The sacrifices were great too for his wife, also forty-three, left in sole care of the three children. Foster was sixteen, Emma was twelve, and Henry was only ten.

The seventy-five-dollar bounty barely enabled the family to cover the costs of food—molasses, vinegar, lard, beef, flour, corn, apples, ginger, coffee, codfish, and cheese—along with tallow and wicking for candles and logs for firewood, all recorded in the family ledger. Medical care could also be costly: A physician's services were six dollars, but a tooth extraction was only twenty-five cents. Repairs and general house maintenance added to the financial burden. And boots had to be mended, saws had to be sharpened, the horse had to be shod again, and the family sled needed repairs.

Sometimes Deborah bought used clothes and sometimes she bought cloth to make garments for herself and three growing children. They needed pants ($3.20) and shoes (now $1.39), as well as paper and pencils ($.15 each), slates ($.25 each), and schoolbooks ($.70 each).

This farming family suffered in the absence of their father's love and guidance. And as painful as the absence of their father was, the local newspaper accounts of grueling war facts intensified their anguish. The newspapers reported suffering and loss far greater than anything that Mr. Cross was to describe in his letters.

News from the battlefield was precious:

One New York daily officially states that during the four years of the war, it has paid half a million of dollars for the single item of correspondence from the army. Its entire expenses, before a single copy of any Number is printed, can not be less than a half a million of dollars a year. It bears all this expense and yet sells the sheet for less than a cent a copy more than the white paper costs, simply because there are 100,000 people who are willing to pay four cents each morning for a daily newspaper.[6]

Joseph Cross was a loyal correspondent, writing regularly, regardless of circumstances. Each of his letters arrived in a hand-numbered envelope, which enabled the family to know if one in the sequence had been lost in its delivery north. In the two and a half years that he was away from the family, Joseph Cross wrote 130 letters, and every one of them was received at home. The war letters were from four to six sheets in length. Joseph was apparently aware of his need for the correspondence, for he wrote: "Perhaps going to war makes me talkative."[7] Had there been no Civil War to separate the father from the family, we would never have known of the hopes and fears that this man felt for his wife and his children. It was only through necessity that he wrote what is ordinarily spoken, leaving for posterity a record of the interests and hopes of this soldier.

There were times when Joseph had to apologize for the difficulty of reading his penciled writing. He regretted that he could find no hard surface against which to write, and yet he felt he had to continue his flow of letters. At times he wrote sitting on a rock; other times he wrote when he and all the contents of his knapsack were drenched with rain. The hardships of weather were compounded by the strains of travel and the absence of any substantial housing. In an entire year, he slept with a roof over his head just once.

Nevertheless, he regularly maintained his correspondence, writing the family two letters a week. He was no doubt sustained by the family's responses: "I had a feast last night and what do you think it was? I got three letters from home."[8]

Joseph's sensitivity to the interests and differences among his children is revealed in his letters. When he wrote directly to each child, generally sent as enclosures with letters to their mother, he adjusted his style and subject matter to suit the child's particular interests.

Writing Home

Ten-year-old Henry received a note from his father appreciating the child's accomplishments in writing and drawing. Acknowledging Henry's latest letter, with its drawing of a "cunning and crafty fellow" that he hoped his father could find and track down, Mr. Cross wrote: "Henry, I have not seen anybody that looks like the picture you sent but I will keep my eyes pealed [*sic*] for him and if I see him I will bring him, if I can."[9] His father's ability to play along with his fantasy creation encouraged Henry to continue to send gifts of drawings. Joseph wrote with thanks, "I found Henry's apples and mice."[10]

The envelope that included a note to one child generally had ones for each of the other children. To Emma, Joseph wrote quite differently. She received what he called "some natural curiosities,"[11] mystery objects that he wanted her to explore and to try to identify. He knew she could succeed in identifying these objects from her extensive knowledge of plants. Enclosed in one letter were a castor-oil bean pod and a petrified piece of seaweed.

Her father's attention made fourteen-year-old Emma miss him even more. To her request that he come home to stay, he responded:

Now Emma, it would not be more gratifying to you than it would be to me if I could render my country as much service at home as I can now. It certainly would be a happy time for me if our country was in condition so I could go home and stay and felt we were all safe once more and our liberty secured forever.[12]

To Foster, the oldest child, Joseph wrote most seriously. Expecting him to be exemplary, Joseph praised him for his successes and always urged him to labor ever more diligently in the promising work he had chosen. In March 1863, a letter arrived that praised him for his success with wood engraving. "I heartily hope your future labors in the art will be as successful as your first attempts have been encouraging."[13] He then criticized Foster for his poor penmanship, saying he hoped he would "improve with pen as you do with your pencil and graver."[14] Joseph continued to urge Foster "to make all useful improvements you can in your mind and manners."[15] He was to be responsible not only for his own improvement, but also for that of his younger siblings: "Ever be careful to set good examples before others that are younger than yourself. . . . I want you to feel an interest in

Emma and Henry. You can learn them many good and useful things if you will [*sic*]." [16]

Foster took his father at his word. Evidence survives on those cream-colored snippets of paper with children's drawings that Foster literally set an example for Henry in his drawing lessons at home. On one paper, there is a drawing of a hand, rendered in a mature and skilled fashion by the older brother, and then another hand less expertly copied by the younger brother. Each boy's drawing is signed.

Joseph Cross assumed that his sons would be particularly interested in the details of battle, and so he provided images to help them visualize what he witnessed. For the sake of the boys, he says, he wrote about the Battle of Fredericksburg:

If they want some idea of the noys [*sic*] we had out here when Fredericksburg was cannonaded, just imagine twenty Fourth of Julys all at once and then think how many cannons were being fired and then multiply them by ten and you may have some idea of the firing. It was estimated that there was from five to fifteen shots per second for hours but we (or our brigade) was not in sight but we were in battle line ready to move at a moment's notice, but was [*sic*] not called on. [17]

The letter continues with grim details of carrying the wounded from the battlefield and of the death of his captain, who did not survive his wounds.

Proceeding along with his regiment, Joseph thought of his boys. His provincial perspective was altered when he saw parts of his nation about which he had only read. In May 1863, he wrote, "Now a few lines to the boys about farming. I suppose the little place you live on looks as if it would give both of you as much work as you would want to do. Now what if you had a Kentucky farm of three hundred to five hundred acres?" [18]

Acknowledging his receipt of letters from the children, Joseph wrote his wife:

I am glad the boys are getting along so well with their out of doors work and I hope they will do their work well. Keep the weeds in good subjection and learn a good lesson from it: That is never allow weeds to grow where anything better can grow. . . . [19]

Joseph Cross knew how to help his family envision his experiences. From Cincinnati, he wrote about the crooked Mississippi

River: "If you want to know how crooked just go down to the Cemetery Brook and look at the brook, for Cemetery Brook would be a fair miniature picture of the Mississippi River."[20] Whatever he saw had analogies to features of the landscape he knew so well back home. Helping them visualize the bluffs and ravines he saw in Mississippi at Haynes Bluff, he wrote Deborah, "If you recollect the bluffs or ridges in your brother Ivory's pasture, you may have some idea of them here only there is one hundred here where there is one there."[21]

Mr. Cross's device, comparing new scenery to familiar places at home, accomplished two things: His beloved hometown remained vivid in his mind; at the same time, details helped his family picture where he was. As the war proceeded, he passionately reported: "Now it has been nearly two years since I saw the old place or any of you— and I have not seen a place that seemed to me like home all the time."[22]

Joseph Cross found that memories often relieved the intense feelings of sadness stirred by his sense of loss of the family and his impotence to serve them and his nation at the same time. He was deeply touched by people back home who, since his family was spending its first Christmas alone, comforted the children and Mrs. Cross. Of the "Unitarian friends" who surprised Deborah Cross for Christmas 1863, he wrote:

When I read of the kindnesses shown you, I could not restrain the tears and I couldn't finish the letter. . . . When I hear of such genuine acts of kindness toward you it melts my hard heart but it makes me stronger and braver and I should be glad to say, with truth, that it makes me a better man.[23]

He assured his wife that it was his "prayer that they may prosper as a church and society by ever loving and cherishing truly Christian principles."[24]

Mr. Cross never censored his gloom, but also never succumbed to it. Sometimes, perhaps, he protested a bit too much:

If you had asked me two weeks ago what I had thought of war I should have said *dark, very dark* for then it *looked* gloomy. But now it is wearing away. We are allowed to express our opinion on the war or anything else and may denounce the war in unmeasured terms, but since then there has not been an hour since I left my peaceful and happy home that I was sorry I enlisted.[25]

His convictions were being tested, "I did not enlist through the impulse of the moment but considered long and well before I did it,

and I should do so again."[26] He readily admitted many times that he would "be glad when this war is over and solid peace is established."[27]

At the first anniversary of his mustering into the regiment, Joseph Cross took stock of his travels:

We have traveled between 3,000 and 4,000 miles since we left New Hampshire. We have been in the states of Massachusetts, Rhode Island, Connecticut, New York, New Jersey, Delaware, Maryland, Iowa, Illinois, Mississippi, Kentucky, Arkansas, and Alabama.[28]

As if all the dangers he faced were not enough, he reported seeing a six-foot copperhead snake. "But thanks to Him who cares for all of us, we were safely carried through it."[29]

Many were not so safely carried through. Joseph summed up the grim news in a letter in which he again notes the anniversary of his enlistment: "Started out from Concord [New Hampshire] in August 1862 with ninety-two men besides the officers, a year later some detailed out of the company, some discharged, some sick, others dead, now only forty-one left."[30] Given all the casualties and miseries, it was of minor consequence that only on September 13, 1863—one month late—did Mr. Cross finally receive the money due him for his first year of service.

Joseph seemed to have especially tender feelings for Henry, whose health suffered in the course of his absence. From distant Virginia, he wrote his wife, "I found Henry's picture in my vest pocket and it is a very pretty one. I shall look at it every day as I do and have yours, since I received it."[31] Perhaps due to the bulkiness of the pictures, he had no room in his pocket to carry Emma's and Foster's pictures, though he wished he could.

The father's absence and his continuous flow of letters required that the children read and write. Sometimes explicitly, Mr. Cross begged and bribed the children to write to him: "I will send Henry a trumpet from Dixie to put on his cap and I want him to write a letter to pay for it."[32]

From January 1863 on, Joseph worried about Henry's ill health. Deborah's other responsibilities and the added one of a sick eleven-year-old made Joseph fear for his wife's health as well. Continually, Joseph concerned himself with matters of the family's daily life. In one letter Joseph debated whether the family should spend of its mea-

ger resources to buy a horse. Joseph concluded that, yes, they should buy a horse, because it was an advantage to Emma's schooling. Especially in winter, a horse would help. The snow lies deep on those New Hampshire hills in the winter and presents a serious obstacle to children on their way to school. Though for all the Cross children, the schoolhouses were extremely remote, it was about Emma that Joseph worried. It would not be inconceivable that she could get lost in a drift and freeze to death. Since the family lived at least three miles from the center city, where all the schools were, in all seasons a horse, Joseph thought, could ease her travels back and forth.

January and February 1864 turned out to be so severe that neither Emma, then age fourteen, nor Henry, then twelve, went to school. They studied at home through that winter, assisted by both their mother and Foster, who by then had completed his schooling. Joseph urged the family to move into the city. "I think Emma will be very much benefited by living nearer to school; as she now ought to be getting her learning."[33] Proximity to the city was also valuable to Foster, who was starting his engraving business. No matter that they were not remaining at the farm; Mr. Cross told them to "Keep Nellie no matter what. . . . Speak to Mr. Simpson to pasture Nellie for you must keep her even if you must keep her up."[34] Two months later, he wrote, "Learned that you were about to leave Old Mammoth Road. I think I know it will be better for you and the children to be nearer the city. It will save you all a great many steps."[35]

No letter explains the specific illness that once again beset Henry through May and June 1864. Joseph felt sad and depressed by his inability to help Henry and the rest of the family, as well as by the disasters of the awful fighting and severe losses. He wrote Deborah: "I hope you have been as sustained and supported as well as I have been."[36] Shortly again: "I am always sorry to have any of you sick and then to think I can't do anything to help you is not at all a pleasant feeling."[37] Through September, Henry remained seriously ill. "I hope to hear that Henry is gaining. I hope and I know you will be careful of him. I want him to be careful of himself. I wish I knew what to do for him. Wouldn't it be a good plan for me to go home and shake him up a little?"[38]

Throughout the letters, along with the concern for Foster, Emma, and Henry, Joseph expressed his hopes for their schooling. With tongue in cheek, craving more mail to unite him with the family, he wrote, "Don't the children learn to write in school? Wish they would write a little so I could see if they improve any."[39] Finally, he delighted in the receipt of letters from the children: "I see by the letters that the children all know how to write. I was afraid they had forgot how and I am really glad they have not forgotten."[40]

There is irony in Joseph's urging his children to demonstrate their writing. Not at all concerned any longer with perfect form in penmanship, he yearned for relationship and contact. Every visualizable bit of news brought Joseph Cross closer to his home. Totally with the family, he wrote, "I am really glad Emma has a chance to ride [on horseback] to school and I hope she will accept the chance and improve it. Henry can stand to walk if he is well. Foster will take good care of Nellie."[41]

Through the letters, Joseph Cross felt himself living the life with his family. The written word carried spirit and feeling. The correspondence of the family through the war surpassed any school text in educating these children about reading and writing. The contrast between home writing and reading and that of school paralleled that of home drawing with Mr. Herrick and the school's format for drawing study. The Civil War letters had taught them about reading and writing in the same way that Mr. Herrick taught them about drawing—through relationships between people. All three children wrote and all three loved to draw through their years in the Manchester public schools. Unfortunately, what the public schools were to call drawing bore as little resemblance to what the Cross children had learned about drawing from Mr. Herrick as writing exercises such as "Procrastination is the thief of time" resembled their father's Civil War letters.

The Manchester School Committee had no intention of teaching anything with such intensity of feeling. The school committee and the Amoskeag Corporation's biases reflected a growing need for technically skilled labor in industry and mechanized farming. That same motive caused Congress in the midst of the Civil War to pass the Land Grant Act of 1862, establishing an alternative system of advanced

higher education. The agriculture and mechanical arts colleges established under this act provided an entirely new approach to education based on scientific and technical study; children attending common schools were on a track in preparation for them. If the schools offered drawing, it was to be technical drawing so the colleges might be spared the waste of having to teach their students matters they could have learned earlier.

The Cross children's motivation for drawing trees, flowers, and animals had been their attraction to them and their affection for them. Had Bronson Alcott's Temple School in Boston survived from the 1830s, his approach would have suited them better than what they got. Alcott, friend and colleague of Emerson, Hawthorne, and Thoreau, was father of the four remarkable girls who served as models for the characters in his daughter Louisa May's *Little Women* and teacher of many other boys and girls. Drawing was one means of his finding out what children thought, and he encouraged them to draw everything, believing that until they drew, they did not see.

Because such important investigations as drawing warranted recording, Mr. Alcott required that his students at the Temple School redraw their pictures in their journals. In the journal, the container of everything, pictures were interchangeable with words. Nothing was censored. As if to test this belief, one young girl drew Mr. Alcott himself whipping a student. Surely he would have preferred that left unrecorded, because he denied he ever did such a thing.

Most school people saw no value in children's spontaneous art. Few could have understood the drawing that Foster, Emma, and Henry did at home. Alcott's unusual and controversial theories ultimately led Bostonians to close his school. Even Horace Mann maligned such efforts, writing that he feared the introduction of drawing into the schools because it might "degenerate into mere play and picture-making." [42]

Schools promised everything to everyone, but, in fact, never intended to meet everyone's needs. Subtly, children and their families learned what did and did not belong in school, and they did their best to benefit from what was offered. Disappointment and anger struck those who recognized the difference between the school and the

richness of learning outside the school. School curriculum appeared
to be "innutricious husks of knowledge."

Think of it you word-mongering, gerund-grinding teachers who delight in
signs and symbols, and figures and "facts," and feed little children's souls
on the dry, innutricious [*sic*] husks of knowledge; and think of it, you play-
abhorring, fiction-forbidding parents! Awaken the *interest* in learning and
the *thirst* for knowledge and there is no predicting what may or may not
result from it.[43]

During the war years, the most potent learning for Foster, Emma,
or Henry was happening at home. Here, they read their father's
letters and, when pressed, responded to him. Here, they practiced
their drawing and acquired a new related skill, wood engraving. At
this time, both Foster and Henry resolved to adapt their drawing
skills to the work of engraving, just as Mr. Herrick did. And they did
not hesitate to write their father about their enthusiasm.

CHAPTER 5

OPPORTUNITY OF A CENTURY

"No Engraving!" Henry Cross was encouraged in his drawing and urged to follow the example of his older brother in every respect, but when Henry wrote his father of his interest in emulating Foster's work, it gave Joseph a jolt: "Henry, as Foster wants to work at engraving, I want you to be a farmer, a little while at least."[1] The "little while at least" was necessary because Joseph Cross needed time to become accustomed to the changes taking place in his family. Henry, only just eleven when he wrote this to his father, would yet stir with other wishes, many of which he would never choose to pursue, but Joseph could not consider that. That neither son would be a farmer was too threatening to be tolerable.

The letter reiterated Joseph Cross's resolve that Henry become a farmer. He directs his activities: "I want you to have a little garden and a little place to plant and have you do all the work on it and see if you can't keep it all cultivated nice."[2] He waited for the much-desired news of Henry's garden—and praised him when Henry wrote that his peas were in blossom and his potatoes were already eight inches high.

Henry still sent drawings, and his father continued to compliment him on them. One drawing of a person's head came enclosed in a letter that arrived in Petersburg, Virginia. Joseph Cross wrote his wife

about it: "I found a picture in Henry's letter that had very good features."[3]

Despite his appreciation of the drawing skills of both boys, Mr. Cross had to make distinctions. Foster could be a wood engraver so long as Henry remained a farmer—a hostage, perhaps to Mr. Cross's dreams. From Haynes Bluff, Mississippi, came this fatherly letter:

Foster . . . I want to know how you are getting along with your work and how things look. Do you find plenty of jobs of engraving to do? And do you like the business as well as you thought you should? How big is your corn and do the weeds grow well? . . . Henry, I don't know but I ought to have asked you about these things instead of Foster for come to think you was a going to be the farmer and let Foster engrave. Now have you got a good lot of things planted? Have you got a good carrot bed and a good lot of watermelons? Do you go atrouting?[4]

Joseph Cross, aware of the opportunity engraving offered, agreed that Foster could be a wood engraver but forbade him to leave Manchester. He could not accept a job offer in Lowell, Massachusetts. Joseph resolved his conflict by saying, "There should be some planting done and if you work on your [wood] blocks [in Manchester] you can see to it."[5] As long as Foster would continue to work the home farm, he might also pursue cutting his wood blocks, and all indications were that he could find plenty of engraving work even at home.

By age eighteen, Foster had left farming to work exclusively at the wood-engraving business. He solicited customers by advertising in the local newspapers[6] and met them in an office workroom in the Welles block in downtown Manchester.

Eager for a firsthand report, Joseph asked Mr. Hunting, a Manchester volunteer on leave from his regiment, to visit Foster's "room" in Welles block and bring back a report. Joseph was disappointed that Mr. Hunting failed to see Foster when he went there, but he was reassured by hearing that Hunting nevertheless was told that Foster was a very promising boy.

As the children grew, everything they undertook they did more capably. Joseph Cross had difficulty imagining them other than as the young children they were when he left. In one letter, Deborah reported to her husband that the family had just completed the August haying, usually done with him, without the assistance of hired help. On August 23, 1863, almost the anniversary of his departure, he

wrote back, jokingly, that they may get on even better without him than with him.

The children, feeling themselves so remote, wondered if their father would even recognize them. Emma sent her father a picture of herself. In a letter to Foster, he responded to Emma's gift: "She said I could have it if I could guess who it was. Now I used to know a little girl on Old Mammoth Road that looked just like the picture."[7] The concern was mutual. Sometime later, Mr. Cross admitted to Henry that it was difficult to write to him since it was a year and a half since he had seen him.

Joseph Cross was determined that the war not rob him of his influence as father of his children. His passion to shape their lives increased the longer he was away. To eighteen-year-old Foster, he wrote: "I am glad you are succeeding so well in your engraving and I hope you will be attentive to your business and be careful and not form any bad habits. If you work at the City, I hope you will keep entirely clear of all the fashionable dog holes."[8]

Again, almost a year later, he wrote:

Now Foster, I want you to be very careful about going into bad company and forming bad habits. Make the best use of your time that you can and if you want to be independent, make your wants as few as you can. I believe you will succeed in business if you adhere strictly to the principles of truth and justice.[9]

He urged the children to obey and stay with their mother: "I hope you will not absent yourselves from home evenings except on important occasions."[10]

Joseph Cross's strength of mind extended into every domain. Not only did he want to control his wife and children, but he controlled himself. From Hancock Station, Virginia, in January 1865, he described an intense rain so penetrating that he had to wear drenched clothes to sleep. He feared he would get ill:

I felt rather blue when I turned in. I first thought I should get my death of a cold and then I thought, *what's* the use of getting cold? That's not what I enlisted for and I won't get cold, and I didn't get cold and I think it cured me from getting cold and I have been as tough and hearty as a buck most of the time since.[11]

In the war, it was hard to keep track of time, especially with no Sunday church service: "There is but a very little in the army to re-

mind a soldier when Sunday comes, unless he keeps the run of the days himself." [12] Through letter writing, he kept track of Sundays. "It would not seem like Sunday, if I could not write to you or some of our children." [13]

When Deborah Cross worried about her husband's neglect of devotional duties, he assured her that his attention to his family in his Sunday letters *were* his devotional duties: "Feeling as I do, that if I forgot my God, I shall forget my country and if I forgot them both, I shall forget my family also, which I pray I shall never do." [14]

Independence Day, 1864, revived intense feelings about the cause that justified the family's separation. Familial, religious, and national feelings became fused, and Joseph Cross's personal sense of justice and commitment continued to take precedence over any formal religion:

We must not expect to find all the good qualities in any one sect, but we ought to find more of the Christian graces than we do in all of them, but I should not criticize any of them. *We* are determined to be Christians, we can be with or without any of them. [15]

Spiritual convictions combined with aesthetic interests to keep Joseph mentally intact. In the course of the exhausting trek through the South, he had pleasure in seeing and crafting objects that connected him with his home. Finding just the right wood, he cut some nice trout fishing poles and proudly wrote from Jackson, Mississippi, "I see by Henry's [letter] he goes a fishing some but he hant [sic] got a pretty fishpole as I have. I have cut some of the nicest trout poles I ever saw." [16] He also, "sent Emma a bone ring that I whittled myself with my jackknife." [17] Reading of Emma's ring, Deborah Cross hinted to her husband that she wanted such a ring for herself. Joseph replied, "Now I had one for you when I sent Emma's but I did not wish to send but one at a time and I thought the bone one would look inferior, so I sent that first. Yours is made out of pearl shell taken from the Kentucky River. I dug the hole through it with my knife." [18]

As he traveled along, Joseph picked up objects that the children would find both beautiful and interesting. In Knoxville, he wrote: "I sent Foster a little piece of stone that I picked up at Cumberland-ford." [19] He also saw petrified stone that he wanted to send to Deborah and Henry, "But they were all too heavy for me to try to save them.

I could pick up a bushel of curiosities."[20] His impulse was to save everything exciting that he saw, but there was no question when he saw great yellow pines—one hundred feet in length, with an upper diameter of one foot eight inches—cut down: "Now I want that a whopper!"[21]

Joseph Cross stimulated the very aesthetic interests that alarmed him. His letters are filled with detailed visual descriptions of caves or mountains and unusual terrain wherever the regiment camped. In a single year, when Cross traveled so many thousands of miles, each landscape generated its own interest and provoked him to describe its details. In Mississippi, he noted, "there are two [magnolia trees] not more than ten rods from my tent that are forty feet high." Specifically for Emma, he added that "the blossom is white and as large when fully blown as your white tea plates."[22] "In the crevices of the rock were as beautiful pinks as you ever saw and at the foot of the valley, between the two mountains is a mountain a mile high and a mile wide."[23] Cross's ability to see beauty in his surroundings must have helped to sustain him. When more than half of the men of the Eleventh Regiment died of wounds or illness, Cross relied on his capacity to enjoy and describe nature to avoid despondency.

Even when surrounded by death, Joseph felt a moral obligation to be positive and to attend to the living. He railed against the journalists' distortion of the war in newspaper reports. "You have the darkest side of the picture, but I can't see it in that light and whoever draws so dark a picture is not a true artist."[24] To Joseph Cross, a true artist must bear the spiritual responsibility for the effects on others of his own description. "A true artist" would have been "in sympathy" with his country, "willing to bear his share of the burden, for what good does it do to wish our country well and not take hold with our own hands and make it so."[25] In the letter, Joseph not only set an example of artistic, aesthetic appreciation, he also directed the children and his wife to see its moral value.

Pictures and Text

Joseph Cross's statements about farming never obscured his aesthetic passion. But even his sensitivity and Foster's choice of career cannot alone account for Henry's growing interest in becoming a wood engraver. Omnipresent were printed pictures that showed him places he

had never seen and taught him things he otherwise would never have known. Back in 1853, the effect of such influences were foreseen:

Not only do the pictorial arts contribute to the tasteful enjoyments of life, but they are steadily growing to be the habitual vehicle for an immense amount of knowledge relating to architecture, machines, and apparatus, to natural scenery, natural history and natural philosophy, to the incidents and surroundings of social and domestic life throughout the world, to the events and accessories of history, and, indeed, to all the learning which involves external forms, whether of natural or human origin. . . . So important is wood engraving to popular art-culture, that it should be sedulously cultivated, for improvements both in its processes and its style. . . . The present time seems peculiarly to invite the enlistment of some more masterly minds in a career where so much good can be achieved.[26]

In the war years, the quest for information intensified. Printed pictures carried home images of battles, people, and changing geography, and provided the nation with information. As Philip Gilbert Hamerton observed in his appreciation of the graphic arts: "It is not possible to estimate the extent to which we are indebted to drawings and paintings done by others for the clearness of our ideas of things."[27] Mid-nineteenth-century Americans, themselves skilled observers, craved every opportunity to learn visually. Adults and children turned to the illustrated press to learn from both its text and pictures. These old pictorial journals and books were passed on from one generation to the next. Rather than storing them in attics, people used them until they fell apart. Images salvaged from dilapidated books or the illustrated newspapers were pasted over old and less valuable book pages and became the basis of new picture books people made for themselves.

Adults found that illustrated books could become their teachers, conveying how-to information about the use of a newfangled piece of machinery or accepted methods of barn building or poultry farming. Before the time of illustrated books, such skill could be learned only by apprenticeship.

Illustrated books also were credited with contributing to the rearing of children. Parents and parents-to-be accepted the notion that picture books were the best way to cultivate the minds of their children. *Parents Magazine* advised its readers on selecting books for their children:

The youthful eye is pleased with beautiful forms in nature: the child is grati-
fied with fine trees, and cultivated fields; . . . houses, birds, and animals,
retard his bounding feet, as he pauses to gaze upon their beauty. A book,
also is fascinating, when it comes with the same recommendations. He will
look at the cover, and the gilt, and the lettering: he will examine the paper
and the type: he will search for pictures of castles, mountains, water-falls,
forests, lakes, and whatever is capable of pleasing the eye; and express
the liveliest gratification in the beauty and perfection of the mechanical
execution.[28]

These attitudes are more like those of a mature bibliophile than of a
child.

Picture books so captured the imagination that Harper & Brothers
published a storybook, supposedly for children, called *Harper's Estab-
lishment: Or How Story Books Are Made* (1855). Then, as now, story-
books had to appeal to the adult buyer, so the detailed description of
book production in *Harper's Establishment* was indeed more suited to
the adult than to the child.

Harper's estimate of adult interest proved correct. Ten years later,
when enough time had elapsed so that people might forget, the firm
reprinted all the same images of the stages of print production from
its children's book, but this time it published them for adults in a
single issue of *Harper's New Monthly Magazine*. The text accompany-
ing these pictures permitted Harper's to celebrate its success and
boast about its significant statistics. It told of the company's first
six months of production in which circulation leaped from 7000 to
50,000. By the year of publication of this article, 1865, 20.25 mil-
lion copies had been sold, enough to "make a solid wall ten feet high,
two feet thick, and almost two and half miles long. They would make
a solid pyramid one hundred feet square at the base and more than
seventy-five feet high."[29]

The image of the pyramid was no coincidence. Pictorial printing
was America's great accomplishment. Harper's attributed its monu-
mental success to the wood-engraved illustrations produced by its
own staff. Their work could transform the shapes of real objects into
little lines of different sizes, creating differences in tone that made
the reader think he saw an actual object. Engravers' skills were val-
ued: "The artistic effect of a fine engraving depends greatly upon the
thickness of the lines . . . [the engraver] must not be merely a work-

HARPER'S
NEW MONTHLY ·MAGAZINE.

No CLXXXVII.—DECEMBER, 1865.—Vol. XXXII.

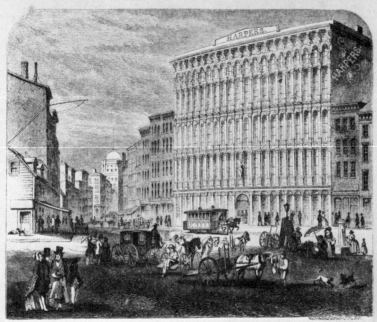

THE FRANKLIN SQUARE FRONT.

MAKING THE MAGAZINE.

FOR one hundred and eighty-six consecutive months—fifteen and a half years; almost half a human generation—we have issued the successive Numbers of HARPER'S MAGAZINE. By "we" are designated the Proprietors and Publishers who planned the enterprise, and under whose constant supervision it has been conducted; the Editors who have carried these plans into execution; the Contributors who have furnished the materials for the work; and the various Artists and Artisans who have put these into shape. There have been singularly few changes in the persons com-

have taken place in the corps of Editors. Now and then a member has retired and another has been introduced; but no one has died. Of the Editors who now conduct the various departments no one has occupied his present position less than eight years. The Contributors, exclusive of the thousands who have furnished the anecdotes and reminiscences embodied in the "Editor's Drawer," number about three hundred. Here many changes have occurred. Some old names have disappeared, many new ones have been introduced. But one who looks at the Table of Contents pre-

This recycled wood engraving of Franklin Square in front of the Harper's Manufactory, where *Harper's Magazine* was printed, was first published in 1855 in a book for children. Adults' fascination with publishing justified its republication in 1865.

Source: *Harper's New Monthly Magazine*, vol. 32, no. 187, December 1865.

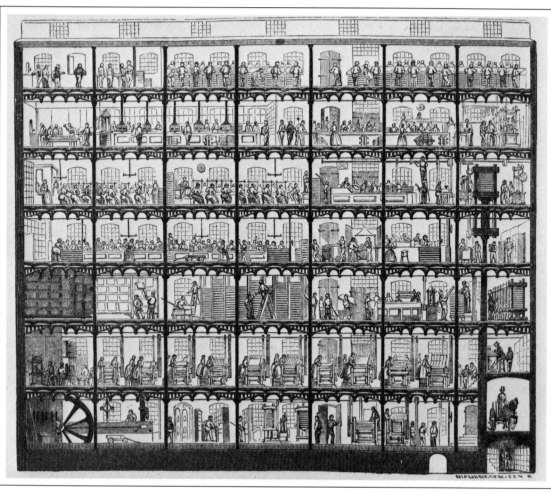

Wood-engraved section of the Harper's Manufactory originally produced for
Harper's *How Storybooks Are Made*, published in 1855.

Source: *Harper's New Monthly Magazine*, vol. 32, no. 187, December 1865.

man but an artist and as such commands a good salary."[30] Because illustrations were essential to Harper's success, no expense was spared in preparing them months in advance of publication.

As adults and children delighted and learned from picture books, an entire new market was opening up for publishers: pictorial school books. By midcentury, masses of students were needing school books for reading, writing, and ciphering, and each subject required a separate book.

The school book market intensified competition for deftly crafted wood engravings. The images became teaching tools. By presenting objects whose names began with each letter of the alphabet, they conveyed the sounds and uses of the alphabet. By picturing blackbirds to be counted, wood engravings taught addition. They taught grammar by showing differences between pictures labeled "a beautiful bird," "a more beautiful bird," and "a most beautiful bird." Adults and children alike found that pictures could teach them whatever they needed to know throughout their lives.

Abilities are fragile and must be nurtured. Even in the 1860s, school committees worried that youngsters were turning away from work in the fields and hard work done with their hands. Many aspired to become office workers who sat at desks and wrote words and numbers. But visual skills, practiced over centuries, are not lost overnight. Through the nineteenth century, pictorial printing developments took the best advantage of Americans' subtlety of sight.

Wood Engravers

Highly observant children and adults, appreciating wood engravings, hungered to learn how to make them. Instead of staying at home and working their land, not a few went in search of a master who practiced wood engraving and who could teach them what Mr. Herrick had already taught Foster, Emma, and Henry. They needed to understand the material conditions in which engravings were made. "In the graphic arts," just as in farming, "you *cannot* get rid of matter. Every drawing is *in* a substance, and *on* a substance. Every substance used in drawing has its own special and particular relations both to nature and to the human mind."[31] For wood engravers, the material substances are the boxwood block into which one cuts, the ink that is applied to the remaining surface of the block after the lines are cut

ARITHMETIC.

NUMERATION.

Note to Teachers. The learners are to have their books open before them, while performing the lessons in Numeration. Do not omit any lesson.

LESSON FIRST. I.

Here is the picture of some apples:—count them.

One, two, three. four, five, six, seven, eight, nine, ten.

See this flock of black-birds: they have lighted upon the bars of a gate, and are all singing together. Find how many there are on each separate bar.

A flock of singing blackbirds have lighted on the bars of a gate to illustrate a child's arithmetic lesson.

Source: *The North American Arithmetic, Part First for Young Learners*, by Frederick Emerson (Boston: Kidder & Cheever, 1852), p. 3

away, and the paper substance onto which the inked block is pressed to leave an impression that is the image of the wood engraving.

Those who were curious learned about the earliest American wood engravings and about New York's Dr. Alexander Anderson who made them. He was born in 1775, almost the same time as Deborah Cross's father. From his printer father, young Alexander got possession of some type ornaments, which when inked and pressed to paper leave those tiny decorative marks that occasionally relieve the monotony of an otherwise uninterrupted page of text. By examining and experimenting with these, he learned the principles of print production. But Alexander credited his passion for images not to his father, but to his mother, "who was in the habit of drawing for his amusement when he was a child."[32] In Alexander's school years, he practiced drawing by copying engravings and then progressed to teaching himself to engrave into rolled-out copper pennies. As a teen-ager, he had sufficient mastery to be able to sell his engravings, made in those days on copper or type-metal, to New York City newspapers. In 1793, after studying medicine for five years between age fourteen and eighteen, Anderson discovered boxwood, that durable substance into which the British master Thomas Bewick engraved his popular *Birds* and *Quadrupeds*. From scrutinizing the images in those two works, Anderson taught himself Bewick's methods. He thus began his career of wood engraving, at the same age, incidentally, that Foster Cross was when he opened his engraving business. As an adult, Anderson pursued his medical career and at the same time set the course for wood engraving in America, producing innumerable drawings and engravings for illustrated books. He became an extensive reprinter of English works, including 300 cuts of Bewick's *Quadrupeds*, creating an American audience for images engraved in wood.

Abel Bowen, who sometimes collaborated with Alexander Anderson, became Boston's first pictorial wood engraver. Following his apprenticeship with a printer, Bowen published his own ornamented maps in *The Gazetteer of New Hampshire* (1823), as well as his illustrated *History of Boston* (1829), and *The Young Lady's Book* (1830). He trained the next generation of wood engravers, the best known of whom are William Croome, Alonzo Hartwell, John Andrews,

Samuel S. Kilburn, and Richard P. Mallory. Some of his students took the skills they learned from him to become prominent in other fields, among them George Loring Brown in painting and Hammat Billings in architecture.

Expanding markets provided work for yet a younger group of wood engravers, including Benjamin Childs, Elias Whitney, Henry Kinnersley, George Hayes, James Richardson, Edward Bookhout, and Henry Walker Herrick. They illustrated not only history books, religious tracts, and nature books, but also the reports on new inventions, the thousand and one household articles, farming utensils, and machines whose novelty attracted readers and seemed to promise wood engravers unending employment.

The quality of wood engraving improved as demand increased. Harper & Brothers' prodigious and high-quality publishing established new levels of achievement in American illustrated books and magazines. Their success led a second publishing house, the American Tract Society, known until the 1850s primarily as a publisher of religious tracts and cheaply produced books for the young, to expand its program and to buy better presses, hire more skilled management, and aim to provide the highest quality work. They hired the cream of New York engravers. The same artists whose work was most in demand, including Mr. Herrick, were selected to produce the wood engravings for *The American Drawing-Book* by John Gadsby Chapman, first published in New York in 1847. William Linton, the chronicler of America's history of wood engraving, said: "I know no other book like this, so good, so perfect in all it undertakes."[33]

Lithographers

As if there were not already enough enticements to work in pictorial printing, more were to come. Much as frequent advances take place today in the capacities of computers, so at midnineteenth century, Americans witnessed daily improvements in pictorial printing.

A decade before the Civil War, John Badger Batchelder, stunned by the dramatic changes in Manchester, seized the opportunity to illustrate and advertise what was happening there. Batchelder spent months perfecting a drawing of the town as if seen from an imaginary position 100 feet above a landmark known as Rock Rimmon. His

Manchester in 1854 became the first in a series entitled *The Gallery of Cities*, produced between 1854 and 1857 in his rooms downtown in Manchester's Tewkesbury block.

Had John Badger Batchelder drawn the new city of Manchester with a pencil and paper, the few people who saw that drawing would have been able to get some idea of the changes that had taken place. But since Batchelder drew his representation of Manchester with a grease crayon on limestone, he could print and distribute thousands of copies of his drawing. Once a drawing was printed, many more people could see the same scene with their own eyes even within their own homes.

Back in the eighteenth century, when the fathers of Alexander Anderson and Deborah Cross were born, the process of lithography was invented in Munich by Alois Senefelder. In a fortuitous accident, he observed that if a greasy crayon were marked on limestone slab, a chemical situation was created that permitted inking and printing of that greasy crayon mark for countless printings. Printed pictures transformed what people saw. The new power to produce large inexpensive editions of images created a revolution in people's knowledge and experience. In the early nineteenth century, an occasional wood engraving might illustrate a book and conjure scenes that otherwise could be created only through the author's choice of words. But the woodblock could not endure the pressure of too many printings and limited the number of clear impressions. Now with the improvement of techniques for running larger editions of images, in both wood-engraving and lithography, more and more people shared knowledge of the same visual information.

The technical discoveries changed more than the quantity of images. Up to the middle of the nineteenth century, the pictorial world of Americans was almost exclusively black and white; colored pictures were seen primarily on ornamental shop signs or decorated horse-drawn carriages. Displays of oil paintings were indeed rare. The works of Thomas Cole and Frederick Church were known only to those in urban centers such as New York, Philadelphia, and Boston. If few had seen colored pictures, fewer yet had seen multiple printed color pictures, but with Senefelder's invention of lithography, it be-

came possible first to generate black-and-white pictures that could be hand-tinted and, soon after, to print multiple images in color. Pictures became among the most exciting things people could see.

The first lithographs made in the United States may be dated as early as 1818, but it was not until 1825 that there was a successful commercial shop, W. and J. Pendleton's of Boston. This shop and its successor, Thomas Moore's, served as a lithographer's training ground. Nathaniel Currier studied at Pendleton's Boston shop from 1828 to 1832, and then set out for New York to establish his own shop with James Merrill Ives. In those days, Currier and Ives printed and tinted pictures in such great quantities that they were able to price them cheaply enough for many families to afford. Their black prints on white paper were individually hand colored; the tinting process was done by a group of women who sat at long tables and daubed on a single color, perhaps a blue, and passed the print on to the next colorist. For a rush on a job, they used stencils with holes to match the area of the print on which the paint was to be applied. These piecemeal painted prints were the first popular colored pictures available in America. No doubt these hand-colored printed scenes of daily life changed every household they entered. It is hard to exaggerate the excitement and aspirations that these images stirred, and the fortune they generated.

Color fascinated printers and drew them to learn the European technique of color printing called chromolithography. John H. Bufford, like Nathaniel Currier, served his apprenticeship at Pendleton's and at Moore's, and later joined Pendleton's successor, B. W. Thayer, where he perfected the printing of chromolithographs. Bufford then separated from Thayer to start his own company, J. H. Bufford and Company, which in the 1850s and 1860s became known for the high quality of its colored printed images made by drawing patterns with grease crayon on several limestone slabs, each to be printed with a different color ink. The cumulative effect of one layer printed upon another produced an image in full color.

At this time, Europe's most skilled lithographers were producing images with layers of ink from as many as thirty stones. They set the standard for Americans. At about the time that Batchelder was producing his Manchester portrait, a young Prussian refugee named

Louis Prang was trying to find his way in the world of American lithography. In 1856, he arrived in Boston, and after initially working in partnership with Julius Mayer, he set out on his own, hiring the best European lithography artists who had reached America. His artists, mostly German, reproduced paintings, using thirty layers of color printing to create the illusion of the paintings' surface.

All the varieties of printed pictures found their way to Manchester. The Cross's attic was full of chromolithographs at different stages of development. The family treasured those they could get and kept them so carefully that their color today is as brilliant as the day they were printed. Even in their early lives, the Cross children already had the opportunity to know many different types of pictorial printing. Henry Herrick, almost one of their family, had seen to it that the making of prints—perhaps a vague dream to many young people— was a distinct possibility for them.

CHAPTER 6

INFLUENCES

*Away in the South*

With all his pleasure and concern for his children, Joseph Cross now had a new worry: "Foster, I was in hopes that this war would be over before you became of age of being a soldier but it is not, and now you are just as likely to be called on to join the service as anyone. I would recommend you buy a book and study the tactics."[1] Until 1863, regiments were composed only of volunteers, but with the coming of the draft, every man might be called. Some choice remained in the matter, however, because each man drafted was paid three hundred dollars, which he could keep as bounty or use to hire a substitute.

Foster wrote to his father about the lure of the soldier's bounty in light of the family's need for money. His father replied: "This will be a bearing year for the orchard, and I think the apples and the extra produce from the manure will make the difference between last year's rent and this."[2] Never naive about money, Cross warned Foster of the financial realities of the war, citing the inequities between officers and privates (his rank): "The officers get one half of the articles given out. If a private wants to buy anything, he must pay three times as much for no better than the officer gets at the commissary."[3]

In July 1864, Cross discouraged Foster from enlisting. "All the money in the world would not hire me to enlist for three years. . . .

84

Now it is a hard thing to be a soldier. If a man believes in it in his heart and soul . . . I say *go in*, and if it is not by all means keep out."[4] After discouraging Foster from pursuing the bounty, Mr. Cross went about trying to help the family make ends meet, and as he helped them, he envisioned himself returning: "About my overcoat for Henry, I think you better not cut up my army coat for I may want it myself. If you think best to cut the brown one, I have no objections."[5] As Mr. Cross watched the waste on the battlefield, he thought, "To reduce the load, a soldier throws away everything except what he has on. (Didn't I wish they were where you and the children could get one grab at them.)"[6]

The depth of his own political sentiments kept Joseph Cross from ever wavering about his own decision to join the regiment. Troubled only that he and other men out on the battlefields who believed in the cause might not be able to vote in the 1864 election, he wrote in November 1864 that he was relieved when they got the opportunity they wanted to vote for Mr. Lincoln.

Mr. Cross had several good reasons for discouraging Foster from enlisting. His son, he thought, lacked the political sentiments, was needed by the family, and had just launched his promising wood-engraving business. A letter from Henry Herrick suggested that if Foster remained in Manchester, his fledgling business would prosper. Joseph proudly wrote his wife: "Mr. Herrick has quite a good opinion of Foster and I hope he does and will continue to merit that opinion."[7]

In all his letters, Joseph remains clear in his thought and expression despite the most depraved and bizarre behavior that he witnessed throughout, and especially toward the end of, the war. Joseph's grasp on his values is apparent as he tried to understand slavery as it functioned in the life of the South. On July 26, 1863, from Mount Sterling, Kentucky, he wrote, "I am down in old Kentuck among the nigs. Kentuck is to [sic] fine a country to ever be cursed by the Negro. I ought to say not by the negro but cursed by the debasing institution of slavery."[8] Villages and housing "not fit for human being [sic] to live in" made him wonder:

"And now, why this difference [between Ohio and Kentucky]? Is it in consequence of any law of nature or is it owing to the habits of the people inhabiting the two different places . . . I am confident it is not the former, for it has

all the advantages of nature. It seems to me there need be no finer country than this. Now we should not blame the negro for he is not to blame. Now I think the difference is in the two institutions—Ohio being free and Kentucky being under bondage of slavery, which paralyzes all their efforts to improvement."[9]

"I have not seen many nigs here, but they were quite numerous at Newport News . . . peddling oyster cakes, and pies and getting clothes to wash which they did first rate."[10] He described Negroes he'd seen insulted: "I have frequently seen them insulted and imposed upon and have often wished that I could take an imposition as calmly as they do."[11] Joseph Cross identified with the slaves, inspired by those same feelings that, eleven years before, had caused him to name his younger child after Henry Clay. Different states presented stressful situations, and yet each confrontation with slavery confirmed his purpose in having left home. Slavery in Joseph Cross's eyes was a distortion of human life to which he was unwaveringly opposed.

Few letters actually described the sight of slavery, but one letter from Foster prompted Joseph to declare his feelings. When Foster wrote that he had read that book that everyone was reading, *Uncle Tom's Cabin*, by Harriet Beecher Stowe, his father responded:

I have no doubt it holds slavery up in its true light. I have not seen many slaveholders except in Kentucky where the mildest form of slavery exists, and even here the poor white people are as ignorant as the blacks. The blacks have all been taught to believe that the Yankees are awful creatures. Their masters in Kentucky tell them when the Yankees catch the blacks, they take them off and hang them—in Louisiana and Mississippi, the nigs say that they thought the Yankees had horns.[12]

Joseph Cross was in City Point, Virginia, when he was shocked to hear the news of Lincoln's assassination. Responding to his wife's fear that this act might prolong the war, he wrote: "I think it will not. . . . I think the rebels have lost their best friend. I think President Johnson will deal with them justly but if they wanted mercy, they would have done better if they let Lincoln alone."[13] He closed the letter with a promise that he would be home in a few weeks. His last letters describe his march north.

Reaching the end of their separation, Deborah Cross admitted her loneliness. Like a psychoanalyst today, her husband only repeated her words: "You say you are quite lonesome and wonder whether I am

too."[14] He said no more. That was the next to last letter. The one letter without a number was the last, when it was no longer necessary to keep track of the sequence of correspondence. He interspersed descriptions of the beauties he saw on his final trek—particularly, Mount Vernon—with rage over Confederate villainies "that will put the inhabitants of the infurnal [sic] regions in the shades."[15]

Beyond all the books and schooling the children were to receive, these letters must have been *the* text of their childhood. These letters teach the power of giving form to one's thoughts, of enjoying and observing where one is, and of ever keeping sight of what one loves.

In a world where written communication was a prized accomplishment, the family must have treasured every letter that their loving, stalwart father managed to get into their hands. The family's experience of this sustained correspondence set an example of how to be alone and yet still feel connected with those one loves.

In the years of Joseph Cross' absence moral support for the family came from a man only slightly more available to them than their own father—Henry Walker Herrick. Early in 1864, he was considering moving back to Manchester to be close to his mother, widowed at the start of the war. Referring to the possibility of Herrick's return, Joseph Cross wrote Foster, "If Mr. Herrick goes back to their place [the homestead on Mammoth Road] I hope you will work with him."[16] Herrick's interest in Cross's children, expressed throughout the war years, was a comfort. Henry Herrick and Joseph Cross kept in touch through notes. "I answered Mr. Herrick's letter and intended to have written more but was obliged to close it then for the mail."[17] The Herrick family is mentioned either reporting on a visit or regarding a question such as the desirability of purchasing the elder Mr. Herrick's gun, to which Joseph said: "No objections if he [Foster] will work it out and use it properly."[18] Toward the end of his stint, Joseph reported that Henry Herrick wrote, "Asking me to give him a call if I go home this spring. . . . It's quite doubtful my making any calls this side of Hall Hill. As Foster is having letters from Mr. Herrick, it will be useless to write about them."[19]

The Herricks' move back to Manchester would require a radical transformation of their lives. In the prewar years, the nation's art ac-

Away in New York

tivity centered upon New York. In one year alone, 1858, New York imported European art worth over one-half million dollars. Art galleries, the art union, art associations, schools, and academies proliferated. One journal claimed, as is still maintained today: "It is almost imperative that a painter should come hither 'ere he can seal his fame."[20] In New York, Henry Herrick reached the peak of his success and followed a style of life to which he and his family had become accustomed.

New York was where the young Frederick Church, who wrote, "My highest ambition lies in excelling in art,"[21] headed directly after completing his studies under Thomas Cole. The name Frederick Church and the phrase "successful New York artist" had since become synonymous. Primed for the showing of his painting *Niagara* through articles highlighting coming attractions in the *Crayon* and the *Cosmopolitan Art Journal*, "All New York flocked to see it." When the doors of the Williams and Stevens Art Gallery opened in April 1857, "I [saw] there at one time, Horace Greeley, George Bancroft, George Ripley, Dr. Chapin, Henry Ward Beecher, Charles A. Dana, William Henry Troy, and Fitz James O'Brian—but indeed everybody in New York, resident or sojourner came to see it."[22] The art gallery owned not only the painting, for which it had paid twenty-five hundred dollars, but also the copyright to chromolithographs of it, which had cost an additional two thousand dollars. On the basis of these rights, two versions of *Niagara* were sold: a thirty-dollar artist's proof and a less prestigious twenty-dollar version. More than eleven hundred people signed the subscription book to reserve their own copy.

Since approval by the British of an American painting was deemed as important as their approval of our industrial products, in the summer of 1857 *Niagara* was packed and shipped to London. There, the British art authority John Ruskin praised it, his raves justifying the exorbitant shipping expenses. Following its London success, the painting returned for yet another New York City viewing. It traveled next to Boston's Williams and Everett Gallery where, day or evening, it could be contemplated for a fee of twenty-five cents.

The painting's travels increased the sales of its chromolithographs, and these, in turn, proclaimed the success of art in America and of New York City as an art center. Even greater tumult was created in

New York when, in the spring of 1859, Church displayed *The Heart of the Andes*, a five-by-eight-foot canvas, in his own place in the Studio Building on Tenth Street. The police had to clear the street for people to get through. With admission at twenty-five cents, receipts totaled more than three thousand dollars in one month. Even on the final day, after the painting had been on view for seven weeks, the crowd was so great that many were turned away without seeing the picture. Through 1861, *The Andes* traveled to Philadelphia, Chicago, St. Louis, and Boston, where schoolchildren were admitted at a nominal charge, so that they might stand before it and be instructed by their teachers.

No doubt, as his father persisted in calling his son's artistic career a business, Frederick Church realized that indeed it was. Having studied well the skills of his businessman father, Church contrived an extraordinary contract that could have been conceivable only as a result of his upbringing and the phenomenal wealth and prestige of art in New York. The contract called for Church to sell *The Heart of the Andes* to a New York manufacturer, William T. Blodgett, for ten thousand dollars two years from the signing date, June 6, 1859, *unless* the painter were offered, in the meantime, a sum of twenty thousand or more for the painting. At either the higher or the lower price, this sale made *The Andes* the most expensive landscape painting sold in America up to that time.

Though the Civil War disturbed much in the lives of New Yorkers, "strange to say, it had less effect upon art than upon many things of more stable foundations."[23] The art world thrived during the war. The National Academy of Design completed its new building during these years. It opened amidst a flurry of artists' receptions and balls, events that became so prominent in the lives of the "fine people" that there was always a rush for tickets. As a result of all the money, New York attracted many aspiring artists. They streamed into the city and sometimes felt more lonely in that noisy Babel, than they had in their sojourns to study art in foreign cities.

Henry Herrick was one of New York's established artists. He had risen through the newly emerging ranks, beginning as a novice student at the National Academy and becoming a well-published artist and teacher. For Herrick and other artists of his stature, New York

was a showcase from which they could only benefit. The desperate news of war casualties formed only background for the ebullient art life that continued to prosper.

The war was not totally invisible, though. Artists did make contributions to the war effort; they helped through organizing and contributing to fund-raising fairs inspired by the Federal Sanitary Commission, which offered assistance in the care of sick and wounded soldiers and their dependent families. One such fair was the Brooklyn, Long Island Sanitary Fair. Its art gallery contained an album with 120 sketches contributed by Asher B. Durand, William Hart, Thomas Moran, John Kensett, Robert Swain Gifford, James Smillee, and Henry Herrick, among others. The album was divided into six parts, each going to one of the six lottery winners. Five hundred shares in the album were sold to raise funds for the benefit of the soldiers.

Wood engraver Elbridge Kingsley, a native of western Massachusetts, described New York's wood engravers' community, of which Herrick was one of the "important men":

The engraving community was not very large and the important men were known to the rank and file. . . . Examples of their work are cherished and studied. Some apprentices were great collectors of prints and eagerly discussed anything new. A signature was not needed to tell the expert whose work was under discussion. This distinction or habit in the use of the graver is a matter of slow growth and when once acquired, is as much a part of the individual as a handwriting. Thus the professional's mode of reading his contemporaries is entirely different from that of the public.[24]

Artists, whatever their forte, made their own community in New York. Occasions were found either to honor one returning from a tour of Europe or one reaching senior status. One such testimonial was organized by artists and dealers to honor the ailing senior portrait artist, John Goffe Rand, from Manchester, New Hampshire, who had settled in New York in 1848. He had left New Hampshire to accomplish what could not be achieved back home—becoming a successful portrait painter and a colleague among artists. Rand's accomplishments must have impressed even New Yorkers. In his London sojourns, after the initial success of his portrait of the Duke of Sussex (a commission secured through his wife Lavinia's friendship with the Duke's wife), he won several commissions for more portraits of the royal family.

Beyond this glamour Rand also was an acknowledged inventor. Special recognition was due him because, in 1836 during one of his journeys to England with his friend Samuel F. B. Morse, he introduced his invention, which was promptly marketed: the now familiar screw-top metal compressible paint tube, which replaced the prepared animal bladder as a pigment container. John Rand's testimonial was likely to have been the last that Herrick attended before he returned to New Hampshire.

In New York Herrick had his finger on the pulse of the art life of America. The National Academy, which initially lured Herrick to New York, had now become so much of an artistic center that it was the target for every kind of criticism. Housed since 1865 in a lavish and controversial Venetian-style palazzo on Twenty-third Street, the academy was criticized by some as being insufficiently discriminating and by others as being too exclusive. Those who wished the academy were more selective were opposed by those who believed it should admit a broad variety of students and be tuition-free. Still others attacked it for promulgating "high art" and deluding and diverting young artists from "profitable and honest employment."[25]

The debates revealed a problem that until then would have been hard to imagine. It seemed that many thriving artists and art communities differed in their definitions of the best art education, and artists and patrons argued about how and for whom art schools should operate. Some favored education for "high art," and others defended the training for the income it produced. Henry Herrick, in his leadership of the New York School of Design for Women, was identified with the latter position. The war had proved the wisdom of his early efforts, since many women, left alone, were desperately in need of marketable skills. In the continuing debate, Cooper Union, which in 1859 had incorporated Herrick's New York School of Design for Women into its larger, more ambitious institution, continued to argue for free art and technical education for working-class women and men.

At one point, when the tension between the goals of their respective institutions was not quite so clear, the National Academy and Cooper Union actually considered merging. The academy, then primarily an exhibition gallery, sought to preserve its tax-free status by affiliating with an institution offering tuition-free instruction. But oil

and water could not, and did not, mix. The heart of the matter was whether or not art education was intended for employment, as indicated in the letter that Miss K. L. Kellogg of New Haven wrote to Cooper Union:

Will you be so kind as to inform me whether the demand for designs in the highest department of Designing, namely that of illustration for books and periodicals is, in the usual times of business prosperity, a good one. Also whether the present political crisis affects seriously this department throwing out of employment those already successfully engaged and checking seriously the demand for it. I am hoping sometime to have the advantage of your school.[26]

She was one of many who responded to an article on Cooper Union in the March 30, 1861, issue of *Harper's Weekly*.

The sophistication developing in New York perhaps resulted largely from what American artists saw in their sojourns in Europe. There they learned not only of art clubs, but also of government support of art in setting up studios, purchasing art from living artists for museums, establishing art schools, and granting scholarships. New York artists and art patrons, impressed by what they saw in Europe, wanted similar opportunities. Patrons, the consumers of art, were impressed by the economic and political implications of support for the arts in Europe: that art objects were perceived abroad as civic investments for which huge numbers of tourists might travel to a city; "each pays his fares to the railroads at the hotel, and leaves something at the church and many purchase souvenirs."[27]

These new ideas about art created a vast gap between New York and the rest of the nation. Gradually, Americans came to see the advantages of cultivating a society of artists, but they did so slowly, assimilating European ways with local mores. Artists began to bring glamour—and their work—to resorts in New Hampshire's White Mountains, whether by leading train excursions or by traveling scenic routes and painting the landscape as they went. People came to admire and follow them.

Although America seemed backward, American artists who went abroad yearned to come home. But this would mean relinquishing the dream that Europe would recognize and certify them as artists. They had to endure the reality that, particularly outside of New York, an

American artist without the European imprimatur was a very uncertain, often invisible being. When Elbridge Kingsley decided to leave New York City to return to Hatfield, Massachusetts, he felt toward New York as many artists had felt toward Europe. He chose to return to "the heart of Puritan New England . . . a little community, doing something to help art and not waiting until [art] came back from abroad with honors and medals."[28]

In the artists' struggle to find a function in America, the role of cultural improver seemed like a life raft, helping them avoid drowning in accusations that their work was mere luxury. As cultural improvers, they could benefit their own city or town and their own social position at the same time. This social empathy of the artist echoed Joseph Cross's description of the true artist in his war letter. With the promise of cultural improvement, the nation felt it could only benefit from having artists in its midst.

By the close of the Civil War, the artist's role as cultural improver was welcomed by all. Much healing needed to be done, and the artist could rise to the occasion to help meet this need. Even the clergy in this period concurred that art was a means of improvement. Ministers' sermons sought to counteract the old puritanical antiart tradition. Aesthetic education became a moral obligation. Vermont minister George Perkins Marsh began his classic, *Man and Nature*, published in 1864:

Sight is a faculty, seeing an art. The eye is a physical but not self-acting apparatus, and in general it sees only what it seeks. . . . Next to moral and religious doctrine, I know no more practical lessons in their earthly life of ours than those relating to the employment of the sense of vision in the study of nature.[29]

What could be more devout than the study of art? Moving back to Manchester seemed possible for Herrick if he could bring with him the art he loved. By the end of the Civil War, learning to draw was a far more complex ambition in the popular mind than it had been previously. Drawing could now convey more of America's social concerns, of which delight in American scenery was only a part. Drawing, it was believed, might permit people who could neither read nor write to express their thoughts and prepare for scientific thinking: reading, recording, and analyzing nature's variety. New mechanical

inventions also could be presented by drawing. Ideas, once fixed on paper, could be shared with others and become something more than figments of one person's imagination.

Drawing would help people to see and treasure their own land, would improve their deficient taste, and would help them to rise socially and culturally. American products would become competitive with the finest goods from Europe. Freed of reliance on European production, the United States would also achieve what it thought it had obtained in 1776—true independence. Via the carpenter's working drawing, the gap would narrow between American culture and the artistic heritage of Europe. When Henry Herrick was preparing to move north, Americans, with almost childlike faith, were stroking their drawing papers like Aladdin his lamp, hoping for fulfillment of all these wishes.

CHAPTER 7

HOMECOMING

On the fourth day of June 1865, Private Joseph Cross was discharged from Captain A. C. Locke's Company E, Eleventh Regiment of New Hampshire Infantry Volunteers, completing a three-year term for which he had enlisted on August 29, 1862. His discharge, only slightly before a full three years, was given by reason of "Telegraphic Orders from the War Department," May 17 and 18, 1865, at the closing of the war. A certificate awarded to him at Alexandria, Virginia, on June 4, 1865, announced his freedom "To all whom it may concern," in curved type arching over a two-and-one-half-inch-square wood engraving of an eagle in whose claws are clasped a sheaf of arrows. The remaining spaces in the wood block are engraved with three flags and a panoply of stars.

The certificate identified Joseph Cross as forty-four years of age, five foot eight and one-half inches tall, light complexioned, with hazel eyes and brown hair, who, when he enrolled, gave his occupation as farmer. Money due him was paid upon presentation of the certificate on June 10, 1865, and any further debts to him were disclaimed. Thereafter, he was off on his own to reconstruct his life with his wife and children.

The end of the war was an intensely emotional time. Many grieved again for the men who would never return. Survivors and their families were challenged to reorganize their lives and reinterpret the war's

To City Farm

95

legacy for the nation that had survived. The Crosses, reunited, were also reorganizing their lives, and they were not to remain long in their old place.

Joseph had written to his family, "I don't want you to hoard up your money for money is of no use to anyone any farther than to relieve the necessity of wants of life, so use all you need."[1] Now he needed a stable way of assuring himself and his family of an income. The family, which had survived on the most meager resources through the war, now needed to begin to rebuild. When he was asked in March 1866 to replace Hiram Simpson, who had just completed five years as superintendent of Manchester's work farm, City Farm, an immediate problem was solved. The job of superintendent suited Joseph Cross's skills, at least in part, for in fact it had two parts: one aspect was farming, in which Joseph excelled; the other was caring for the least reputable of Manchester's citizens, who resided there and who had to be taught farm labor. His disappointment that he had failed to inspire his sons to farm might even have made Cross want to teach farm work to adults who had no other choice.

In his war letters, Cross had already supplied all the reasons the family should move closer in to town: Foster was working at Welles block downtown, Emma was in high school, and Henry was in grammar school. Yet the advantages of the City Farm appointment outweighed even those reasons. Joseph and Deborah Cross's overwhelming need was for permanence and stability. This job assured them a salary, a home at the old familiar Ephraim Stevens tavern stand, which they had known years before, and magnificent vistas of farmland and woods that were beautiful to behold in all sorts of weather. City Farm's more than one hundred acres had stands of dark evergreens, an old carefully built stone wall, and endless opportunity for growing the plants and vegetables that gave such pleasure to the Crosses.

That City Farm was at least three or four miles from downtown may have been cause for mixed feelings for everyone in the family. They each could see reasons for living in town, but after reviewing all the pros and cons and probably with some urging from Joseph's brother Ira Cross, the Crosses finally accepted the city's appointment and, in 1866, moved to City Farm, on Mammoth Road just south of Shady

Back view of City Farm—1874, so titled by Henry. The Cross barn to the left
may well have been the setting of Herrick's *Life on the Farm,* published in
1867 by Harper's.
Cross Family Collection.

Nook Farm. Apparently, they sold Shady Nook to a family named
Stockbridge.

In the war years the children were young and desperately needed
familial closeness, especially with their father. By the time he came
home, the children were older and becoming emotionally separate
from their parents, preparing for independent adult lives. By the time
Joseph Cross could "go home and stay and feel we were all safe once
more and our liberty was secured forever,"[2] the children were think-
ing of leaving. These early City Farm years were the last that the fam-
ily would be together.

Foster, at twenty, was an adult, and his wood-engraving work might
now take him anywhere, even out of town. Having fulfilled his prom-
ise to his father to stay with the family until he returned, Foster was
now free to accept any job that appeared attractive. Emma, sixteen,
and Henry, fourteen, still had a few years to remain together and to
become reacquainted with their father, their new home, and with the
City Farm inmates, their new extended family. As they wandered
through the hills and drew the plants and trees, they became deeply
connected to this place. For years, even after Henry no longer lived
here, he returned to draw the beautiful vistas of City Farm, picturing
from every angle his favorite subjects—the barn, house, stone wall,

and trees. Living at City Farm proved to be one more aesthetic oppor-
tunity that the Cross parents offered to their children.

At Russell Street History often acknowledges the importance of teachers to their stu-
dents, but when Henry Herrick returned to Manchester at this time,
it was the young Crosses who proved critically important to their
teacher. Foster, Emma, and Henry Cross were among the few who
could share Herrick's interests, so they and his own children were
likely to be the beneficiaries of his zeal and knowledge. In the latter
half of the 1860s, their relationships must have been mutually nour-
ishing and sustaining, in an environment otherwise dry of artistic
activity.

Following the material and emotional depletions of the war, new
energy and ideas began to flow back into family life. Though Henry
Herrick had been back and forth between New York and Manchester,
it was only at the close of the war in 1865, when he was forty-one,
that he actually moved his whole family back to the state of his birth.
Herrick's widowed mother, Martha Trow Herrick, sold her house on
Mammoth Road and moved into her son's new family home at Russell
Corner Prospect, now 97 Russell Street. It was then set on acres of
land with a lush apple orchard. The location's closeness to town rep-
resented an investment in the new city and in the mills and was a tacit
statement of Herrick's intention to become involved with the new
community that had grown up in Manchester while he was away.

The household was filled with all the energy and interests that the
Herrick family brought with them from New York. Alice Ekern,
Herrick's granddaughter, recalls the house as "pretentious, with par-
lors you didn't go into."[3] Mrs. Ekern's daughter, Margaret Haller,
said that the house "originally stood on open ground with a pleasant
view of the hill across the river. There was an apple orchard on the
slope out back, and my mother remembers a barn and that they kept a
pig."[4] Herrick's studio, right within the house, was not opened to the
public. Not even "Clara," his wife, was allowed to enter and tidy
there. "Brushes were stored in the sink, and there were canvases
piled against the walls, piles of books on the floor. Although there
were paintings hung everywhere about the house it was in the library
that Herrick hung those of which he was most proud."[5] The house

must have been very much like a museum. One New Hampshire magazine wrote: "When he invites you to his home, don't fail to go."[6]

By the time Herrick settled back in Manchester there was great concern for the so-called outside vulgar influences, such as "men and boys skating on the pond of Merrimack Common in full view of everyone who was going to church on the Sabbath."[7] The poor who had been away fighting the war returned and shocked the city that had become accustomed to their absence. The safest shelter from rowdy influences, the place to nurture cherished values, was believed to be the home. Just when people accepted that "the happiest place in the world for young people ought to be their home and this required beauty and amusement,"[8] Herrick began to use his own house as a center for art for his own children and for their friends. In his domestic sanctuary, he set an example. He "encouraged art at home in every way possible. . . . He never seemed happier than when he was assisting a struggling young artist."[9] At the time of their settling into Russell Street, the Herricks' three children—Allan, age eleven; Robert, age eight; and Henry Augustus, age four—and their neighors and friends, including the Crosses, became the first in Manchester to be recipients of Herrick's art teaching in this new phase of his life.

For an artist of Herrick's caliber, Manchester must have been a most unwelcoming city. "Art and literature never seemed to an outsider to be terms in harmony with the spirit of our city, known far and wide as a manufacturing center."[10] Until 1865, when Herrick returned, little pertaining to visual art took place in the city. The *Daily Mirror & American* had little art news. One tiny newspaper article reported an exhibition in an "atelier" of "our talented artist, Edward I. Custer," who had just returned from the proverbial artist's tour of Europe. "Many of those grand and beautiful scenes in nature which the Old World affords, he has reproduced on canvas since his return." The newspaper reported that Custer "consented to give lessons in drawing, painting, sketching from nature, and linear perspective."[11] No notion was here of the Eden that was America, no reference even to the virtues of the New Hampshire landscape. The only other items appearing in the *Daily Mirror & American* were Mr. and Mrs. Murdock's announcement that they will teach "Drawing, Painting, and Writing in their rooms at the Merchants' Exchange,"[12] and E. B. Clarke's no-

tice that he did "sign and ornamental painting." He did not offer to teach but he did promise that he "painted scenery on short notice." [13] Finally, the Amoskeag Manufacturing Corporation offered drafting classes for its own workers, similar to those John Rogers agreed to teach back in 1855.

Books were a help and a relief from isolation. Herrick could enjoy the support of, and silent dialogue with, John Ruskin, whose educational ideas fortunately were committed to print. Ruskin had discouraged formal art instruction for children younger than fifteen, and so during the years when Herrick still lived in New York and came only for visits, the Cross children probably were encouraged only to enjoy the effects of their own marks on paper. But by now, they were eager to improve, and Mr. Ruskin would have approved, since by 1867 the youngest of the Cross children, Henry, had turned fifteen and Emma was seventeen. Ruskin, had he been there, would have been delighted. The wood engraver was his ideal of a drawing master, and here was "Father Herrick," master engraver, eager and ready to teach. Ruskin wrote:

A limited number of good prints should always be within a boy's reach. In these days of cheap illustration, he can hardly possess a volume of nursery tales without good wood-cuts in it, and should be encouraged to copy what he likes best of this kind; but should be firmly restricted to a *few* prints and to a few books. . . . If a boy has many prints he will merely dawdle and scrawl over them; it is by limitation of the number of his possessions that his pleasure in them is perfected and his attention is concentrated. [14]

Herrick may have been less concerned about restricting the number of prints the children saw, but he did encourage them to copy the prints they liked best.

There is evidence that all three young Crosses learned to draw by copying. Foster and Emma used lithographed prints of the human figure that appeared in William Hermes's *United States Systematic Drawing Schools* (German edition), as well as wood engravings that appeared in storybooks. By the late 1860s, the availability of Chapman is no longer a matter of speculation. Emma's sketchbook contains an elegant hand, drawn directly from one of Kinnersley's wood engravings in that volume. Henry's copies include two, *A Fox in a Well* and *The Kite and the Pigeon*, that were from Herrick's own profusely illustrated *Aesop's Fables*. [15] The copy of the *Fox* reverses

The Fox in the Well drawn and engraved by Henry Walker Herrick, from *Aesop's Fables*, published by Hurd and Houghton, New York, in 1865. This illustration was one that Henry Cross chose to copy.

Henry Cross reversed Herrick's printed engraving of *The Fox in the Well* from
Aesop's Fables. Henry felt entitled to take liberties when using images by
others, as here, where he replaces Herrick's wolf with a goat. Drawn in 1869.

Herrick's original. Frustrated in his attempts at reverse drawing, a skill essential to becoming a wood engraver, Henry gives up in mid-stream. He added his own goat here too rather than faithfully following the Herrick.

In 1868, Henry Cross also copied a print of a gathering of ducks and chickens from Harriet Beecher Stowe's *The Queer Little People*, published just that year and here he took a different liberty. Though Henry used the illustration entitled, *The Hen that Hatched Ducks*, he humorously retitled his version *The Happy Family*, after a tradition in animal shows that he knew from local fairs. (The Home of the Happy Family was a novel animal cage in which the family consisted of different kinds of animals that would eat one another were they not trained otherwise. Cats, rats, large birds, small birds, squirrels, and rabbits were caged toether, ate from the same dish, and were no threat to one another because they had been raised together and were trained to exist in this odd situation. Henry might have known of this because his family owned *The Nursery for Youngest Readers*, a volume of stories and poems published in 1869, which gives an account of these cages. The author, identified only as E. L. D., explains that the animals must all be well fed, for if they should ever get very hungry, the cats would eat up the rats or the very large birds would eat the smaller ones.) When Henry wasn't using this book for his drawing ideas Emma was. Two illustrations from *The Nursery* served as models for her copies: one picture was of a young girl and her dog gazing out a window and another was of a sister and her younger brother seated in an ample, highbacked, tufted armchair looking at a picture book.

That these drawings survived until today suggests that the parents valued them and cared for them. Unlike children's early untutored drawings that adorn many refrigerator doors today, these drawings are meticulous, disciplined work. Their parents may have kept them because they represented certain cherished virtues, probably concurring with Ruskin that the "purpose of learning to draw was to ensure true seeing."[16]

Joseph Cross had already taught his children about subtlety of sight. In his early instruction in farming he required that they look at and appreciate differences and changes in growing things. Again, in

THE HEN THAT HATCHED DUCKS.

A STORY.

ONCE there was a nice young hen that we will call Mrs.
Feathertop. She was a hen of most excellent family,
being a direct descendant of the Bolton Grays, and as pretty
a young fowl as you should wish to see of a summer's day.
She was, moreover, as fortunately situated in life as it was

1

Opposite: This wood engraving of a dynamic, unusual family attracted the eye of Henry Cross. It illustrated the tale of *The Hen that Hatched Ducks* in Harriet Beecher Stowe's *The Queer Little People*, published by Ticknor and Fields, Boston, in 1868.

 Above. Henry's faithful copy of *The Hen that Hatched Ducks* was retitled *The Happy Family*. Drawn in December 1869.

his Civil War letters, he taught Emma subtlety of sight by sending her curiosities as he called them, mystery objects that he wished her to recognize. He was again teaching subtlety of sight as he described the flowers and the caves that he saw as he marched with his regiment. This agricultural family would have felt quite comfortable with Ruskin's words: "I would rather teach drawing that my pupils may learn to love Nature, than teach the looking at Nature that they may learn to draw."[17] Visual instruction, even on as technical a level as the mastery of the wood-engraver's technique on tinting, must have been appreciated as a means of loving nature.

Learning to draw requires as much practice in looking at images as in making them. This part of a person's art education is usually left unaccounted for because it is the most difficult to document. Little that is physical usually survives to provide a clue. Fortunately, the Cross family's attic boxes contained an object that proves most valuable in this respect: a pasted picture album.

Album pasting was common in the nineteenth century. Both adults and children seemed to have found pleasure in pasting together pictures, advertisements, poems, and even prayers. Some albums were full of trade card advertisements, often collected for the brilliance of the chromolithography. Others were assembled like doll houses, with each separate page representing the space of a room with opulent curtains, overstuffed furniture, and even tiny gilt-framed pictures on the wallpapered walls. Many people devoted time and love to the making of albums. Though albums contained commercially printed images, they could be as personal as if they were drawings, showing what the owner loved to look at then and wanted to be able to see again and again.

The album that the Cross family treasured was a large leather-bound volume on whose front cover was inscribed in gold letters Scrapbook, T. P. Donaldson, 1868. It is unclear why the name Donaldson is on the cover, and indeed who T. P. Donaldson was. Pasted inside were the finest wood-engraved images of the time, demonstrating the available repertoire of compositions, visual narrative, and wood-engraving techniques cut from newspapers, and illustrated magazines such as *The New York Graphic* (1869), *Punch* (1868), and *London Illustrated News* (1866, 1867).

Typical pasted picture album organized so that each page becomes a room.
Pages show floor, walls and windows, and the storage of items appropriate to
each room. Moveable paper dolls can be inserted in each page and can be
moved on to the next. This example was not made by the Cross children.

The album seems to have been a portable museum, providing tradition, how-to techniques, and a community of fellow artists for the aspiring Cross children. Containing only wood engravings, it appears to be a self-teaching tool for those who wished to become wood engravers. There is no doubt the album was owned and kept by the Cross family, who probably used it and even assembled it. Though no definitive attribution of the album can be made, images in it can be cited as prototypes for Henry's later drawings. As such, it is a physical embodiment and a concrete way of establishing the family's visual memories.

Since art was a social experience for the Cross and Herrick families, they may have viewed this album together. Handwriting on the pages suggests that at least two people left their marks: one, a mature, cursive writing, is in ink; the other, immature, awkward, childlike printing, is in pencil. The ink writing identifies the title or subject of the individual engraving. In a few cases the writing is more extensive. Next to the ship *C. S. W. Chicago* was written: "Saw her in New York, 1867,"[18] suggesting that these remarks are from the hand of Foster, who had been in New York on business that year.

The penciled writing refers neither to subject nor title, but instead imitates the signature of the artist, i.e., Linton, Swain, Morin, Huyot, and of course, Herrick, all of whose engravings are contained in the album. Imitation of a signature can be a means of incorporating an admired person's skill. The pencil writer mastered the tricky task of extracting the engraver's name from the web of lines that form the image of the wood engraving itself. Next to a small engraving of a bagpiper on horseback entitled *Through the Forest* are three rows of five dots each and a patch of cross-hatching, parallel lines drawn perpendicular to another set of parallel lines. Dots and hatching are devices used in that particular wood engraving to create texture. The pencil writer who observed these and then imitated them was too immature by then to be either Emma or Henry. Perhaps one of the Herrick's younger children got a hand in on this volume.

Though Foster was already in business and traveling to New York in 1867 and 1868, he returned to Manchester for visits, and these may have become even more focused occasions for Foster to meet with Mr. Herrick and share his skills as an artist with Henry and

A hand drawn by Joel Foster Cross, signed J. F. C., provides a model for
Henry to copy. Henry's drawing beneath is signed H. C. C.

Titled *Seals*, this page includes one seal drawn by Joel Foster Cross and two copies beneath by Henry Cross. Foster's version is copied from a Jacob Abbot storybook, *Gibraltar Gallery*, an account of various things both curious and useful, published in 1856 by Harper and Brothers, New York.

Emma. In 1868, as if the words of his father's war letters still echoed in his mind, he literally set an example for Henry by drawing certain pictures that Henry set about copying. Among the many loose papers in the Cross family boxes were drawings that the two brothers did together on the same sheet of paper. As mentioned earlier, on one page there is a drawing of a hand in the upper left corner, signed "J. F. C." below, and beside that drawing is another version of that same hand, signed "H. C. C." On another page Foster copied a seal from a wood engraving from Jacob Abbott's 1856 Harper storybook, *The Gibraltar Gallery; being an account of various things both curious and useful*, in which heads of seals peek out through holes in the ice. Again, right next to Foster's seal, Henry emulated his brother's drawing. He did two copies; trying to get an even better copy in the one. Henry must

have felt proud because it was admirable to be able to imitate another person's work.

To appreciate the life Henry Herrick made in Manchester, we must understand that the loss of New York actually afforded him certain opportunities. Despite the obvious commitment that Herrick had to his mother, his decision to return to New Hampshire seems to have been based as much on aesthetic as filial concerns. In retrospect, we can see that the move coincided with a change in Herrick's own art. His New York work was primarily black-and-white wood engraving; his New Hampshire work also included watercolor landscapes, house portraits, and history paintings.

Ideas about art in New York between 1844 and 1865 no doubt influenced this change. Thomas Cole's essay on "American Scenery" seems to have had as profound an effect on Herrick as it did on most American artists:

Rural nature is full of the same quickening spirit—it is in fact the exhaustless mine from which the poet and the painter have brought wondrous treasures, an unfailing fountain of intellectual enjoyment, where all may drink and be awakened to a deeper feeling of the works of genius and a keener perception of the beauty of our existence.[19]

Although Cole regretted in 1836 that "the number of those who seek enjoyment in such sources is comparatively small,"[20] once he pointed the way, Herrick and many other artists, even twenty years after Cole's death in 1840, followed his direction even to specific sites in New Hampshire: "The Sandwich range on the way to the White Mountains," "Winnipisogee [sic] with its multitudinous islands," and the two lakes "situated in a wild mountain gorge called the Franconia Notch. . . . In the mountains of New Hampshire, there is a union of the picturesque, the sublime, and the magnificent. . . ."[21]

Herrick knew well what the Amoskeag Manufacturing Corporation had done to the Manchester landscape and shared Cole's

sorrow that the beauty of such landscapes are [sic] passing away—the ravages of the axe are daily increasing—and the most noble scenes are made desolate . . . often times with a wantonness and barbarism scarcely credible in a civilized nation. . . . [A]nother generation will behold spots now rife with beauty, desecrated by what is called improvement.[22]

But by the 1860s, the ideal had shifted from Cole's sublime wild-
ness to a more domesticated view of rural harmony; New Hampshire
remained the painter's ideal. Artists frequented the state so much that
their presence became a magnet for multitudes of curious tourists,
and in the 1850s, great hotels were built. From New Hampshire, New
York painter Daniel Huntington, president of the National Academy,
had written in 1855, "'Having heard of the merits of this place as a
sketching ground . . . I am passing some days here and find it indeed
a very agreeable and desirable place for landscape study.'"[23]

Every artist wanted to come to New Hampshire to paint. "To the
landscape artist . . . more than any other one influence is due the
prosperity of North Conway."[24] Not only the artists' presences and
their paintings, but also the popularity of print reproductions of their
landscapes, drew more and more interest to the New Hampshire land-
scape in the 1860s. The preciousness of New Hampshire's landscape
increased as industrialization increased, and artists heard a new
urgency in Cole's words: "Nature has spread before us a rich and de-
lightful banquet. Shall we turn from it? We are still in Eden."[25]

Herrick was no longer young when he returned to his native state.
He would have welcomed at midlife the opportunity for a fresh start,
suggested by the words of Asher B. Durand's *Letters on Landscape
Painting*: "I would urge any young student in landscape painting, the
importance of painting direct from Nature as soon as he shall have
acquired the rudiments of Art."[26] The flourishing state of American
landscape painting must have excited Herrick and strengthened him
since he was already "at home" in the region for which all the New
York artists yearned.

Wood engraver John P. Davis, in an 1890 lecture to Los Angeles's
Ruskin Art Club entitled "Individuality in Wood Engraving," sug-
gested that Herrick left wood engraving for the individuality possible
in painting, but Davis's view is not supported by the facts. In 1864, in
order to continue his wood engraving for prominent New York and
Boston publishing houses, Herrick in fact declined what must have
been a tempting offer: to become director of the newly formed School
of the Fine Arts at Yale University. Herrick seemed to find watercolor
painting personally and professionally compatible with wood engrav-
ing; he never abandoned wood engraving, despite being drawn to

watercolor. He designed and cut wood engravings for Kilburn in Boston and Harper's in New York well after resettling in New Hampshire. Even if he did it for income, that he voluntarily taught it to others suggests that he also really loved it.

Soon after his return, a Manchester-inspired wood engraving appeared as a full-page illustration in *Harper's Weekly* of December 29, 1866. Herrick drew the image, which *Harper's* proudly announced by setting his name in type next to the picture, entitled *Hauling Home the Christmas Boughs*. The engraving shows four boys, warmly clad with hats, mittens, and mufflers, guiding two yoked oxen pulling a sled piled with boughs that reached as high as the children's eye level. Bellyside down, one child rides on top of the pile of boughs, as though intending to prevent them from falling off, but more likely just for the pleasure of it. Two children walk along, one at the side of the sled and one bringing up the rear, checking to keep all their precious cargo. Snow buries the feet of the children, making them appear even more diminutive than they are. Emerging from the dark forest into an open field marked only by some bare tree stumps and evergreens, they are heading down to a house, their destination beyond a snow-covered fence. This large engraving was actually a composite of eighteen separate 2¼-by-3-inch boxwood blocks, in a popular oval format that accentuated the curves of hills and paths undulating back in space.

The engraving itself is an example of the virtuoso cutting that people came to expect at this time. Fine black lines created varieties of grays, and bold chunks of wood block were lifted to create areas of white. A snow scene such as this ideally suited the dramatic effects of cutting out large chunks of wood. Empty white spaces were juxtaposed against dark fine lines cutting in, for example, a dynamically drawn tree. Dark black lines were contrasted sharply with lumps of white snow poised at the tips of the branches. The same kind of contrast was required in the depiction of the shadows of the oxen and the children in the snow. Here again, tiny black fine-line engraving contrasts with large chunks of wood removed to leave the white area in the print, depicting the brilliance of snow. Herrick used his newly reclaimed environment to stretch and invent beyond the customary technical skills of the day.

Hauling Home the Christmas Boughs, by Herrick, appeared in *Harper's Weekly*, December 29, 1866. Wood engraving, 16½″ × 11½″.

Harper's must have been delighted with "Hauling Home the Christmas Boughs." The following August, it commissioned another such rural piece, this time a double spread, twice the size of the winter scene, entitled *Life on the Farm.* The lettering for the title, rather than being typeset, was elegantly engraved in the block, as were the words "Drawn by Herrick, 1867." This ambitious project had four main parts: two circular scenes of reaping and mowing and two rectangular scenes of plowing and sowing. Each of the scenes is fully engraved with many finely spaced black lines creating varieties of grays. White areas are used for dramatic effect to focus the eye on the tools of the reaper and mower or the workers and horses plowing or sowing. Borders surrounding these four scenes are ornamented with branches bearing apples, cherries, and peaches. Watermelons and ears of corn mark the bottom corners. The left side of the image includes three more scenes of summer: a boy fishing at a trout brook, a girl feeding chickens and sheep, and another boy, seen silhouetted against the sunset, driving the cows. On the right side, more children are depicted much in the manner of Herrick's book illustrations. We see the animated figure of a boy climbing a tree, gathering nuts and handing them down to a young girl, who collects them in her basket. Children are caring for the donkey, calf, and ox, their pets. In the lower right-hand corner, milking time humorously contrasts a calf nursing at its mother with a boy seated at a milking stool, extracting milk for human consumption.

In order to produce this engraving, Mr. Herrick had to observe a farm. He appears to have chosen City Farm. Since Herrick had already asked Emma Cross to pose for him in 1865 for a small watercolor of a girl in a red cape—"Little Red Riding Hood"—it is likely that he also asked the Crosses to serve as models for this work. The engraving's barn roof matches that of City Farm's barn; other features also match. But if City Farm was the site for the engraving, its seamy side and its poverty were edited out. Herrick preserved only the charm and the competence of farming.

When Herrick returned to Manchester, ready to meet new challenges, he could hardly have anticipated the degree of his isolation. Inspired by the New York City painters' idealization of New Hamp-

Colonel Parker

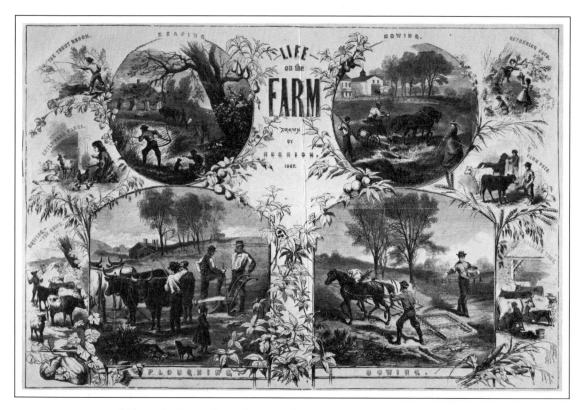

Life on the Farm, drawn by Herrick, center fold in *Harper's Weekly*, August 10, 1867. The wood block is dated 1867. Barn resembled rear view of City Farm. Pictured are childhood activities, gathering nuts, caring for farm pets, milking, fishing, feeding the chickens, and driving the cows. Size: 23″ × 16½″.

shire, he never imagined what a singularly lonely artist soul he would be. In 1947, Manchester artist Maud Knowlton wrote of Herrick's situation back in 1865:

We of today can scarcely realize what it meant to be the lone representative in a community of a phase of life as exacting in its demands as that of an artist of Mr. Herrick's ability and of his period. Art meant very little to the majority of the people of Manchester who were at the time mainly engaged in the business of amassing wealth in an expanding textile city.[27]

One of the people who would have appreciated Herrick was a young schoolteacher who had just returned from the war, Col. Francis Wayland Parker. Born in Bedford, New Hampshire, a town right next to Manchester, Parker was from the old families on the western shore of the Merrimack River. He was the nephew of John Goffe Rand, the portrait painter and inventor of the screw-top paint tube who had been honored by the New York artists' community shortly before Herrick's return to Manchester. Both Parker and Herrick were educators, and both felt drawing skills were important in education.

His father died when Parker was still young, so he was bound out to work for a farmer in nearby Goffstown. For five years, between the ages of eight and thirteen, he had only a few weeks of wintertime education each year. After the age of thirteen, Parker attended private academies, first at Mont Vernon and then at Hopkinton. With no further schooling, he soon was engaged as a teacher and remained one until he went off to war.

When he returned from serving in the Fourth Regiment of New Hampshire Infantry Volunteers he came home as Colonel Parker, a hero who had his choice of careers. Rejecting other proposals, he returned to his preferred work, teaching. The position he accepted was as master of Manchester's North Grammar School, where Henry Cross was at that time concluding his schooling. Henry Herrick and Frank Parker shared a love of teaching as well as of art. They shared even more, for they were both teachers of Henry Clay Cross.

Colonel Parker was an intelligent and restless man who felt that children's education should be a more imaginative and expressive process than the then-current curriculum permitted. In most schools, the curriculum was mainly language: writing language and reading language. In November 1865, Manchester's *Daily Mirror & American*

Stereopticon card showing North Grammar School, where Francis Wayland
Parker served as Master and Henry Cross was his student.
Cross Family Collection.

boasted: "Great innovations have been made in schoolbooks, new
methods of making students fascinated with their studies are yearly
being adopted." [28] This was the year that Parker entered the Man-
chester public school system as master of North Grammar School. In-
novation was welcome, and Parker was to take advantage of that.

Even before Parker's trip to Europe in 1872, he was familiar with
the theories of European educators, particularly the ideas of Friedrich
Froebel, the founder of the kindergarten. As North Grammar School's
master, Parker adapted Froebel's ideas to the school yard, discovering
that he could use not only language, but also athletic and military
drill to teach concepts to his students. One of Henry Cross's grammar
school classmates reminisced about Parker years later, "He was a
pioneer in kindergarten methods of instruction and tried some of
them out on us." [29] Though Henry Cross and his classmates were due
to graduate in January 1868, "The entire class of fifty pupils willingly
remained over time, so great was the esteem of the pupils for Mr.
Parker. He introduced the military drill in the schools and it was at

his suggestion that athletic exercises were indulged in, and a horizontal bar erected in the school yard."[30]

These fragments of history would hardly suggest that Parker was a teacher whose style was uniquely matched to the needs of a child like Henry Cross. It is only thanks to Parker's later writings, particularly *Talks on Pedagogics*, a compilation of his lectures at Chautauqua, New York, published in 1894, that we may speculate about his probable impact on Henry in the latter half of the 1860s. In *Talks on Pedagogics*, Parker recalls a child who might even be young Henry Cross:

Take a little boy with the environment of a farm. . . . He studies spontaneously his entire environment. It is safe to say that he knew every plant on the farm, every kind of grass, every weed. . . . He can tell you the shape of every tree; its trunk, its foliage, its fruit, he spontaneously classifies. Thus every child is an earnest lover of botany.[31]

The farm child instinctively begins to study "all subjects that are known in the curriculum of the university. He begins them because he cannot help it; his very nature impels him. These quiet, persistent powerful tendencies we must examine and continue with the greatest care."[32] Parker admired the way children spontaneously studied geology, mineralogy, zoology, and anthropology through their daily life. Rather than emphasize what children lacked, Parker appreciated the resources that children possessed.

The capacity of children to absorb new knowledge fascinated Parker, as did the means by which they did so. First, he observed, they *attend* to what attracts them. Because they want to know more, they concentrate and inhibit "foreign" activities. They can thus focus their minds on the object of their attention. Attention makes children's minds active and imaginative. After a certain amount of attending the child is impelled to do something and needs to *express* his new ideas, his "intense acts of imagination."[33] For children to form their own ideas, they must be given the opportunity to express them.

Every child has the artist element born in him; he loves to model objects out of sand and clay. . . . Give a child a piece of chalk and its fancy runs riot; people, horses, houses, sheep, trees, birds, spring up in the brave confidence of childhood. In fact all the modes of expression are simultaneously and persistently exercised by the child from the beginning, except writing.

It sings, it makes, it moulds, it paints, it draws, it expresses all the forms of thought expression with the one expression.[34]

Parker's intellectual independence and confidence arose in part because of his familiarity with the advanced European educational theories, but his pursuit of those theories was a consequence of his personal history. Education was his family's tradition. His maternal grandfather was the first recorded teacher in Derryfield. His mother also had been a teacher, and perhaps even his artist-uncle, John Goff Rand, taught. It is extraordinary, but possible, to know so much about Henry's eighth grade teacher because he was later to be acknowledged as one of America's leading and most original educators. John Dewey called him, "more nearly than any other person . . . the father of the progressive education movement."[35]

The real teachers in one's life can appear entirely by surprise. Henry Cross was surprised twice, once quite outside any system of formal schooling, by Henry Herrick, then again just after the Civil War, within the public schools, by Colonel Parker. Not only were these teachers to inspire Henry Cross, they were likely also to be a benefit and comfort to each other in an environment that did not know quite what to make of either one of them. In Herrick's later years, it is said, he was at work on a book "embodying the educational power of art, its elevating and enlightening interest [and] tracing a comparative analogy between music, language, and art."[36] The ideas attributed to Herrick's unpublished manuscript suggest that a dialogue between Parker and Herrick continued through the years. Perhaps Parker's concept of the equally important modes of learning music, gesture, speech, painting, building, and writing enticed Herrick to elaborate his own theories.

Rebuilding Society

Herrick's move to Manchester required that he prepare himself psychologically for a far more austere life, one where most amusements, perhaps with the exceptions of picnics, were disdained. He found himself in a city that needed a shape for its social life and needed to find its own morality. Just as the Amoskeag Corporation had realized in the 1850s that art could be the means of increasing its profits from manufactured products, so now the clergy and the religious commu-

nity began to see art as a means of promoting virtue. Art, like religion, promised "to be the cheapest police." [37]

The existence of poverty troubled Manchester. Its missionary society tried to help.

No human arrangements can in all cases prevent poverty. It is God's plan to permit it for wise and benevolent reasons. The existence of the poor in any given community, is one way of disciplining the rich. It tests their generosity, or gauges the degree of their selfishness. The poor keenly feel their trials without being able to avoid them. They want sympathy to help them over the hard places in life's journey. They should have it. [38]

In 1847, the Manchester Missionary Society organized Sabbath classes for persons who would not otherwise have attended places of worship. Its church, established in 1852 with Congregationalist and Presbyterian funds, once had as many as eighty-six members. Ultimately, they drifted to other churches or to no church, and through the war years the organization foundered. As if to justify the vanishing group, people agreed with the Boston Missionary Society that there were benefits from the needy merging into other existing churches rather than remaining segregated: "The poor must not be treated in any obnoxious sense as poor. They must be approached as those who are sought for on account of their own intrinsic worth—not to be set off as a distinct class by themselves." [39]

After the war, in May 1866, the city missionary was reappointed and 250 families were on the society's list. Services included Sabbath preaching, meetings every other week in the jail, "hopeful conversations," temperance pledges, assistance in provision of food and clothing, and provision of Sabbath school.

Just when art was beginning to be seen as a means for uplifting and controlling social life, Mr. Herrick returned to Manchester and assumed leadership in its social and religious life. The same sympathy that led him to empower women to support themselves through wood engraving inspired him to teach the families of the missionary society. In April 1869, Henry Walker Herrick was elected superintendent of the Manchester Missionary Society's Sabbath school. It met in the forenoon of two Sabbaths a month. Father Herrick taught classes to the 150 children who paid their weekly penny contribution, which helped the society meet its expenses and taught the children the habit

of giving. The society, which sought to foster a better system than street-begging, taught temperance, found homes for the homeless, provided evening school for the many who needed instruction in the "rudiments of book knowledge" and a Sabbath school for those who sought religious instruction, and extended a social welcome to foreign populations, specifically the "Protestant Germans and Swedes" coming in increasing numbers.[40]

Both Henry Herrick at the missionary society and Joseph Cross at City Farm found themselves sharing responsibilities for the city's poor. The abject poverty so apparent after the war required special efforts. Subscriptions were taken up to provide assistance. A missionary circle was organized by the women to repair and distribute used clothes.

Herrick's public image in Manchester was as a spiritual leader of the poor. Since he painted at home, his Sabbath school was the only work that required that he leave the house. Few others knew him in his work as an artist or benefited from his skills as had Foster, Emma, and Henry. Herrick still had a huge gap to bridge. He realized Manchester was worlds removed from New York. He had yet to find a way to bring art to this city, which lacked sophistication in such matters. For his own psychological survival, he might even have had to deny or resist seeing how very different these two worlds' art might be. He seemed willing, even fascinated, by the challenge of trying to bridge the gap.

Changes in the culture were taking place that were to ease Herrick into a position where he might actually make a difference. In the popular mind, a "subtle conspiracy was forming. . . . Beauty was replacing cleanliness in its proximity to Godliness."[41] Art was becoming a power for redemption, for reconstruction, and Herrick was in just the right place at the right time to be instrumental in the process.

CHAPTER 8

PREPARING TO LEAVE

In the late 1860s, City Farm was hardly the bucolic scene that Henry Herrick depicted in *Harper's Weekly's Life on the Farm*. Postwar conditions increased the numbers of the destitute and criminal populations who had to be shipped out of town. The city realized that its investment in a work farm back in 1847 now could yield the city a jail as well. The foundation of the old tavern house in which the Crosses and their charges lived was adapted to contain cells to house the incoming criminals. Now, two unwanted populations—the indigent and the criminal—were to be confined in one dumping ground. The poor would continue to work the farm while the newcomers would be confined to the cellar dungeon.

This new decision could hardly have been warmly received by the Crosses, who until then had proven that they could make the best of even the most stressful situations. They had survived separation through the war, ill health, and isolation, but the new decision put the greatest burden on their inseparable work- and homelife. City Farm was hardly the happy home of which Mr. Cross had dreamed throughout the war. The depressing environment must have speeded the departure of their children, who in any case were preparing for independent lives.

In 1868, Henry Cross, sixteen, was still living at City Farm. Like

Starting Careers

123

most adolescents, he was preoccupied with his future. Despite his father's strong objections, he was deeply engaged in his plan to become a wood engraver. His many drawings were signed using the engraver's convention *del*, for delineant—"he drew," beside his name, identifying himself as the person who had drawn, not just engraved, the image. Subtle professional distinctions already mattered to him.

Following years of informal instruction from Mr. Herrick, with whom he shared far more than a first name, Henry persisted in his wish to engrave. It was not only his teachers who reinforced his choice; his parents' own aesthetic interests, his brother's already significant achievements, and even the illustrators of his own adventure storybooks all conspired to support his own inclinations.

For Henry, becoming a wood engraver was more than a romantic goal, it was work at which he practiced diligently. Ruskin suggested that the draftsman must draw, at the start, for at least an hour a day, and this son of a farming family who knew about labor cherished its results. Ruskin's advice seemed to be written for Henry. In describing how the art student could develop control, Ruskin wrote: "The pen should, as it were, walk slowly over the ground, and you should be able to stop it, or to turn it, in any direction, like a well-managed horse."[1]

Henry's drawings at this time are copies. Landscapes, such as that on Perry's Wild Cherry Anodyne medicine bottles as well as those in book illustrations, attracted him. Copying was important not only for the improvement of his drawing skills, but also for his future work as a wood engraver, incising an exact, albeit reversed, copy of a drawn image onto a wood block.

Despite Henry's apparent efforts to make correct copies, his results were not Ruskin's ideal. One specific piece of Ruskin's advice was unacceptable—or impossible—for him: "Work with [pencil] as if you were drawing the down on a butterfly's wing."[2] Henry preferred to dig the paper with force as if his pencil were the engraver's tool. His vigorous strokes show the intensity of his temperament and suggest how well-suited emotionally he was to the work of digging lines into wood. The incised pencil line distinguishes Henry's drawings from student work that might have followed Ruskin more faithfully.

Copying never intimidated Henry or discouraged his invention of

original compositions. Though Henry chose to emulate other people's pictures, he never did so passively. Drawing was often an occasion for his willfulness, rebelliousness, and even for private jokes. On one paper scrap, he commemorated the demise of a "killer," drawing the gravestone and planning the inscription Pain Killer, 1840–1870. On the reverse side of that paper, in a different vein, Henry humorously shows a tiny frog looking up from a pond, gazing at a tall horse who sports a top hat in his mouth. Over the horse's back are drawn two racing birds and three tiny birds, presumably their offspring, who can barely keep up with them.

Henry also undertook drawing problems for which no example existed. In August 1868, he drew his barefoot friend Eddie McQuin, who posed sitting on a porch with his back against a wall. Drawing Eddie required a different kind of thinking than drawing from copies. To find a way to draw Eddie's crushed hat so that it would really appear to rest on his head, he decided to draw Eddie's ear sticking out over the edge of the hat. Despite all Chapman's directions about firm lines in *The American Drawing-Book*, here Henry drew delicate marks to capture the thoughtful expression on Eddie's face, his lips parted as if he were in the middle of saying something. Eddie's crossed arm and leg positions created problems, as did Eddie's arms pressed around his chest, creasing his jacket. Another difficulty was Eddie's hands, of which Henry drew every knuckle and bend, creating a misleading image of the gnarled arthritic hands of an elderly man. Henry made the toes of shoeless Eddie better suited to his age. This drawing shows the persistence and the courage of this young artist who was willing to produce an awkward and unbeautiful image in order simply to figure out how to draw.

Sometimes Henry couldn't tolerate the awkwardness of his efforts. He censored one drawing of a standing woman with a muff over her hands by totally scratching out the face. Such impatience was rare and must have seemed wasteful. Often, to save paper, Henry practiced his drawing on both sides of the paper and even combined several separate efforts on one and the same side.

Henry portrayed his mother in a drawing dated July 9, 1869. The same sensitive line that explored the face of his friend Eddie is used to capture her sad, forbearing look. Sitting with arms crossed, she

In August 1868, "barefoot boy" Eddie McQuin posed for his friend Henry
Cross. The year before, the Prang Company had popularized the image of *The
Barefoot Boy* by its mass-produced chromolithograph of Eastman Johnson's
painting by that name.

stared ahead patiently, giving Henry the time to figure out how best to
draw her. This tiny drawing is a loving, revealing insight into what
Henry could bear to see. He does not glamorize or idealize her, but
rather captures the sorrow and fatigue of City Farm life and her will-
ingness just to be available for Henry to draw her.

Another drawing, undated, seems to be Joseph Cross. He has a full
beard, which he wore from the war years on for the rest of his life.
Despite his round wire spectacles, he holds his newspaper at a dis-
tance. Henry drew him seated in a spindled armchair, with his legs
stretched far out in front of him, slippered feet crossed. In this draw-
ing, instead of drawing lines, Henry used his pencil to make various

Deborah Cross as drawn by her son Henry on July 9, 1869, two days after his seventeenth birthday. The adolescent studied his contemplative, fatigued mother by drawing her.

gradations of gray, creating the illusion that his father was really seated there, in a realistic space. Between the linear qualities of his drawing of his mother and the broadly shaded, nonlinear quality of his drawing of his father, we already see Henry's control and versatility; indeed, he handles his pencil like a well-managed horse.

These were all drawn within the year following Henry's graduation from high school. Back on June 25, 1868, Henry and his thirty-two classmates had said farewell to North Grammar School and received the newly devised token of their accomplishment, the grammar school diploma. After parting from this devoted class, Colonel Parker officially submitted his resignation to the Manchester School Committee and departed to head a teacher training school in Dayton, Ohio.

In the following academic year, 1868–69, Henry quite irregularly attended the spacious, newly built Manchester High School. It offered him little in his search for his identity as a wood engraver. Learning more about engraving through his occasional trips south to Boston to visit his brother, Henry became one of those truants about which the school system had become so concerned.

Henry's search for an ideal was greatly spurred by the success of Emma and Foster. On November 21, 1868, the local *Daily Mirror & American* listed the name of each young person graduating from Manchester High School, and eighteen-year-old Emma was one of only fifteen students who achieved this last step in the Manchester public school system that year. Proud families celebrated their children's fulfillment of the hope the school system literally created for them.

Emma, who had been in the school system for so long, became one of its teachers. School department reports show that she took her first job with the school system on September 14, 1869, less than a year after her graduation. The school committee elected her to serve as an assistant teacher for Manchester's intermediate school even before she received her official teaching certificate. Her students were those who had not yet learned to read and yet were too old to attend primary school. Her job was especially difficult because many were truants and late starters, mostly very poor and unable to attend school before. Their needs already were familiar to her through Henry Herrick's Sabbath school of the missionary society and City Farm, where she saw the cumulative effects of their neglect.

A somewhat more distant study by Henry Cross of his father, removed from awareness of his son's drawing by his absorption in the newspaper. Undated.

No sooner was Emma teaching than she was informed that drawing was to be taught in the schools. The school committee voted to introduce the drawing books and drawing cards of William Bartholomew and invited him to Manchester to advise teachers in their use. Emma was in a curious position, knowing Henry Herrick's approach to drawing and now having to learn another. Since Bartholomew had every right to assume that these teachers had no training in art, he made each step as simple as possible. Each form was a geometrical shape dressed up as if it were a picture of a thing. The motive for copying the drawing card was mastery of the geometrical form. Such drawing seemed beneficial to the manufacturing interests of the city.

Bartholomew's instruction, geared to the lowest common denominator, could hardly excite Emma as Herrick's instruction had. Herrick's teaching, so akin to Ruskin's views, refused to merge art with the service with manufacturing. Ruskin had already written that he "did not want to teach accurate command of mathematical forms which were deemed useful in their application to industry. . . . Try first to manufacture a Raphael, then let Raphael direct your manufacture."[3]

The current popularization of American landscape painting and the conviction that love of nature was even more important than love of drawing were important counterbalances for any pressure upon Emma to adopt Bartholomew's system. Though her way had no place in school, Emma must have felt sustained by the spiritual qualities that she and her brothers attributed to drawing. They continued to devote themselves to nature, drawing the landscape of City Farm and elsewhere, because, for them, "The best drawing masters are the woods and the hills."[4]

On March 25, 1870, after she had attended training institutes, the Manchester School Committee awarded Emma a teaching certificate for the intermediate school. This entitled her to a position as a full teacher with a slight raise in salary. The certificate proclaimed that Emma was examined and found qualified to teach the several branches—including drawing—in the common schools of the state on the intermediate level. A red, green, and black wood-engraved seal of the city ornamented her certificate.

Teaching drawing became big news. Manchester was so committed to the pursuit of drawing that the school committee's annual report

took an extraordinary position. It claimed that neither talent nor the lack of it was relevant to the study of drawing in the public schools:

There are children who study the spelling book for years and then are unable to write a page without misspelling. . . . Others study arithmetic for years without being able to repeat the multiplication table correctly . . . and yet no one thinks of discontinuing these studies in schools or of excusing scholars from these exercises.[5]

Suspected lack of art ability was to serve neither children nor adult laymen, nor indeed anyone in the entire school system, as an excuse for absence from drawing classes.

Until then, art teaching had been primarily a private affair. Talent and its magical discovery had pervaded many artists' biographies, and it was regarded as a scarce but crucial asset. For mass art education to be offered to the working class, such ideas had to be disposed of. The city of Manchester hit upon the heart of the matter and publicly reversed a centuries-old attitude. The school committee's claim that talent was irrelevant freed everyone so they could begin to acquire skill. The investment of public money in mass art education made sense only when this shift in beliefs took place. No longer could people cherish the fantasy artist as genius, as hero, or as privileged prince. Art now could become the property of everyone.

This rare moment was short-lived. Even as Emma witnessed these changes, a curious split took place. At the very time the possibility was opened up for everyone to study art, the kind of art offered to the poorer classes was different from that offered to the more privileged. A new separation and stratification took place. There was low art and high art. The split perpetuated the bias that what the working class drew could not really be art. The public schools' actual art lessons created products that looked distinctly different from what Herrick had taught the Cross children. Sophisticated viewers immediately recognized the differences. Emma, because of her unusual childhood experience, had exposure to both. Through Henry Herrick she was nourished early by ideas of art that flourished at the National Academy. Now she watched the drawing procedures designed for unruly school children. She was caught in the middle.

Emma had her work to occupy her and Foster had his. Finally relieved of the family responsibilities that he had accepted during the

war, Foster left New Hampshire to pursue his career. After traveling
to New York in 1867–68, he moved again, this time to Boston. There,
he was employed by Samuel S. Kilburn, a wood engraver whose office
was at 96 Washington Street, in the busy printers' and artists' district.
Kilburn's office employed many artists, sometimes by special com-
missions such as those offered to Henry Herrick, who is likely to have
written an initial letter of introduction to Mr. Kilburn for Foster.

With the added responsibilities at City Farm and the departure of
the two older children, life became very difficult for the Cross par-
ents. With all their valiant efforts to carry on, they must have been
infuriated to read in the *Daily Union* on January 11, 1869 that the
new city government was casting a critical eye at City Farm. The
newspapers reported its "indecent neglect."[6] "The beds are unfit to
lie upon and the covering tattered and filthy. . . . It is reported to us
to be a hospital for invalid furniture generally."[7] The newspaper re-
port implied that the Crosses were to blame for the abysmal condi-
tions. A committee on the City Farm, appointed by the city govern-
ment, promptly made a visit and filed a report denying that the
Crosses were at fault. In February 1869, the *Daily Union* reported:

It will be seen that the Committee on City Farm do [sic] not sustain any
rumors unfavorable to its management. . . . It affords us pleasure to say that
Mr. and Mrs. Cross have always seemed to us to make the best of a hard
position. The house and furniture are old and the company not always very
select; yet we have heard from the inmates no complaint and seen no cause
for it.[8]

Later that year, another newspaper reported even more extensively:

City Farm has grown a hundred tons of hay, six hundred bushels of corn,
grain and twice as many potatoes. Mr. Cross . . . experimented with plant-
ing for greater productivity. . . . [As for Mr. Cross's new hay lifting device,]
if the invention proves as valuable as it at present promises, the twenty-five
dollars necessary for its purchase will be an economical investment.[9]

The writing concluded admiringly of Mr. Cross's ingenuity that "all
farmers learn to think more, that they may toil less."[10]

Henry may have felt himself a hostage to City Farm, subject to that
old New England assumption that it was the duty of the youngest son
to remain at home and take care of the aging parents. Besides that,
back in the war years, his father had explicitly demanded that Henry

remain a farmer if Foster were to become an engraver. When Foster wrote Henry on Kilburn's letterhead stationery in March 1869, "I suppose next Monday I commence my new salary, $1250 a year. Amn't I doing well?"[11] Henry had every right to feel jealous.

Foster was making his way as an engraver in Boston, but he was lonely on his own. Away from the family for barely a year, Foster found himself a new "little brother," Frank French, who also aspired to become an engraver. Foster helped him in much the same way he helped Henry. Today known as one of the better nineteenth-century engravers, Frank French started life in Louden, New Hampshire, in 1850. Both his parents died when he was quite young. He moved to live with relatives in Deerfield, Massachusetts, whence he went off to Boston where he met Foster. When French shared his dream of learning to do wood engraving. Foster urged him to contact Mr. Herrick and offered him an introduction. Encouraged by Herrick, Frank French moved north to Manchester and learned wood engraving quickly. With Herrick's aid, he got his first job at a local newspaper, the *Daily Mirror & American*. Until the time when he left to develop his career in New York, French remained close to Herrick and was part of the small art circle that was Herrick's extended family.

Foster remained in Boston and learned about French's success on his visits home. Despite difficulties, Foster thrived on independence. In March 1869, he wrote Henry at City Farm, "I have not yet heard whether you stay on the farm another year, but I hope you do."[12] He liked knowing Henry provided comfort to his parents at home, and he preferred to protect his separateness and continue to be independent. But Henry broke loose and went to Boston, where Kilburn, impressed with the quality of drawing in Henry's sketchbooks, hired him immediately. Neither the circumstances of his departure nor his parents reactions are known. Thereafter, the two Cross brothers faced Boston and the business of wood engraving together, and met opportunities and disasters that were unimaginable to these still young men.

Herrick must have watched the lives of these two men with interest. Because he knew artists and engravers in Boston, he could have helped the young men learn the ropes, but he also realized how important it would be for them to make their way on their own.

Boston Foster and Henry Cross saw Boston through the filter of their years in Manchester. They had left behind more than a hundred acres of rolling hillsides of City Farm and the city of Manchester, with its active downtown linking the separate agricultural villages nearby. Only Manchester's very busy central downtown and the river cutting through it resembled their new city. Boston was old, densely built, and crowded. Built to be a harbor city, it was a bastion of business and social activity. Its winding streets and historic architecture were reminders that British ways had been practiced here for a long time.

The distinct physical environment of Boston was fascinating.

The city is a construction in space . . . one of vast scale, a thing perceived only in the course of long spans of time. . . . At every instant there is more than the eye can see, more than the ear can hear. . . . Nothing is experienced in itself, but always in relation to its surroundings, the sequence of events leading up to it, the memory of past experiences.[13]

Boston's downtown was really a peninsula surrounded by the harbor. Its streets, even then, were congested. In the maze of distinctly different districts, a newcomer oriented himself by the major landmarks: the Boston Common with the gold-domed State House at one corner, and the Charles River. Finding one's way from one district to another was no easy matter.

The newcomers needed to orient themselves. In Manchester, the young Crosses had been mavericks. Their experiences with art had made them isolated and different. In Boston, they were unclear about who they were and what all their skills might mean to the larger world. Though Foster and Henry felt themselves to be different, they realized as they met others in Boston that they were only two out of a multitude of people with dreams of art. Many young people with more or less preparation came to Boston seeking to make their way as artists. Henry T. Tuckerman, an artist and art chronicler of this period, observed them:

There is a singular identity in their experience; first the indication of an aptitude and facility in imitating natural and artificial objects inexplicable on any but intuitive grounds, and exhibited perhaps under circumstances totally unsuggestive of Art; then the encouragement of friends, an over estimate of the promise thus foreshadowed, an isolated practice, and in some cases, marvelously stumbling onward until some generous patron, lucky hit or fashionable success launches the flattered, confident, and not incapable

yet altogether uneducated disciple into a career which according to the strength or weakness of his character, will be a trade, a trick, a mechanical toil, an unmeaning facility, a patient advancement or a triumph of genius.[14]

Foster and Henry found themselves part of a mass of young people of their generation who, perhaps having been shown Chapman's *American Drawing-Book* by some acquaintance and following its guidance, persisted in the wish to become artists despite parental confusion and, sometimes, objections. Many came from families who, unlike the Crosses, suspected that art was a wicked and useless profession. It is unclear whether all these kindred souls were a comfort to the newcomers from Manchester.

Had it not been for Mr. Samuel Kilburn, their anchor, Foster and Henry would have been quite at sea. As their boss, he provided a center for their work life and their social life. They had reason to feel proud because he hired some of the best artists and engravers around. Kilburn's history also gave Foster, Henry, and his other workers a heritage. Years back, Kilburn and his friend Richard Mallory had both studied wood engraving with Boston's first engraver, Abel Bowen. From him they learned how to cut into blackened boxwood blocks and to examine the reflection of their engraved block in a mirror so that they could be ever aware of the image reversed, as it appears when printed. That early generation of Boston wood engravers included, along with Kilburn and Mallory, the brothers Nicholson B. and George T. Devereux and J. James and Benjamin Greenough, William Croome, Benjamin Childs, and John C. Crossman. Some later left Boston to join the distinguished New York Circle of Elias Whitney, Nathaniel Orr, William B. Annin, Henry Kinnersley, and Henry Herrick.

Over the previous ten years, Samuel Kilburn, who first established his own shop in 1860, had produced wood engravings for every purpose: book illustrations, advertisements, and even box labels for children's games. In 1865, Mallory joined Kilburn's firm and became a partner. The men worked jointly on many blocks, illustrating such boys' adventure stories as *Frank, The Naturalist* (1867) and *Patriot Boys and Prison Pictures* (1866). Kilburn had invited Herrick, once he settled back in Manchester, to do special commissions, and their tie, which was of long standing, assured the young Crosses a place in

that historical line of professional engravers extending from Abel Bowen's shop.

Kilburn's firm was a heady experience for the young Crosses. Working with the best illustrators of Boston, they saw their work distributed all over the country. Men such as Thomas Nast, who drew for Kilburn's Starry Flag series, *Down the River*, made vigorous drawings of figures in action that presented new possibilities for wood engravings beyond anything they had yet seen. The drawings were expressive, tonal, and allowed for large areas of dramatic blacks and whites. Herrick's work for an adventure series, *Upward and Onward*, included a book called *Desk and Debit; or the Catastrophes of a Clerk*, for which he drew bold, full-bodied compositions reminiscent of Daumier's drawings. The freedom with which these artists worked suggests Kilburn's encouragement of experimentation.

Just as the Crosses were settling into Boston, Boston was coming into its own—the center not only of the state, but of the nation in educating Americans in art. A popular weekly periodical, *Every Saturday*, described why art was needed: "The success of our industry now depends upon the union of the artisan with the artist. . . . By neglecting art we are thus in danger of lowering the value of industry."[15] Since the end of the war, Americans were becoming increasingly preoccupied with workers who could design, handle, and exploit sophisticated manufacturing technology to produce beautiful industrial objects. The plea voiced years before by Minifie and by Silliman and Goodrich for art labor in American industry was finally being heard. The financiers decided that the time was ripe. They saw they might gain both aesthetic ornaments appropriate to their social status and increased profits from their industries.

Charles
Callahan Perkins
The yearnings for art objects that signified status and for skilled art laborers remained quite vague until one man came along who recognized how these were the means for realizing his own dream. The man was Charles Callahan Perkins, born March 1, 1823, to James Perkins, Jr., and Eliza Breen Perkins. From a very early age, he studied drawing and piano, and came to know original oil paintings by the masters, amenities appropriate to his high social class. Art was at the very heart of his family tradition; his grandfather donated his Pearl

Street house to be Boston's first museum, its athenaeum. He grad-
uated from Harvard in 1843 and, uninhibited by the prevailing view
that the pursuit of art was a self-indulgence, he set off to study art in
Europe.

Arriving in Rome just after the death of the respected Boston artist
Washington Allston, who had been living there, Perkins devoted his
pilgrimage to touring art galleries and churches, and painting and
drawing from a model in his own studio. From this period, one of his
drawing books has survived. In 1846, he left Rome for Paris, to study
with painter Ary Scheffer, but Paris did not divert him from thoughts
of home. His vision of his contribution to America's art education
crystalized: "'I shall help organize musical meetings and an Acad-
emy of Design in our modern Athens. I have realized more these past
few months what lies before me to do.'"[16] Perkins, well aware of the
neglect of art teaching at the National Academy of Design in New
York, envisioned his academy where the priority would be systematic
art education. In 1847, he wrote home:

I build castles in the air of a future academy of Fine Arts to be set going,
and I am more and more convinced that there is a glorious chance of worth-
ily immortalizing oneself in our country by being the first to set such a work
systematically in operation.[17]

Bostonians recognized Perkins as a man who made things happen.
In 1849, when he returned from Europe, he gathered a group of
skilled musicians, and in 1850 they formed the still flourishing Handel
and Haydn Society. After serving as its first director and occasional
conductor until 1851, Perkins returned to Germany to study piano.
During his next return to America in 1857, Perkins acknowledged
that he was neither a painter nor a musician and decided instead to
write and speak on art. His first lecture series at Hartford's Trinity
College, entitled "The Rise and Progress of Painting to the Beginning
of the Sixteenth Century," confirmed his vision. From his first lecture,
Perkins won recognition as an art scholar and became the person who
could create the academy of which he dreamed.

In order to prepare himself further for the task he was sure was his,
Perkins returned once more to Europe with his family. Living chiefly
in Italy and France, he wrote *Tuscan Sculptors*, a two-volume history
illustrated by his own drawings published in 1864. Four years later

From the 1844 European sketchbook of Charles Callahan Perkins, Harvard
College, Class of 1843.

his *Italian Sculptors*, was in print and firmly established his preemi-
nence: "No previous works of similar character had ever come from
an American."[18]

Perkins's immersion in European art and ideas had, in fact, made
him into exactly the art authority American needed. In 1869, when
he returned to Boston, ready to realize his dream, Boston was ready
and waiting for him. The city full of young, hopeful artists—Foster
and Henry Cross and the multitude of others—craved leadership. So,
too, did those who craved art objects as signs of their wealth. The city
had sufficient wealth to support the purchase of art and to keep sev-
eral galleries in business. The time was ripe to compete with Europe
in terms of both culture and industry.

From 1869 on, Perkins remained in Boston and started to realize
his dreams. His first step was to organize that much-needed center for
artists and patrons, the Boston Art Club, of which he served as presi-
dent for the next ten years. This social club provided opportunities

for artists to sell their work through exhibitions. Henry Cross joined the club, though Foster never did.

To launch Americans on his experiment, Perkins offered public lectures. A series on Greek art was held at Boston's Girls' High School and at Boston Normal School. Both school buildings were, and still are, decorated with plaster cast reproductions of Greek sculpture donated by Perkins himself. Perkins also offered lectures at the Lowell Institute on Greek Art during the academic year 1871–72, on Italian art during 1873–74, and on the history of engraving during 1877–78. Though it is hard to envision how, all his lectures were said to be illustrated with the aid of the stereopticon.

Perkins's campaign for mass art education got underway with a lecture in 1871 in Fitchburg, Massachusetts, which he titled "On Drawing as a Branch of General Education." His theme was that art learning shaped culture and provided possibilities for citizens of all classes; his passionate belief in this remained with him throughout the rest of his life.

Society in Boston was driven by two powerful forces. One was the hunger for something other than rare vintages of wine and select breeds of dogs that would enable people to display their affluence. The other was the need for assurance that neither international competition nor competition between the states might diminish the status and success of Massachusetts's industry. Charles Callahan Perkins realized that if he could link these two needs, he might be able to bring to fruition his dream for America. He adroitly used both arguments to further his cause.

Perkins persuaded each constituency in Massachusetts that it stood only to gain by systematic art instruction. A class of artistically trained workers would emerge whose products would yield ever greater profits for the state; at the same time, more tasteful ornamental American objects would be available to grace the homes of those who could afford them.

Perkins first made drawing into an asset for the life of the individual:

Drawing is a practically useful power, because it teaches men to observe and to express; . . . It may be regarded as an accomplishment, or as a means of a livelihood; either as a means of raising the standard of taste in a community, or of giving skill and knowledge . . . whether through fine or industrial arts.[19]

Perkins said of the person who knew how to draw: "'Thrice is he armed' who can use the pencil to illustrate as well as the tongue and the pen to describe, whatever of interest he has seen. . . ."[20] Then he deftly shifted his argument to reflect the value of drawing to society. He claims that, the value is not just to the individual: "A skilled artisan is a mechanic who knows how to draw, and who, thanks to such knowledge, has quadrupled the value of his labor to himself and to the state."[21]

Perkins's genius lay in combining these two distinct aspirations. When people became uncomfortable with the materialism of acquiring beautiful objects for themselves, Perkins could subtly shift tack and argue for the generosity and benevolence of uplifting the taste of the less fortunate. When his argument about skilled art laborers and American business profits made people feel too greedy and manipulative, he could redirect their attention to the pleasure workers might receive from their experience of art. Perkins's persuasion was a balancing act, and he was skillful at it.

Perkins knew Massachusetts, and especially his hometown Boston. He knew the power of hitching these two arguments together. Politically, in order to realize his vision for systematic art education, he had to build two different arguments for two different constituencies. But he also knew that the people who controlled the affairs of the different constituencies all knew one another and that there was much overlap. Every piece of preparation Perkins did reinforced every other piece. His efforts on behalf of the 1870s art world in Boston were a study in the economy of effort.

The Fire Foster and Henry watched all this, wondering what it had to do with them. Just as Emma was amazed by all the interest surrounding drawing in the public schools of Manchester, Foster and Henry had to be curious, if not puzzled, by all they saw happening with art in Boston.

Because their training went way back to their early experiences with Mr. Herrick, and because they were now working with Samuel Kilburn, whose ties went way back to Abel Bowen, they must have felt they were part of an ancient tradition. Yet, in the eyes of the Boston powers-that-be, Foster and Henry were representatives of the new. They and all the others who could draw and engrave so beau-

tifully could produce books that, when bound in leather and titled with gilt engraving, would grace the bookshelves of prominent Boston families. These same artworks could be mass-produced in innumerable cheap copies to yield publishers great profits. Many of Kilburn's books were, in fact, published in both luxury and cheap editions. Whether or not Foster and Henry realized it, they served as examples to Boston investors of what art education might produce. Systematic mass art education promised to create multitudes like them, doing fine work in a variety of materials.

All these plans paled on the night Boston was struck by a virtually uncontrollable fire. The great Boston fire broke out Saturday night, November 9, 1872, and burned until noon of the following day. Through a combination of adverse conditions, block after block of stores and offices fell with the sound of thunder and an unusually large number of valuable collections of art and literature were destroyed. Numerous collectors, in transition between their several homes, or abroad, or recently deceased, had rare art treasures in storage in warehouses believed to be most secure. When fire broke out in the downtown district, these warehouse buildings and their contents were pulverized in a fiery vapor. China, armor, swords, paintings, and great libraries were reduced to powder in a matter of moments.

For the first time, an American city grieved for the loss of its paintings, "deemed of incalculable value to America."[22] Immediately after the fire, an obituary was published by the New England Historic, Genealogical Society for the art that was lost. The obituary was actually a thin gray pamphlet itemizing the works that no longer existed. William Morris Hunt's studio on Summer Street, in the neighborhood where the fire originated and burned the hottest, was described in detail, as was the loss of Hunt's sketches, paintings, and travel souvenirs. With the fire, Bostonians realized they were hit twice. They lost the art that connoisseurs had collected from past centuries— Copleys, Van Dykes, Fragonards, and Claude Lorrains—and they lost the art of the new generation of American painters.

The passion for art was, if anything, intensified by the fire. Rather than fatalistically accepting this wreckage, Bostonians convinced themselves that they could have built more secure storehouses. Sci-

entific improvements promised the prevention of any such disasters in the future: "As we advance in life, we realize that at least half the misfortunes we experience here, are the results of our own carelessness or want of knowledge. We were conceited. We thought we knew how to build as well as they do in Europe—We built poorly." [23]

Though the art objects were now gone forever, the long list of losses inspired new artistic production. Just as Chicago's fire of 1871 inspired a great boom in architectural ingenuity, so in Boston the fire inspired artistic activity. The pamphlet consoled Bostonians: "Hunt fortunately can paint for us more of his powerful pictures if he pleases." [24] Though the art lost in the fire was quite different from the art envisioned as a result of Perkins's systematic art study, they became merged in the public mind. Records show that Kilburn's firm, not far from Summer Street, was spared the fire. Its business carried on, and Foster and Henry watched art—in all its variety—become the main topic of conversation in Boston.

CHAPTER 9

ARTISTIC IMPROVEMENT

enry Cross had come to Boston to learn more about art and to earn money by using what he already knew. At home, drawing had already become his tool for thought. With it, he could shift from the humor of the horse with a top hat to the sadness of the portrait of his mother to celebration of a popular hero such as a local baseball association president, George Sands, to meditation on a fragment of nature such as a tree stump at the edge of a brook. Any image he saw, he could replicate, or enlarge or diminish in scale with his pen. His technique was imitative of tinting, the line gradation of the engraver. Even his ornate signature and monogram were executed in the manner of a professional. From his associates in Boston he expected to learn even more.

For Henry, and Foster before him, the place of learning was Sam Kilburn's office, where both worked to measure up to Kilburn's high standards. Each piece they engraved received criticism, sometimes in writing. Experts reviewed proofs pulled at a stage of the engraving when changes could still be made and wrote their criticism on the print itself. Those attic boxes included proofs with pencil marks that extend from a particular point in the image out into the white in the margin, where a critic wrote exactly how that point could be im-

Places to Learn

143

A so-called scribble sheet by Henry Cross reflects the images on his mind. More typically adolescent than his landscapes, these drawings include "types," male characters, and regal women. A local baseball celebrity and another man seem drawn from life. Various possible monograms are considered for use in his future career as a wood engraver.

Woodblocks cut by Henry Cross showing three alternative designs for Henry's business card (engraved in block backwards).

H. C. Cross
Engraver on Wood
P.O. Address, Box 156
Manchester, NH
Credit: Weber Photography, Newton, Massachusetts

proved. Sometimes Henry was directed to sharpen a detail, to lighten an area, or to diminish its contrast with what was next to it.

Shop standards established the quality that young engravers aspired to reach. The opportunity to learn on the job was a privilege. In a field such as wood engraving, skills and technology were always being refined, so that the best training available was professional work. Sam Kilburn had learned this way from Abel Bowen. Many students dreamed of having access to such training, but few were sufficiently prepared to even set foot in the door.

Most of the young people who came to Boston to be artists had some art skill they could adapt to a trade. They eked out a living by hand-coloring photographs or making signs for store window displays. Through one job or another they learned about the business. The

little money they did earn was stashed away to buy art materials and perhaps pay a teacher for further art instruction. The dream of a "more complete art instruction,"[1] after all, had brought them to the big city.

Art classes became the ideal way for strangers in town to meet one another. (Though family lore suggests they came to Boston to study, no evidence survives that Henry or Foster took art classes. Much remains to show that Emma, however, did attend art classes when she came down to join them.) One place drew everyone: Boston's Lowell Institute provided free public lectures on the subject of art and free studio classes in drawing up until 1878, when its building at Winter and Bromfield streets was demolished. Its classes were a meeting place for, among others, Willard Metcalf, John Joseph Enneking, William E. Norton, J. Wells Champney, and Horace Burdick, all now recognized American artists. There, too, Dr. William Rimmer offered his artistic anatomy classes, which he taught by drawing life-size chalk outlines of muscles and limbs on a huge blackboard.

Not only did artists get jobs and take classes together, they also rented studios side by side. Entire buildings were known as artists' buildings, and artists toured one another's studios and kept track of what each was up to. Some kept a guest book beside the door, which they requested visitors to sign. Studio visits became a sociable way of learning more about art and proved unexpectedly useful. As people visited one another, they could assess with whom they might want to study. Informal banter on the possibilities of taking on students led many artists to do so. They became suppliers of that "more complete art education," right in their studios, where they both taught and did their own artwork. "Benjamin Champney had a studio at Bromfield Street where he gave lessons in landscape painting to hosts of pupils who were invading the world of art."[2] William H. Titcomb established his Academy of Art at Pinetree block, at the corner of Washington and Essex streets, where he collected a "wonderful library of illustrated books and portfolios of the best lithographs, from which his pupils were encouraged to make copies in lead pencil."[3]

The most famous of all the artists who taught in their studios was William Morris Hunt, a Vermonter by birth, about ten years older than Henry Herrick, who had married into that patrician Perkins family. Society men and women held him in such high esteem that

they vied to have him paint their portraits. Both the right family con-
nections and the proper European exposure in Düsseldorf and Paris
gave Hunt the qualifications to meet Boston's definition of an artist.
Rather than perpetuate the landscapes in the manner of the Hudson
River painters, Hunt inspired his students to work spontaneously and
to pursue figure and landscape painting more freely in emulation of
European art.

Devastated by the great fire, Hunt had no choice but to establish a
new studio; he moved to 154 Tremont Street and resumed his classes.
With his enthusiasm for French painting, these classes provided the
most European-influenced education in Boston. One of his ablest stu-
dents, Helen Knowlton, a strong painter in her own right, basically
carried on the classes though he continued to make daily visits.
A sense of these classes is captured in *Talks on Art*, in which Knowl-
ton recorded fragments of Hunt's advice that was so precious to his
students. Hunt's following included many affluent women, and as an
art proselytizer to the rich, he was able to influence Bostonian taste.
It is due to his enthusiasm for the French masters Courbet, Millet,
and Couture that the Boston Museum of Fine Arts, founded in 1870,
owns works by these French painters.

Interest in obtaining an art education was so great that the painter
Horace Burdick, too, decided to set up his place at 12 West Street for
classes:

In still life and fruit painting I soon became a success. . . . These works
attracted many feminine pupils to my studio, who on the strength of what
they had done with my help, set themselves up as teachers of still life and
attracted at low prices more pupils than I could with my limited acquaint-
ance in amateur circles.[4]

Though some doubted whether Americans could really become art-
ists, these classes proved, at least to Henry T. Tuckerman, himself an
artist, that Americans were teachable:

Our people do not lack insight, observation, perseverance; many of our
young artists have a vein of perception or feeling which they long to express;
and at the outset they do express it—crudely perhaps but sincerely. . . .
However little our people know about Art, they are teachable.[5]

When they were not at their jobs or taking classes, the poorer art-
ists spent evenings in the Christian Union or the public library or
somewhere else sheltering themselves from the cold and perhaps

drawing the others who huddled about in the warmth. Artists gathered
in different places according to their specialty. The painters went to
certain spots, the lithographers went to others, keeping themselves
distinct from the wood engravers. These gathering places served not
only to provide warmth and sometimes drink, but also to help artists
keep tabs on who had what job and who was new in town. In just such
a wood engravers' hangout, Frank French could have made the ac-
quaintance of Foster Cross and, ultimately, could have been offered
the opportunity to study with Henry Herrick.

For those who sought to learn more about art there was, in addition
to the art and engraving businesses, artists' studios, and various art
classes, the Boston Art Club, initially organized in 1855 as the
Nutshell Club. Its membership included many well-known Boston
artists. Samuel Lancaster Gerry became the club's president in 1858,
and in his *Reminiscences of the Boston Art Club* he characterized its
activities during the 1870s. The Boston Art Club acquired that name
only in 1871 because of the efforts of Horace H. Moses, George D.
Russell, and of course Charles Callahan Perkins. At that time, policy
was set that the president should be an art connoisseur, not an artist,
a decision that Gerry cites as the source of club's subsequent prob-
lems. Perkins himself became the president and served in that role
for many years, using the club as a forum for promoting his academy.
In the 1871 reorganization, the ranks of the Boston Art Club were
limited to eight hundred, and artists were by no means in the major-
ity. The membership fee was fifty dollars or the contribution of an
original sketch. Rather bitterly, Gerry wrote that artists could do
better things with their work, time, and money. Art patrons and less
than half of Boston's community of aspiring and established artists
joined to benefit from its periodic concerts, exhibitions, lectures on
art, and social contacts. The patronizing attitudes of the club mad-
dened some of its artist members, who grew impatient with the poli-
tics and social pressures. Chosen by the government of the club, ex-
hibition jurors became the butt of Gerry's pages of ridicule and rage.
Their predictable judgments forced Gerry to conclude, "Jurymen are
very unsafe guides."[6]

The history of the Boston Art Club enables us to observe a growing
tension about artists and money. The Art Club seemed to require that

artists be independently wealthy or deny any interest in monetary gain. Gerry observed that artists without private means were presumably expected to take vows of poverty. So poorer artists, lured to Boston by the hope of a more complete art education and the opportunity for work, found themselves ridiculed: "It is true some artists are not accused of *making* money but what is more reprehensible, *trying* to do so."[7] Theirs was an impossible position. The artists' pride in the growing interest in art was undone by public contempt for their efforts when they aspired to make a living. The more the public became devoted to an artist's work, the more vulnerable he became.

The only reprieve for artists who needed money was teaching, and even that work was barely acceptable. Gerry observed:

In this country money is freely spent on education. Hence there is some reliance for support to artists who are "apt to teach," and can be persuaded to leave picture-making for the time they are thus employed. . . . There is [also] in this country a foolish prejudice against teaching art. The supposition being that one who can subsist without it will not employ himself thus. In Europe, some of the most eminent artists give much of their valuable time to students . . . the compensation being chiefly derived from the honor of their following. Nor is the gain wholly to the pupil. Hunt said he gained hints and ideas frequently from his pupils. And then the mental exercise of analyzing in order to impart methods is of service.[8]

Henry Cross joined the Boston Art Club and, no doubt, was subjected to these same pressures. Said to have enjoyed a good drink and social companionship, Henry learned to deny the constraints in this environment. Like other clubs, this one introduced him to people who might require his professional services. But, to generalize from Gerry's reminiscences, that Henry worked at all lowered his social standing. Non-artist members disdained artists' efforts to make a living. Making a living was simply deemed demeaning.

No matter how quixotic and elitist the Boston Art Club may have been, its members thought about, looked at, and talked about art. There, when Gerry troubled himself with important questions, he was not alone. He intrigued other Art Club colleagues when he compared artists to scientists:

Matter of fact people, they analyze, dissect their subjects, stand on their heads or look under their arms at nature. . . . Like surgeons, they look beneath the surface and study the laws of effect. They seek to know what muscles of the face are essential to produce a smile—or a frown.[9]

The club was a forum. Others could debate Gerry's speculations about how it happened that so many devotees of painting left art for science: His list (of questionable accuracy) included Robert Fulton, who invented the steamboat; Samuel F. B. Morse, the telegraph; John Rand, the screw-top paint tube; Rembrandt Peale, the gaslight; Alvan Clark, the telescope; and Daguerre, the daguerrotype.

From these few instances, it is evident that there is something in the study of art which leads to discoveries in science. The efforts to fathom the depths of chiaroscuro and color seem to lead to general exploration into the laboratories of chemists and the intricacies of the wheels of the mechanism, besides searching the forces of the upper and lower depths of the sky and the sea.[10]

If the Boston Art Club got even a handful of its members to reflect on the artist's position and the artist's education, the club more than served its purpose. Gerry's musings are central to a whole generation of artists in the 1870s. These artists had learned to look, learned to handle materials, and though they loved art, they also investigated it scientifically. The elite of the Art Club may have wanted to separate art from work, but at the time of Gerry's writing, Boston was still full of these aspiring artist–worker–farm-kids who themselves had not yet chosen sides and, in fact, had no choice. The Art Club must have been a consciousness-raising experience that confronted artists with real-life dilemmas of society and art.

While Henry and Foster went about their business in Boston, they could, if they went over to Dartmouth Street at St. James, watch the Museum of Fine Arts being built on ninety-one thousand square feet that the city of Boston granted to the trustees of the museum corporation. This project was the linchpin of Charles Callahan Perkins's academy, the storehouse of art. Of course, Perkins was appointed the museum's honorary director. The building, formed of brick in an Italian Gothic style, had a facade ornamented with ornate terra cotta work, including two allegorical compositions, *The Genius of Art* and *Art and Industry*. The main entrance was to have polished marble steps with polished granite columns topped with terra cotta capitals.

Boston did not quite know what to make of this grand effort. Its periodical, *Every Saturday*, celebrated the creation of the museum, but questioned the public's ability to make use of it: "It is hopeless to dream that this education of the Public Eye is possible except by es-

tablishing a sort of 'kindergarten school' of fine arts."[11] *Every Saturday* worried that workmen not knowing how to use such a place ought to see copies and casts of art before ever setting their eyes on the real thing:

Workmen must have some place where copies of the masterpieces of architecture, sculpture and painting are freely displayed, some place as open to them as the Boston Common, before they can catch the inspiration of Art. The object of the Museum of Fine Arts is to furnish them with a magnificent school where they will be insensibly trained.[12]

A curious transformation had taken place in the twenty years since Henry Cross was born. Much as the creators of the 1853 New York Exhibition of Industry of All Nations, had dreamed, the art spirit burgeoned in every direction. But the reasons for it could not have been anticipated in the 1850s. Masses of Americans wanted art as a token of social prestige. The sale of paintings by the old masters, the reproduction of fine art paintings by chromolithography, the proliferation of artists' receptions—all were symptoms of the economic changes that were taking place. Art had become a commodity appreciated as a sign of luxury, and perhaps even of education and culture:

Pictorial exhibits attract all classes, our journals abound with glowing tributes to native genius, which springs up unexpectedly from remote quarters. Fashion annually extends her capricious hand in our large cities to some fortunate limner to whom "every sits;" hundreds of painters among us can execute a likeness which no one ever mistakes; to sketch a little from nature, to own a tolerable landscape or engraving, to read Ruskin and Mrs. Jameson, and buy "old Masters" at auction for a song, are among the most common of our social phenomena.[13]

The artistic element was seen as the way for the rich man to extend his pleasures. In 1871, *Every Saturday* criticized Americans:

The immense energy of the American People has been disproportionately directed to the industrial, as distinguished from artistic, creation. What is their reward for their labors? Simply this, to live in ugly expensive houses, decorated with ugly expensive furniture and to find no compensation for their work but in wine, dogs, and horses. The artistic element comes in at this point in the rich man's experience to extend his pleasures.[14]

Despite the apparent prestige of art and the multitude of art classes, few artists felt wanted in Boston where an art career seemed to be "a cold and coy mistress" to its artists. To Henry and Foster the situation

of the artist in the center of Boston may have felt sometimes to be a small improvement on that of the artist isolated in New Hampshire. In 1873, the Boston Art Club hosted a memorial tribute for wood engraver John Andrews, described by S. R. Koehler "almost as a martyr. . . . How few men are there to be found, especially in this land of unbounded possibilities, who will remain so firmly true to their first love even when the love proves to be a cold and coy mistress."[15] Of Andrews's art education, Koehler says, "We who live in more favored days, although still no doubt deprived of many of the advantages which old Europe offers to the student of art, are apt to forget that those who went before us had to labor under yet greater difficulties."[16] Henry Cross, then a prospective Boston Art Club member, must have shuddered at Koehler's words: "Of all the artistic careers, that of the line engraver of modern times is perhaps the most thankless."[17]

In these more favored days, wood engravers still were thankless workers who rarely shared in the glamour, the sumptuous dinners, and the inflated art prices. What kept Henry and Foster and other wood engravers going was the pleasure in seeing the beautiful proof pulled from a carefully cut wood block, whose subtle distinctions attained such widespread currency. They were tradespeople of the working class who were motivated by dreams of promises heard in their childhood. The art crusaders at midcentury had convinced Americans that art would and could accomplish everything. Art would teach discipline. Art would train the hand and the eye. Art would increase profits of American industrial production by the production of beautiful, useful objects. Art, it was said, could elevate the base tastes of the growing working class, and it would promote a democratization of culture, in which all would share "good taste."

They also knew that the art, good as it was for them as individuals, also promised to be advantageous for their nation. Art would help America be self-sufficient. Art would also teach Americans to admire their own natural scenery, to revere the land they had at least as much as that of distant shores. The young artists who gathered in Boston in the 1870s had heard up to twenty years of rhetoric about the good art would do for America, materially, spiritually, and even in promoting literacy, and they believed it.

A page from *Progressive Drawing Book of Flowers for Beginners, Drawn and Coloured After Nature*, by John Andrews (London: Charles Tilt, circa 1840)
Lithographed outline drawings are printed twice. The first image enables the student to correctly define outlines. The second permits the student to practice the application of watercolor tints.

Color samples from *A Course of Water-Colour Painting, with Twenty-four Coloured Plates*, by R. P. Leitch (London: Cassell & Company, Limited, circa 1880)
Advances in color lithography made it possible to instruct the student in applying watercolor washes with one tint blending into another.

"Analysis of Styles of Historical Ornament," Subject 23 of Class A Elementary Drawing, by Frank G. Parker, Student at Massachusetts Normal Art School, Boston, 1875
Massachusetts proudly displayed a bound volume of student artwork at the Centennial Exposition in Philadelphia. Pages of perspective drawing, renderings of furniture and industrial equipment, patterns for ceramic tile, oilcloth, and textiles were bound together along with this page of "Analysis of Styles." Every skill taught at the school was represented.

The cover of *Art Education Applied to Industry*, by George Ward Nichols (New York: Harper & Brothers, 1877)
In the same year that Homer painted *Blackboard*, Nichols contributed this volume to the debate on how and why art should be taught. European systems are contrasted with then current practices in the United States. Nichols defends Walter Smith as the advocate of an art that is "not the especial property of one class, but that . . . may be possessed and enjoyed by all."

Waits Mt., Malden, by Henry Clay Cross, June 1882, 5″ × 7″

By the time Henry painted this he had exhibited at the Boston Art Club and had a public reputation as a watercolor painter. Every gesture, blotting, stippling, dragging, and scumbling is used to explore this site in the town where Henry was then living.

Old Man of the Mountain, by Henry Clay Cross, July 23, 1884, 5⅜″ × 9″

When Henry returned to the state of his birth, he saw landmarks with the eyes of an urban visitor. He exploited the effects of dropping globules of watercolor and allowing shapes to result from the ways in which they dried. This free, experimental technique offered a sharp contrast to the rigors of his wood-engraving business.

Baboosic, Not a Florida Swamp, by Henry Clay Cross, July 4, 1885, 10″ × 14″
In summer the Baboosic, the brook behind Henry's parents' home, was a sensuous explosion of
sound, color, and reflected light. Its lush, thick, almost tropical greenery prompted Henry's choice
of subtitle. The dark color is placed on thickly with a brush or palette knife and is then rapidly
scratched with a knife blade to create the forms desired, just as Herrick had recommended in his
recently published *Water Color Painting*.

Henry Clay Cross, by Henry Walker Herrick, 1889

By the time Henry posed for this watercolor portrait by his mentor, both men enjoyed considerable recognition. Herrick's deft stippling technique—almost pointillistic—fills the space that surrounds his subject. Herrick wrote, "Not only are these mixtures compounded by pigments, but they are made on the retina by reflection, by persistent impression" (*Water Color Painting*, p. 14).

Easter, by Emma Cross, undated (circa 1880s)

Despite the apparently equal opportunity that all three children had to learn from Herrick, unequal employment opportunities inevitably influenced the art that Emma would produce. Surviving adult artwork includes her portraits of relatives, her studies of flowers, and her experimentation with Prang's invention—holiday greeting cards.

Provincetown, by Henry Clay Cross, 1896, 12″ × 20″
This view of subtle, desolate changes psychologically matches Henry Cross's experience. His control
of form and his restraint in using ebullient color are matters of choice. At age 44, with none of the
supports upon which he had built his life, he looked out across unmarked dunes toward the outer
limits of his country.

Opposite page

Top:
The Cover of *Fun and Frolic Painting Book* (Boston: De Wolfe,
Fiske & Co., no date)
The young artist, palette and brush in hand, is encircled by her
multicolored male admirers, those only recently invented screw top
compressible paint tubes.

Bottom:
The Cover of *Art Studies for Little People, Landscapes* (New
York: McLaughlin Bros., 1901)
Eventually the popular aesthetic was published as propaganda to
generate good taste and good behavior in children. The inside of the
cover was printed with a palette with dye deposits arranged as
globules of paint. A wet paintbrush daubed on the colored shape lifted
enough pigment so that the child could use it for paint. Each image
within the booklet was printed twice: once in tonal black to white, and
again with the tonal image overprinted with layers of color in
chromolithography.

Fast Neptunite Dyed Umbrellas were advertised by trade cards chromolithographed by Charles Sheilds' Sons, 20 & 22 Gold Street, New York. Both figures depicted here anticipate the sexualizing of advertising that has become rampant in the twentieth century.

To advertise its strictly pure white lead paint, Armstrong & McKelvy of Pittsburgh, Pennsylvania, commissioned this card from the National Bureau of Engraving in Philadelphia. Chromolithography was ideally suited to capture the tones and colors of the artist's wild hair.

If Perkins needed confirmation of his vision of the academy, the artists who came to Boston seeking art classes and wanting to see art objects gave it to him. They bolstered Perkins's sense of the correctness of his plan. But partly because of his efforts, the art institutions that developed in this time were marked by a split. They either concerned fine art and served the wealthy, or they were devoted to industrial art, or art labor, and were designed for the working class. Perkins knew exactly how to push each of the buttons to promote each of the two different sorts of institutions, and the rest of his life proves how skillfully he did so.

Already president of the Boston Art Club and honorary director of the Museum of Fine Arts, both for Boston's elite, Perkins now set about developing institutions for the working class. To produce a class of skilled art laborers, he had to work with the Boston School Committee, which allocated budgets and approved curricula for the children of the working class. Perkins let Dr. John D. Philbrick, superintendent of schools, and the school committee know that he would be available to them during their deliberations on how drawing should be taught. Their concern with this subject derived from Massachusetts's new law that drawing had to be taught not only in the schools, but in evening classes offered for adult workers by the local government of each of the larger cities and towns.

As early as 1860, the state of Massachusetts included drawing as a subject permissible to teach in the public schools if "the school committee deem it expedient."[18] In 1869, the Massachusetts General Statutes, chapter 80, directed the board of education to prepare a plan for free instruction "to men, women and children in mechanical drawing, either in existing schools of in those to be established for that purpose, in all towns, and cities in the Commonwealth having more than 5,000 inhabitants."[19] In 1870, the plan became law. Chapter 248 of the Massachusetts General Statutes of 1870 announced:

An act relating to free instruction in drawing. *Section 1.* The first section of Chapter 38 of the General Statutes is to be hereby amended so as to include drawing among the branches of learning which are by said section required to be taught in the public schools. *Section 2.* Any city or town may, and every city or town having more than 10,000 inhabitants shall, annually make provision for giving free instruction in industrial or mechanical drawing to

persons over fifteen years of age, either in day or evening schools, under the direction of the school committee.[20]

Massachusetts argued that workers had a right to demand drawing instruction:

As the education of the common schools fits the youth for the performance of his general duties as a citizen, so the technical school prepares him for the special duties of his trade or profession. Divinity, law, and medical schools, . . . have long been in successful operation. . . . If our citizens engaged in mechanical pursuits and they comprised the body of the people, had realized that the state could have provided schools as useful and necessary for the education of mechanics as the divinity and law schools are for the training of ministers and lawyers, they would have demanded and obtained them before this.[21]

Much as today's students believe they cannot survive without training in computers, so workers then believed they had to know how to draw. They believed the board of education when it said:

Drawing is the language of mechanics and ability to use the pencil freely lies at the foundation of success in many mechanical pursuits. . . . Without such education the American artisan must gradually descend in the scale of industry and content himself with a menial station in life.[22]

With this persuasion, it is not surprising that evening drawing schools were well received throughout the state. Responses exceeded all expectations, and many students had to be turned away. The numbers in attendance ranged from 120 to 400, with especially large classes in Springfield, Worcester, Boston, Cambridge, New Bedford, and Fall River. A shortage of drawing teachers was apparent everywhere, and many who were available were not yet equal to the task.

The Massachusetts Drawing Act put pressure on the cities and towns for which they were hardly prepared. To respond to the new law, Boston established its Committee on Drawing. The committee was empowered to employ a suitable teacher who could train teachers for the popular evening drawing classes. Charles Callahan Perkins, now consultant to that committee, urged it to contact Sir Henry Cole, director of London's South Kensington School, whose model for British industrial art education had proven highly successful. The committee wrote Cole. He in turn proposed the name of Walter Smith as a gentleman who could graft the British art-labor system onto the American educational system. Smith, a graduate of South Kensington,

was currently directing the Leeds Art School. If he were to come to America, he would have to be persuaded to cut his ties to England.

In order to set up a successful experiment, the city of Boston had to coordinate its plans with the state. The job ultimately designed was a dual one. Smith was to be director of drawing for the city, responsible for providing art instruction and supervision to classroom teachers, as well as state director of art education, disseminating the knowledge of art to teachers across the state. The Honorable Joseph White, who inherited Horace Mann's position as secretary of the state board of education, realized limitations on the state to impose any curriculum, because of each individual town's autonomy. If the state were contractually committed with a city, Boston, for instance, choosing one person to promote one single curriculum, White hoped, would inspire the rest of the state to follow. White saw it was to his advantage if the statewide director of art education was one and the same person as the director of drawing for Boston. He said, "If the legislature grant the means and the right man be secured to send a thoroughly instructed agent into every section of the Commonwealth, whose special business it will be to explain the subject . . . more fully than can be done in a written treatise."[23]

Having conceived the dual job, the city's Committee on Drawing announced its search for a qualified art teacher and promptly invited Walter Smith to Boston for an interview. At the time that Smith was approved by the city, the state legislature granted the means and coincidentally hired him as statewide director of art education, dividing his duties equitably between the two employers. What he may not yet have known is that he had yet a third mission: to create that academy of Perkins's dreams. Though Perkins knew Smith only from his interview, this decision joined the two men in intimate collaboration for years to come. Smith's appointment coincided exactly with Perkins's election to the first of his thirteen years on the Boston School Committee.

Walter Smith, approved and appointed by both the state and the city, returned to England to pack his possessions and prepare his family for the move. Now thirty-five years old, Smith had already had an intense and exciting young life. He was born in January 1836, in Kemerton, a small Gloucestershire town. He showed superior intelli-

gence in Greek, music, and religion—interests that endured through-out his life. Thanks to the influence of his instructor in these sub-jects, Rector Blunt, Walter was sent off at age thirteen to a London boarding school where he studied visual art for the first time. The Crystal Palace exhibition took place during his days in London, and he visited there frequently. The objects he saw affected him deeply, and he recorded his responses to them in his diary. Years later, he wrote of the personal mortification he felt confronting the lack of taste and design in England's exhibitions: "British designers had let our products down, and the Nation was shocked and chagrined to find itself in the rear of all civilized nations in the matter of taste, the United States alone beneath."[24]

His diary contained his most intense feelings. In his public expres-sion emotion was more tempered and intellectualized. Writing art criticism for *The London Builder* became his safety valve. He and his friend, referred to only as Whittaker, had rabid arguments about taste. After each of those, Smith ended the day noting in his diary, "wrote to *The Builder*." When that benevolent Rector Blunt, who ad-vised Smith on boarding school in London, came down to visit him, together they visited the Crystal Palace and admired the French en-gravings and beautiful gardens, but at home Smith noted in his diary, "All was glare, no competition, all anyhow. Wrote to *The Builder*."[25]

In his adolescence, Smith was confronted with the issue of the day—industrial production and its impact on the international econ-omy. When Queen Victoria and Prince Albert opened Somerset House for the use of students of science and art, Smith was one of the first students to enter, his efforts in sculpture won him a medal in 1852. At just this time, Smith reported seeing the first wagonload of art carried in to Marlborough House, then the headquarters of the British gov-ernment's Department of Science and Art and home of the first ex-hibitions of the future South Kensington Museum, now the Victoria and Albert Museum. Smith observed years later: "That wagonload of goods has had more influence upon the destinies of the United King-dom than the existence of her fleet."[26]

Walter Smith was an admirer of the French manner, and was drawn also to Isobel Caroline de la Cour, daughter of a French miniature painter, Benjamin de la Cour, who had left Paris to live in London.

Theirs was a family of artists whose interests and surroundings must have been a pleasure for Walter. At age twenty-four, the strong-willed, aesthetically preoccupied young Walter Smith made two commitments: to Leeds Art School, of which he became principal, and to Isobel. Even then, he had a penchant for accepting multiple jobs. When other schools wrote him at Leeds asking him to serve as their director, rather than refuse, he accepted and simply added the new responsibilities to his others. Over a period of twelve years he became responsible in addition to the school at Leeds for the art schools at Bradford, Wakefield, Halifax, and Keighley. The invitation from Massachusetts was attractive enough to Smith for him to release his hold on all of those institutions and leave them in the hands of others. By the time he prepared to leave, he and his wife had six children, who willingly went along.

Smith's first assignment was not in the United States, but on the Continent. He had to travel about Europe selecting plaster casts and flat work for a traveling teaching museum, probably inspired by Perkins's earlier contribution of casts to the Boston schools. The state of Massachusetts had budgeted $500 for the collection. Smith decided to spend the first $150 on the purchase of examples of flat work, forty drawings and paintings by students of the South Kensington School that could serve as examples of the success of the British system of art instruction and provide models for Americans to emulate. The other $350 Smith spent on copies of paintings and plaster casts purchased in France and Belgium. Smith later wrote that he acquired each piece because he envisioned how it would arouse interest in art in Massachusetts's cities and towns. Such a collection of copies was what *Every Saturday* had suggested ought to introduce the working class to art before they ever saw the real thing.

When Smith arrived in the United States, he settled his wife and six children in South Boston in their shore-front City Point home and then became acquainted with the figures important to his complex mission. He set up a schedule for a traveling museum and planned the series of lectures he would present as he accompanied it. Those towns that agreed to pay the meager rental for the traveling museum were put on his itinerary. In his first journey, however, one-third of the objects were either damaged or destroyed, and it became obvious

that the museum required a curator to arrange the transport of that portion of the collection that was still intact.

In 1872, Charles Callahan Perkins, who was largely responsible for Smith's being in Boston, arranged for the remains of the traveling museum to be shown at the Boston Art Club. He especially wanted Bostonians to be able to compare the art instruction of different nations, evaluating the merits of the French, Belgian, and British systems. Members of the Boston Art Club had never seen anything like it. The artists, particularly those who had struggled in relative isolation in their rural villages or towns, were amazed to see that governments supported whole systems of art instruction. A lecture by Walter Smith at the Art Club was one more step in Perkins's building support for that academy of his dreams. Smith alerted the audience to the serious commitment such work required:

"Art is not a branch of education capable of rapid growth . . . for as you know, 'art is long.' We have the satisfaction of knowing that, in beginning with public schools, we are beginning with the right end and we have the prospect of possessing before very long a central institute of art in the Boston Museum of Art, which will be like headquarters for the fine art of the state. The education for teachers will be provided by the Normal Art School.[27]

Through Smith, Perkins's vision was introduced to a constituency of art patrons and artists who could spread the gospel of art across Boston, across the state, and ultimately throughout the nation. Smith told his Boston Art Club audience about a type of art education that the patrician membership would never have personally encountered. Smith was concerned with industrial art education and the making of a class of art laborers, not with the education of the independently wealthy who disdained the need for gainful employment. His bias was perhaps most clearly stated years later when he addressed the Pennsylvania legislature on the subject of his work in Massachusetts:

If it were a question of mere sentiment, or of sensuous enjoyment, I should think it [art education] hardly worth the attention. . . . If it were to be something like the drawing that used to be taught in our schools, a mere innocent and useless amusement, I for one would have nothing to do with it.[28]

Imported to Boston to enlighten the citizens upon the subject of "skilled labor or Art labor," Walter Smith voiced a particular political position:

In proportion as we are unable to introduce into our education in other sub-
jects demands, to that extent we are dependent upon other countries for
what our taste requires. And thus we lose the profit of skilled labor at home
and throw away the power we might have over the other nations of the world,
by our own self-sustaining productiveness.[29]

It remained only for publishers to join the ranks in providing their *The Publishing*
own contribution to art instruction. Walter Smith found it time- *Route*
consuming and fatiguing work to travel throughout Massachusetts as
state director of art education to meet with teachers and supervise
their lessons. Predictably, the difficulties of travel provoked Smith to
dream of more efficient and less exhausting ways of spreading the
word. The publishing route looked promising. Though Smith's initial
contact with the state provided for an agent who would personally "in-
struct more fully than can be done in a written treatise," writing be-
came more and more attractive to him. Through publishing, art could
really travel.

The first book that Smith wrote in America, *Art Education*, ap-
peared in 1872, published by the Boston firm of James R. Osgood and
Company. This hefty tome, almost four hundred pages long, pre-
sented the grand plan for the National School of Art, the "Harvard of
the schools of art." Smith described the megainstitution that would
result from the coordinated planning of the art museum, library,
horticultural gardens, and medical college all in proximity to benefit
the students of the art school. He concentrated on the physical con-
struction of the school. By analyzing art schools of England and
providing detailed plans of their construction, in the hope of enabling
Americans to build the best art school in the world. Smith published
three sets of plans; one from a British architect, W. H. Crossland; an-
other from the Boston firm of Sturgis and Brigham, which had been
contracted to design the new Museum of Fine Arts for Boston; and a
third his own building plan, accompanied by drawings of the ideal
furniture and even the arrangement of walls and lighting designed
specifically for drawing from plaster casts. So vivid was this school in
Smith's mind that he could draw even in its minutest detail.

Smith praised Osgood, his publisher, for the quality of the printed
drawings, saying that they had excellent line clarity, as good as the
best in England. The fine printing was demonstrated not only through

the architectural drawings, but through illustrations of antique and modern furniture and glass, which projected the kind of art manufacture that graduates of the new art school might produce.

But Smith's book also included color plates, printed not by Osgood, but by L. Prang and Company. One color page showed a chart labeled "Definitive and Fundamental Scale of Colors," in a tour de force demonstrating the radiance of pure chromolithographed color. Prang color plates of ceramic hall pavements and wood parquetry in Eastlake's *Hints for Household Taste*, edited by Charles Perkins and published by Osgood, were so admired by Smith that he simply adopted these same pages for his own book. Smith saw it as advantageous to embellish his already impressive work with Prang's color. A pattern was established: Prang enhanced Smith while Smith provided a showcase for Prang.

Smith had always felt that excellent visual examples were vital to excellent art instruction. When the traveling museum, which suffered abuse in traveling, packing, and unpacking, was in need of refurbishing, Smith did not request another art-buying junket to Europe; it was good politics, he decided, to buy casts and art reproductions made in the United States. His job as state director of art education required him to find good examples with which he, and the many art teachers throughout the state, might teach. Smith felt,

"The opening up of our [American] resources in the creation of examples for art study . . . seems to me an integral part of the creation of a system of art education. I have thought it especially my duty to cooperate with competent manufacturers in this country for supplying what we want at our own doors, and to take the opportunity of a fresh start to improve as much as possible upon the character of similar examples already provided in Europe."[30]

What could have been more perfect for Smith than to hook up with Louis Prang, whose skilled workers were European lithographers producing works of a quality that he might have bought in Europe.

Smith had power at this point. Whoever received the contracts for providing art reproduction to the schools would reap substantial profits. Endorsement of a printer became part of his mission. With Prang, who could publish both radiant art reproductions and lithographed art instructional books, Smith saw that he could kill at least two birds with one stone. Prang could produce images for the traveling museum

and textbooks of Smith's own art gospel. Prang would relieve Smith of much of his fatiguing travel. Committed to purchasing from an American company, Smith could just as readily endorse Prang as Osgood, and so he did.

Prang himself was really a newcomer to Boston, part of the tide of skilled European artisans who flooded Boston just as the many home-grown maverick American artists arrived in the big city. In a short time, Prang had come to understand his new home. He adopted for himself the problem that preoccupied Bostonians. In the words of one of his chromo salesmen in 1868,

"It has often been asked, 'How shall a democracy be educated in art?' We answer, 'By art.' It is idle to teach without example, and yet the art galleries in our country are few and far between. We have neither the treasures of the past nor a class of painters nor the means of supporting well-endowed academies of design. Without these agencies, we believe that . . . the only substitute for them, the only educator of the people is the Chromo."[31]

Louis Prang put the American dream in the words of his salesman. The democratization of art through art galleries, academies, practicing artists, in fact, all were happening right in front of him, but he emphasized *his* contribution in order to promote sales of his products. Prang's genius was his recognition of how prints satisfied American needs. He understood how insecure Americans were about their taste. By mass marketing identical images that could hang in everyone's front parlor, he could get people to risk a little to bring art into their homes, and yet not risk very much, because everyone could have the same image. Through him, pictures became a tool of social exchange by which Americans revealed a bit of their aesthetic ambition. The chromo in the home and a Christmas card (also his invention) that one sent served the same purpose.

Prang first appeared in the Boston city directory in 1852, the year of Henry Cross's birth, listing himself as a wood engraver. He admitted later "he had no knowledge of the art and a capital of twenty-five dollars."[32] His only experience had been with a magazine, *Gleason's Pictorial*, under the supervision of Frank Leslie. A handmade scrapbook of brown paper with his wood engravings glued into it served as his first portfolio. Even up to 1856, he had no lithographic works to add to it. In 1857, Prang joined Julius Mayer, and together they

formed the firm of Prang and Mayer Lithographic and Copper Plate Press Manufacturers. The partners proved incompatible and dissolved their partnership, but not before Prang had assembled a large scrapbook of the prints of their work together. That scrapbook included lithographic labels for bottles and boxes, with depictions of sodas, spices, inks, and oils that were popular in that day.

By 1860 Prang bought out Mayer's share of the business and forged ahead on his own. On one page of the Prang and Mayer scrapbook were six large labels decorated with fruits and flowers for Preston and Merrill cooking extracts. Next to these Prang wrote: "'This job really laid the foundation for my business.'"[33] Prang's new company was first located at 34 Merchants Row, but his timing was bad. Business was poor, and the first rumblings of the Civil War could be heard. To stay afloat, Prang, with his uncanny sense for making the best of any moment, began publishing what he called War Telegram Marking Maps. These twenty-five-by-thirty-eight-inch maps were intended to aid the families of both Union and Confederate forces and were sold with red and blue pencils so that the position of both sides could be marked. Prang created an opportunity for employment for those Boston artists seeking work, and from then on he never was at a loss for a device for making himself and his artists the center of attention.

The war maps were just a start. Prang knew people loved album making and realized that if people loved to assemble pictures they cut out for themselves, how much more they might be pleased by pictures, printed in sets, ready made for insertion into albums. Album cards were his next labor-saving product that caught the imagination. He published twelve sets of cards, each two by three inches, about the size of the popular carte de visite photographs. The title themes for the card sets included "Paradise of Childhood," "Vessels and Marine Views," "White Mountain Scenery," "Street Scenes of New York," "Butterflies of America," "American Sea Mosses," "Roses," and "Autumn Leaves," of which the last two proved most popular. While the families at home were marking the movements of the troops on their War Telegram Marking Maps, they could also assemble Prang cards in their albums.

When the war was over, the Prang company was ready to add new products to its line. In 1865, Prang began reproducing paintings by

popular artists to be hung in every American home. He advertised
these prints as chromos, oil color reproductions of oil paintings. The
first chromos were landscapes after Alfred Thompson Bricher, a
group of chickens after Arthur Fitzwilliam Tait, and *The Barefoot
Boy*, after Eastman Johnson. Chromos matched the American craving
for signs of status and culture and were deemed educational. Prang's
success was celebrated in verse on the twenty-fifth anniversary of his
establishment (which he preferred to refer to as his quarter centennial):

> When painting and the arts were young
> Pictures in palaces were hung
> And never to a humbler wall
> Came any painting large or small.
>
> But in these new inventive days
> Painting has now found a larger phase
> And now in every dwelling hang
> The reproductions made by Prang.[34]

Once Prang's art reproductions were successful, he expanded and
diversified his products even further. At the Vienna International Ex-
hibition in 1873, Prang introduced the floral chromo business card.
With large orders he offered to print the name of the customer's firm
in the blank space in the center. Upon seeing these cards, the wife of
Prang's London agent suggested that a Christmas or New Year greet-
ing could also be printed in the blank space. Prang tested out such
cards in London in 1874. They were in such demand, he could not
print them fast enough. After exporting and testing his cards in En-
gland, Prang began marketing the artistic Christmas card in the
United States in 1875.

Ever attentive to expanding his market, Louis Prang recognized an
opportunity when Osgood's firm published Walter Smith's *American
Textbook of Art Education* in 1873. Its cover boasted of Smith's mul-
tiple roles and explained that this single book was only the first of a
series presenting his systematic course of instruction in drawing. The
books promised to sell well and make up for the lack of practical text-
books to create a generation of art laborers. Smith's series started
with *Free Hand Object Drawing*, *Model and Object Drawing*, *Plane
Geometrical Object Drawing*, *Perspective Drawing*, and *Mechanical
Projection*.

Cover design for *American Text Books of Art Education*, by Walter Smith, copyright 1875 by L. Prang & Co., Boston. Only one of Smith's three jobs is listed on the cover. In 1875, his title as State Director of Art Education would have attracted interest in other states.

The textbook publications were horizontal in a uniform 11½-by-8-inch format. Each page was divided into sections, with instructions for drawing printed along the top. Below was an outline drawing with dotted directional lines within to aid the student in copying the image in the empty space that remained. Simplified line drawings of a terra cotta vase, a horse chestnut leaf, a silver spoon, and Moorish ornaments were examples provided for students to copy. Smith's approach was far removed from those amateur drawing books so popular up to the Civil War that depicted familiar rural scenes and farm and household objects. Smith was convinced that Americans needed foreign examples in order to learn both industrial drawing and good taste.

Beginning in 1875, Walter Smith's American Textbooks for Art Education no longer came from Osgood's, but were published under the imprint of Prang and Company. They came out in every conceivable variety: little ones, large ones, elementary, intermediate, advanced, object drawing, and model drawing. Eager customers waited to acquire each newly revised edition. Prang and Smith wisely retained the look that was originally developed by Osgood, successfully distinct from earlier school textbooks and the amateur drawing books created for home enjoyment. These books were only the start. Prang and Company published not only the drawing books, but innumerable teaching guides, as well as diminutive drawing cards, which were black with white writing in imitation of the effect of white chalk on the blackboard, so distinguishing Prang's school products from those intended for the home.

The Walter Smith-Louis Prang collaboration was ideal and mutually beneficial: Smith had found a way for his name and ideas to travel and be seen, and Prang augmented his already formidable customer list. Smith with Prang moved the Boston printing business to center stage in art education. They together became identified with Perkins's plan for his academy. Just as Prang kept his business afloat through gauging the best opportunity in the Civil War, he judged correctly again in adopting the dream of making Americans artistic. Walter Smith was delighted because he could spend more time at home, or at least in Boston.

Years later, in the 1890s, Kilburn & Cross published an advertising card suggesting, quite mistakenly, that all these color ventures

First Series *American Drawing-Cards*, by Walter Smith. Both Osgood and
Prang are named on the label. Entered in the Library of Congress in 1873.
Note the images are white on black suggesting chalk on a blackboard.

were experiments that would not endure. Admitting that "to catch the
eye and fix the attention nowadays requires something more than the
plain one color or black printing," the firm recommended everything
but chromos.[35] Perhaps that was wishful thinking. No one could ig-
nore what Prang was up to. Henry and Foster Cross, themselves at the
heart of the publishing world, must have watched Prang's enterprise
with interest, as everyone did. Prang had left his original quarters on
Merchants Row for a larger space at 159 Washington Street, close to
Kilburn's at 96 Washington. This new site proved again too confining
for Prang's burgeoning business. Seeking ever larger quarters, Prang
ultimately left the print district entirely and went off to a quieter area
at 286 Roxbury Street.

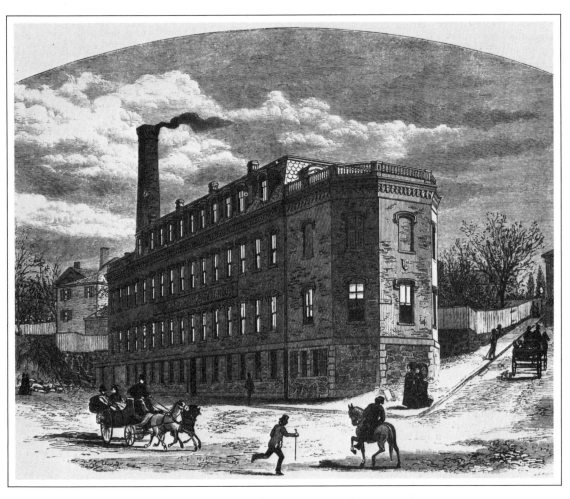

In 1867 the Prang Company moved to this building at 286 Roxbury Street in the Roxbury section of Boston.

Source: *Illustrated Christian Weekly* (New York: American Tract Society, copyright 1874, n.d. recorded).

Prang workers are cleaning and preparing the faces of the
lithographic stones before a single mark is made.

Source: *Illustrated Christian Weekly* (New York: American Tract Society, n.d.
recorded).

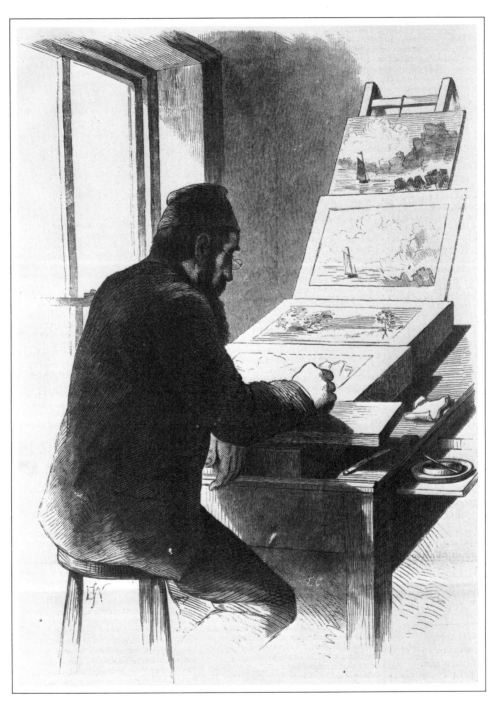

The Prang artist is seated at work on two lithographic stones. He draws the separate color patterns corresponding to the colors on the canvas atop his easel.

Source: *Illustrated Christian Weekly* (New York: American Tract Society, n.d. recorded).

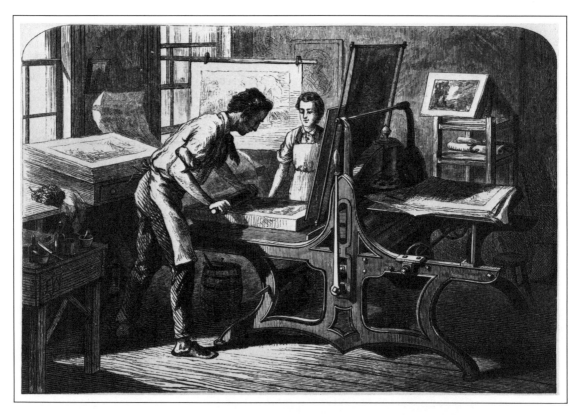

Here workers are inking the lithographic stone prior to printing. The stacks of already printed "chromos" lie on the desks and racks beside the press.

Source: *Illustrated Christian Weekly* (New York: American Tract Society, n.d. recorded).

Though Prang seized the art education market, the core of his production was chromolithographed art reproductions. People were awed by his achievement. The *Boston Daily Advertiser* reported that chromolithography "promised to diffuse not only a love of art merely among the people at large, but to disseminate the choicest masterpieces of art itself. It is art republicanized and naturalized in America."[36]

Not everyone loved the chromos, and even those who did admire them were offended by their proliferation in such great quantities. The abundance of identical images challenged the long-standing notion that art is art only if it is scarce or, better, unique. The ultimate disappointment to such people was the offering of chromos as premiums, incentives to get people to buy some other product, whether magazines, newspapers, or hair oils. In 1870, the *Christian Union*, a religious periodical, offered a steel engraving of George Washington as a premium to its subscribers. The following year, they shifted from steel engravings to offering two chromos, and they doubled their subscriptions! The next year they offered chromos again, and again they doubled their list.

The popularity of the chromo led to disrespect for it. Democratization of art was not working. The chromo had no status in the world of collectors of fine art prints, the world of the Boston Art Club. On the art ladder, the unconscious hierarchy of high art and low art and the various clearly stratified levels in between, the chromo was assured a place at the bottom. That it was socially and intellectually snobbish to reject the chromo as art, never diminished Prang's enormous profits. His art reproductions and art instruction books assured him stature as a leader in art education for the masses.

CHAPTER 10

BUILDING INSTITUTIONS

Between Manchester and Boston

Making art is a far more social process than is generally assumed. Artists have always been connected to one another, have sought out one another and found ways to share ideas. Trips home became opportunities for Henry Cross not only to reconnect to his parents and sister, but to rejoin Henry Herrick and, symbolically through drawing, share with him Manchester's landscape.

To Henry, drawing meant going home. No matter how much he traveled, his drawings kept referring back to New Hampshire. Nature in general and City Farm in particular remained his favorite subjects. Cities, even when he lived in one, had little impact. Henry virtually edited out any signs of urban development from his drawings. This tendency was common to many artists of his time and place. On mild days of spring, summer, and fall when Henry drew out-of-doors Boston, he chose vignettes that most resembled home. In Jamaica Plain, East Boston, Arlington, Cambridge, and Roxbury, he isolated and drew only the most bucolic features of these developing areas. The title page of one of his 1871 sketchbooks embodied his aesthetic ideal: beautifully formed Gothic letters spelling "Henry Clay Cross, Engraver in Wood," encircle an oval image of a landscape fragment of tree roots at the edge of a brook. It was his self-portrait as wood engraver and lover of nature.

Cemetery Brook on September 16, 1873. The back of this drawing was signed by Henry Cross.

Title page of Henry's sketchook of 1871. Henry was probably anticipating—
dreaming—of working in Boston. Significantly, his business-card-like design
gives Kilburn's address but sports only Henry's name.
Cross Family Collection.

Sketchbooks or art diaries such as this, in the absence of written
journals, provide labeled, dated evidence of Henry's visual interests.
That Henry Herrick urged all his students to keep such books with
them at all times we know from his book published in 1882. His
teaching methods were likely to have been well-developed before
they were fixed in print. Herrick must often have told students some
version of ". . . a habit of careful and accurate observation of nature
is a prime essential to all originality and progress in art. . . . We can-
not to the learner too strongly recommend the custom of keeping an
art diary in which may be sketched or written each day, such truths as
he may observe in nature."[1] Absolutely clear about the art diary's
use, Herrick said: "Studies from nature should not be worked up in
the studio; their value consists in the freshness of nature observable
at every touch."[2]

The art diary was no notebook for collecting jottings to be orga-
nized at home. It was supposed to build artists' habits of observation
so that painting and drawing could be completed out of doors. "All
subsequent finishing away from the scene is sure to degenerate them
into parts."[3] Art diaries were tools for observation of form, composi-
tion, light, shade, color, and texture of surface. "These memoranda
may be sketched in pencil, color, or written out, as may be conve-
nient, but there must be work in them, for the artist who expects suc-
cess by any other course will only find disappointment."[4] Every time
Henry worked in it, the art diary itself served as a reminder of
Herrick's words.

The art diary proved extremely useful to artists who were always
looking and who wanted to stop and draw in the course of their travels.
Easy to carry, it required neither an easel nor any other elaborate
sketching paraphernalia. And being a bound book, it preserved se-
quences of changes noted over time. The art diaries served Henry
much as the Civil War letters had served his father, enabling him to
stop, look, appreciate, and enjoy exactly where he was. In addition,
these art diaries became almost a justification for traveling. They al-
ways accompanied the Boston artists who, having made contact with
one another in the city, also provided a travel network for one an-
other. When these artists did not have to be at work in the city, they
were off, art diary in hand, to one another's rural or seaside hide-
aways to draw. In fact, Henry filled an entire sketchbook at the home
of Boston Art Club watercolorist Joseph Wagner on the Isles of Shoals
in Maine.

Though trains had made pleasure trips easy, amusements were also
becoming more available in the Boston area. Some fifty years before,
Boston's "Puritan" Sundays forbade even the most innocent Sabbath
recreations, but times had changed, and even the city government
now provided Sunday public band concerts. In the warm weather,
especially in summer, Boston's seaside resorts competed to attract
crowds. Nantasket, Nahant, and Revere Beach tried to outdo one an-
other in low cost, variety of amusements, and ease of access. "The
trouble of the modern Bostonian is now, not so much what he shall do
to amuse himself, as what he shall choose out of the abundance of
resources afforded him."[5]

Adolescent Henry enjoys irony, odd perspective, and meticulous rendering. Henry titles this piece "Ruins of the Old Laundry Hooksett, New Hampshire," as if no figure were present at all. Dated 1871.

Cross Family Collection.

Henry displays his adolescent skill in this drawing of a tree observed in
Bedford, New Hampshire. Dated July 27, 1871.

Cross Family Collection.

Henry and Foster made their choice. From a station on Atlantic Street in Boston, they boarded a steam car that took them all the way to the very end of Revere Beach. There, at Point of Pines, they found an isolated, quiet spot they came to love, and they acquired a three-part rickety wooden structure that they called the shanty. Two parts were two attached rooms, one probably a sleeping space that could contain a couple of cots and an eating space big enough for a table and chairs and a stove for cooking and heating. The third structure, set apart, was the outhouse. The shanty faced a quiet inlet and was set just at the water's edge. It was so close in fact that they could hop from the shanty into a rowboat to fish, sketch, and enjoy the landscape. Their love of the shanty began to wean them a bit from their ties to home. Despite family and Henry Herrick in New Hampshire, and perhaps sensing the impending loss of the magnificent views around City Farm, they became deeply attached to this place.

The shanty first appeared in Henry's art diary of the summer of 1873. One close-up shows a young man at the shanty's door, leaning back, propping his chair against the rather unstable looking doorjamb. Henry enjoyed dramatizing its fragile, barely thrown-together look. His drawings emphasize the individual planks of wood so precariously nailed to their simple frame structure that one strong wind might blow them apart.

The shanty became one of those social places where artists gathered. Few shacks at Point of Pines got the attention this one did. Its strange, irregular features attracted the interest of the brothers' artist friends whom they invited out here. Each visiting artist had the chance to try his hand at this oddly romantic structure. An old friend and partner of Samuel Kilburn's back in the 1860s, Richard Mallory, did several drawings of the shanty that are still in the family's possession. Mallory depicted the shanty as a rather sturdy, well-grounded little structure, planted firmly on a wide, calm, open beach front. His drawings are reminiscent of those English drawing manuals, popular in his early years, that portrayed calm, orderly nature in gentle, small, well-ordered strokes.

Drawing of the beach shanty at Point of Pines, Revere, Massachusetts. By
Richard P. Mallory, probably mid 1870s.

Cross Family Collection.

Mallory's drawings reflected his age and training. Now a man of sixty with a shock of white hair, he had been part of the generation of Boston engravers who studied with Abel Bowen. The Crosses, and especially Emma, became very close to Mallory, who apparently visited the family in New Hampshire. His photograph was left among those of family members. Years later, when they were all living in Boston, Mallory dedicated to Emma a drawing of the shanty at sunrise. On cream paper, his clear, short pencil strokes, highlighted with white chalk, captured perfectly that time of changing light. The drawing includes three tiny figures, one seated and two standing—perhaps the three Cross siblings, who all lived in Boston by the time of this drawing, 1886. No doubt this elderly engraver delighted in the Cross family's three children, who all knew how to engrave and continued to work at their art.

Whether going to Point of Pines, the Maine coast, or Manchester, Henry frequently found himself on trains. One train line, the Boston-Lowell-Concord, took him directly back to Manchester. When he boarded that train, Henry had to steel himself for the difficult situation ahead. City Farm, that bucolic subject of his drawings, had become a very unpleasant and difficult place for his parents. The work farm and the jail by city orders had also become the pound, and the Crosses now were caretakers for criminals, the poor, and dogs. Newspapers of the time refer to both Deborah and Joseph as superintendents. They did their best to fulfill their roles, but by the cold bitter end of 1872, they had had enough and chose to resign. The last straw was perhaps the Christmas Eve proposal of 1872 that a wing be built onto City Farm for a general hospital, the supervision of which would also be their responsibility. Anyone close to the Crosses might have wished their resignation had happened years before. Even those not close to the family realized the truth of the newspaper report: "The work is of such nature as to wear upon one's nerves so that they feel compelled to change."[6]

Knowing well the toll that City Farm had taken on his parents, Henry could only support them in their decision. From here on, rather than filling his art diaries with sketches of City Farm, he had to look elsewhere for New Hampshire scenery. He wandered to Cemetery Brook, whose crookedness Mr. Cross had described in his Civil

War letters as a miniature of the great Mississippi, and to Smith's Hill, Pulpit Rock, and Baboosic Brook.

In a few drawings the textile mills do creep into his landscapes, glimpsed between the trees. Their presence was less avoidable now that his parents had moved into town. Deborah and Joseph Cross were managers of corporation housing at the Amoskeag mills, where as night watchmen back in the 1840s Joseph Cross and his father had been assigned a room. When Henry visited, he saw how different his parents' lives had become. In town, it was possible for the Herricks to see the Crosses more easily and develop a closer relationship with them. Attending public events awas less of an ordeal, and in the evening, they could see their way home in the luxury of gaslight. In these years, Joseph Cross no longer listed himself as a farmer. Between 1872 and 1875, he gave his trade as model- and patternmaker, and newspapers reported official endorsements of his farm and baking inventions.

The Crosses lived at Orange and Union streets not far from the Herrick's two-story wooden house at Russell Street. Henry could easily walk to the Herrick's, and when he did he approached facing the front central doorway with its symmetrical, shuttered windows at either side. The only asymmetry was an attached glassed-in porch called Mother's porch, probably serving a function similar to today's in-law apartment, being a symbolic replacement for Mr. Herrick's mother's Mammoth Road home yet allowing her to depend on the proximity of her son and his family. The southern exposure of Mother's porch warmed those who sat there. Mr. Herrick's studio is said to have been in the back, on the opposite, far from the family entry through Mother's porch. Rather than through the formal central doorway, it was through Mother's porch that Henry entered. One surviving photograph shows that door ajar as the sun glistens on the glass porch.

Family matters were a priority for the Herricks in these Manchester years. When they first moved into Russell Street in 1865, the children had to adapt to living with their grandmother, who, in turn, must have found it difficult to conform to the pace and style of her son's family. In 1869, when forty-five-year-old Clara Herrick gave birth to Little Bertie (Hubert Wallace Herrick), this older family with

its aged grandmother had to reorganized itself again to cater to the needs of an infant. Five years later, Little Bertie died. No doubt the three older boys—Allan, twenty; Robert, seventeen; and Henry Augustus, eleven—relived through this death the loss of their brother William, who had died in 1864 at age four.

With all the family matters, Herrick maintained his interest in wood engraving. *Young Folks*, *Child at Home*, *Spectacles for Young Eyes*, *Play for Boys*, and other books and magazines burgeoning during this period benefited from his illustrations. In 1870, when Foster and Henry engraved for Sam Kilburn, Herrick drew many illustrations, including those in *Cabin in the Prairie*, *Switch-Off; or The War of The Students*, and *Desk and Debit; or The Catastrophes of a Clerk*. The latter two were part of the Oliver Optic series, which Samuel Kilburn himself engraved. Herrick also worked for two New York firms, Harper's and the American Tract Society, which continued to send him commissions.

It was at this time that Herrick turned his attention to mastery of watercolor, a new medium for him. At midcentury in New York, Herrick saw the dawning American interest in watercolor, which printmakers regarded as akin to drawing. American artists who had been in England came home with raves about this medium, and particularly how convenient it was to use in those screw-top paint tubes John Rand invented. In 1853, the New York Water Color Society had been formed by printmakers who by birth or training were tied to England, but its only exhibition prior to the Civil War was in New York as part of Industry of All Nations. With the arrival of an exhibition of British art in 1857, including watercolors by John Ruskin himself, sophisticated New York art collectors began to acquire works in this new medium. The same double bind that beset other facets of art asserted itself here: Buyers preferred English works yet faulted American watercolorists because their work looked too British. The American interest in watercolor painting was spurred by the American publication of Ruskin's "Elements of Drawing." Most American watercolorists became converted to Ruskin's aesthetics and "followed his tenets with care."[7]

When Herrick moved back to Manchester, watercolors were gaining greater acceptance and visibility in New York. In 1866, the

American Water Color Society was formed there, and its first show included the works of 278 artists. Herrick's remoteness from New York never prevented his participation in the society's exhibitions, and he looked back on his inclusion in their shows with pride. By 1882, he became so knowledgeable and proficient with his new love that F. W. Devoe & Company, the New York paint supply house, published his *Water Color Painting, Description of Materials with Directions for Their Use in Elementary Practice.* Subtitled "Sketching from Nature in Water Color," it became the definitive American compendium on the subject. It is known today as "the most advanced American book" on the subject.[8]

Herrick used watercolors to do portraits of houses. This was one of his ways of preserving Manchester's history. The medium enabled him to capture features of architecture. He used rosy brick-red colors to reconstruct from memory the old Manchester Town Hall, built in 1844, the year he left for New York and destroyed by fire only a year later. Herrick also depicted landmark homes such as that of revolutionary war General John Stark. Governor Moody Currier's house also became Herrick's subject. Were it not for Herrick's painting, in fact, the appearance of this house would be lost to memory for in his will, Currier planned for an art museum to be built on the site of his home. Not surprisingly, Henry Herrick was appointed trustee for the new museum.

Herrick's community was populated by historical and artistic figures. His love of history was apparent in his home as well as in the choice of his subject matter for watercolors. His great library was reputed to have contained the entire *London Illustrated News*, dating back to its first issue, all bound in leather.

The Herrick home was also rich with artworks produced by Mr. Herrick's artist friends. John Rogers, who had achieved great success with sculptural groups depicting scenes of American life, remained in touch with Mr. Herrick throughout his life. Herrick proudly showed Rogers's work in his home. Ulysses Dow Tenney, two years Mr. Herrick's junior, kept a studio in Manchester from 1849 to 1864 and left just as the Herricks returned. Despite Tenney's moves to Hanover, Concord, then New Haven, Connecticut, and back to Portsmouth, New Hampshire, they remained lifelong friends. Tenney painted the por-

traits of Henry Herrick and his wife, probably in the 1880s, that are now treasured Herrick family heirlooms. While Herrick painted the homes of prominent people, Tenney painted their portraits. Former President Franklin Pierce, former governors Moody Currier and Frederick Smyth, and that professor, Benjamin Silliman, who with C. R. Goodrich wrote the record of the New York exhibition of Industry of All Nations—all were at one time his subjects. In the course of painting their houses or their portraits, these artists became intimate with key figures of their time. Their rapport with those public figures may have, in fact, encouraged the growth in public support for the arts that took place at this time.

Herrick's move from New York never diminished his interest in that city or in the world whose pulse was felt there. His granddaughter recalled that in his Manchester years, he read the *New York Times* daily. On Henry's and Foster's visits to Manchester, they probably found Herrick more cosmopolitan than most of the people they knew down in Boston. Few of his neighbors could have appreciated his rich and private life of culture and art.

Manchester

In 1872, when the Crosses moved into town, twenty-two-year-old Emma still lived with them. Henry would have been twenty, and Foster, twenty-six. The children's closeness to Allan Herrick, then eighteen, was not just because of his age; they had in common a love of wood engraving and watercolor painting. Frank French, also about twenty, shared their interests, and together these young people— including the Cross brothers when home on visits—gathered around portly Henry Herrick, demanding new information and assistance.

Frank French, reflecting on his life years later for a newspaper, reported that he got the idea that this little group should be organized and expanded. He thought a Manchester art association would enable Herrick to give more to his community. Although skeptical about Manchester's readiness for such a venture, Herrick did not discourage him and agreed to support his efforts to start the organization. French, full of energy and ambition, started the fledgling association and became its president, remaining in that role until he followed Herrick's footsteps and headed to New York to work for the American Tract Society.

Herrick's private generosity was in the process of being made public. But in the course of working with his new city, his private artistic purposes were inevitably altered. In no way could members of an art association ever learn from Herrick the view of art that he shared with the Cross children, his own children, and Frank French. It is one thing to teach people in the intimacy of their homes because they are attracted to whom you are and what you do; it is quite another thing to teach an audience of strangers in a public forum with other people's money. There was another reason for the difference in Herrick's approach, and that was a function of the times. The attitude toward art was changing; Foster and Henry certainly saw that in Boston. Manchester had read about Boston's new ideas, and they wanted some part of the action.

Herrick had a choice whether or not to feel quite superior to all that went on around him in Manchester. Even in his New York days, he rejected the elitism that ruled the sophisticated art world. His own art straddled two universes; he was both engraver and artist, and he suffered no conflict over status or rank regarding his own art. Furthermore, he was an artist and an educator. Unlike many of the artists in the Boston Art Club depicted by S. L. Gerry, Herrick felt no conflict between those two roles. He was equally committed to both. As a radical educator devoted to training *many* people, especially female people, in the arts, he welcomed a public forum to educate the local citizens who wanted to know more about art.

The nonprofessional diversity of Manchester's art audience may have been even more appealing to Mr. Herrick than the stratified and more sophisticated scene in New York. Pressures unique to his hometown were well known to him. That he remained for years Manchester's art leader and built its artistic life and institutions are evidence of his choice. The role he created for himself in Manchester appears to involve his own romancing, his own interpretation of himself as not only religious deacon of the missionary society, but as artistic deacon of his community.

His impact was enormous. Before he went public, the press contained almost nothing concerning visual art. Then, in 1872, the *Daily Mirror & American* reported:

Manchester is gaining a good reputation in the various departments of fine arts. . . . In painting we have some reputation and are gaining more, while in designing and drawing, we have artists of established character, one, at least, who ranks among the most accomplished in the country, and engraving has become a permanent business here. . . . The Art Association which was recently formed . . . has created a spirit of improvement.[9]

Mr. Herrick was the one referred to, and the art association was his creation.

Public curiosity about his fame drew the audience for the art association's first event, an alternate lecture series entitled Four Evenings With Art. The Art Association's meeting on February 20, 1872, was held in the high school's lecture room, and Mr. Coburn, the principal, opened by saying:

"If the movement had been started fifteen years ago, it would have been much less likely to succeed than now as the taste of the community had been greatly developed in that period. Hitherto our attention had been directed to the fundamental branches of education. . . . The most beneficial studies are those that combine pleasure and profit. In order to study nature profitably, our eyes must be trained in that direction, and here art and science go hand in hand."[10]

Mr. Coburn merged the two arguments that he had heard in favor of art—that it provides pleasure and that it is useful. He suggested that people were entitled to some enjoyment while they were also stimulated by the rumors about art labor, particularly Massachusetts's new drawing legislation.

After Mr. Coburn's introduction, Herrick spoke, feeling perhaps somewhat unsure of how to interest this audience. Techniques of composing a picture was his theme, joined to "'the practical applications to everyday life, such as architecture, interior decoration, landscape gardening, furniture, dress, manufacturer's and mechanical arts.'"[11] He deemed pictorial composition practical, but to this audience it probably did not seem so. He probably never realized how distant he was from the practical applications he tried to make. The mature, experienced artist, so immersed in his world, had little sense of his audience. Herrick's lecture was so detailed that it could have intrigued only the serious practicing painter. He described how people may compose pictures and suggested how light, color, and form contributed to composition. He supplied certain rules: There should al-

ways be a focus of light and color, and curved forms should be con-
trasted against the angular. If this was not already too much for his
audience, he must have lost them completely when he cited the con-
struction of Spain's great Alhambra palace to people who knew little
of architecture outside their own city. The gap between the speaker
and his audience painfully dramatized the difference between the
possibilities in New York and in Manchester.

Poor Reverend Dr. C. Q. Wallace, who had promised closing re-
marks following Herrick's lecture, was "altogether out of his moorings
. . . it was too deep water for him." [12] He concluded briefly, "no doubt
that there was truth in the statement that a study of principles of art
would enable us to appreciate and enjoy the works of artists. Yet," he
thought, "there was some enjoyment in looking at a good picture by
those who knew nothing about it." [13] In other words, he knew nothing
about art, but he knew what he liked.

Herrick's lecture series continued to concern principles of art in
great detail. In the last of his lectures, he spoke of color and credited
"nature as his authority for whatever he might present." [14] Again, the
particulars of color mixing and color distribution could have suited
only the curiosity of a practicing artist. Taking pains to satisfy his lay
audience by discussing color in the context of dress and room decora-
tion, Herrick concluded with the hope that the study of art would
flourish in the public schools. That thought was gauged to match the
interests of his audience, which he sensed was ready to emulate
Massachusetts.

Even though few could have found Herrick's lectures engrossing,
the city wanted its local art association. After the series ended, the
association looked for rooms where it could continue to meet. Space
was made available in the old Court House. Two drawing classes were
immediately established—Model Drawing and Object Drawing, both
after titles of instructional drawing books by Walter Smith. The asso-
ciation inched ever so gently toward what was happening in Massa-
chusetts. Herrick's justifications for art study had little relevance to
the teachings of Walter Smith. To Herrick, "[t]he usefulness of the
study of art is the habit of observation which it reinforces," [15] and na-
ture, not industry, was his authority. Bit by bit, Herrick was pressed
to provide a quite alien form of art instruction. By December 1873,

the art association took an even more explicit industrial orientation. Its exhibition included, in addition to drawings and paintings, silk scarves, ribbons, and textiles designed and woven for the Jacquard looms at Amoskeag.

The dilution of Mr. Herrick's personal aesthetics did not discourage his participation. At Manchester's Music Hall, earlier in the fall of 1873, he organized a large art exhibition of objects suggesting the range of the community's interests. The art association announced the start of its own collection of plaster casts, displaying its Venus de Milo and Mercury. Products from local manufacturers, such as silver by Gorham Manufacturing in Providence, Rhode Island, and glass from Boston's New England Glass Company, were also shown. Herrick invited fellow wood engravers from his New York days, Nathaniel Orr, Henry Kinnersley, and Timothy Cole, to show along with the younger artists he had influenced in Manchester, Henry and Foster Cross and Frank French. Such crowds gathered that the exhibition hours were extended and doors were open from early morning through the evening. Newspapers alerted visitors "to visit this department early in the morning to avoid the crowd that of necessity must be present during the afternoon and evening." [16]

Herrick's leadership involved not only importing the art of his colleagues, but occasionally asking a distinguished colleague himself to lecture. In 1873, Herrick invited Thomas Nast, well-known illustrator and political cartoonist with whom he was at work on illustrations for Kilburn. Nast presented a "chalk talk," in which he drew events of his life before an astonished audience still unaccustomed to having artists in its midst.

The Manchester newspapers, which until 1865 had almost no news of art, by 1874 featured a story on art on a daily basis, and the stories were based on events.

Henry and Emma Cross and Allan Herrick became the committee responsible for selecting and displaying the next exhibit of art objects. They decided that everything with visual interest should be accepted. Nothing was challenged as not being art. The committee's attitude could not have been more different from that of the tastemakers who dominated in academically rigid fine art circles and insisted that

oil painting was superior to watercolor and watercolor, in turn, superior to any form of printing.

In March 1874, the committee set up its two rooms in the courthouse, exhibiting paintings, sketches, casts, and photographs, wood engravings, wood facsimiles of marble, and Jacquard loom weavings that were facsimiles of steel engravings. Japanese calligraphy done by Kirashi Kiraoka, a young boy who came to Manchester from Japan to learn the machinist's trade, was shown along with the drawings of students from Manchester's evening drawing classes. Again crowds came. The committee's nonelitist approach made everyone feel welcome. They encouraged all makers of things to take their efforts seriously and to consider their works art. Patrician onlookers might have been appalled, construing the whole scene as a display of ignorance, but nothing in the newspapers indicates that that happened.

In 1874, the art association classes with an industrial orientation were held without the leadership of a teacher. These were classes Mr. Herrick would not teach. Instead, students guided themselves with the aid of textbooks from the growing association library, which by 1874 numbered about fifty volumes. Predictably, demand was for volumes by Walter Smith.

Each art association event attracted more members, and new participants enthusiastically contributed objects to the young association's growing art collection. John Burgum, decorator of furniture and Amoskeag steamers (steam-powered fire-fighting equipment), contributed a piece adorned with scrollwork, a prized contribution of the year 1874. And as a vote of confidence in the group, Herrick donated one of his history paintings.

In the spring 1874, the art association announced that it had over one hundred members, many of them businessmen from Manchester. In tribute to the efficiency of their new president, Mr. Herrick, they presented a statue that won "praise in Boston papers"—Ella Thompson's *Mother and Child*.

The art association's next big project was to plan an art exhibition to be coordinated with the New Hampshire State Agricultural Fair. The New Hampshire Agricultural Society, founded in 1849, had resumed its fairs only after the close of the Civil War. The state fair

organizers invited the art association to set up art galleries right on the fairgrounds for its September 1874 event. Here, work was to be divided between an art gallery and a fancywork gallery. Though separated into these two general categories, objects were at least as diverse as ever, including watercolors, photographs, architectural drawings, waxwork, crayon drawings, locomotive and machine drawings, dyed silk samples, stuffed birds, inlaid wooden chests, and oven-preserved insects. Whether objects went into the art gallery or the fancywork gallery was the decision of A. G. Stevens, coordinator of this exhibition.

Much preparation had to be done, and anything related to art was directed to Henry Herrick. He either did the job himself or passed it along to someone whose skills he trusted. When the New Hampshire Agricultural Society realized it needed a prize medal to award to distinguished contributors, they asked the newly returned Mr. Herrick to create it. He designed a heavy copper disk, two inches in diameter, engraved with space for the winner's name encircled by pumpkins, corn, and apples sculpted in low relief. Even more elaborate drawing was required for his design on the opposite side, in which New Hampshire personified as a woman stands beside an anvil and gear wheel amid the bounty of her harvest, her right arm extended to offer a prize wreath. Over the years of Manchester Art Association exhibits at the fair, each of the young Crosses had come home with a Herrick medal.

By now, that dream in the minds of Herrick's small group of devotees had become a sizable organization. In October 1874, following the state fair, the membership formally incorporated as a voluntary association to promote knowledge and skill in art and technology among its members and artists and artisans. To achieve its purpose, it promised to provide classes and establish an art library and a collection of paintings, statuary models, and other works of art or science pertaining to similar institutions. Herrick was reelected president, and Emma Cross was elected a director. Since she still lived in Manchester, she could give more to this fledgling organization than either of her brothers.

The next year, 1875, the association published its bylaws, its history, and its ambitions. Its justification seemed self-evident: "In our

city there are at least fifty professions or business interests requiring a direct knowledge of the general laws that underlie all art."[17] The trades that saw themselves as beneficiaries of the art association included carriage makers, taxidermists, sign writers, marble cutters, machinists, upholsterers, dyers, paperhangers, designers, and teachers. The association fully allied itself with the local workers and aimed to support them, specifically with classes and the acquisition of books and models based on their needs.

Funds for purchases came from the one-dollar initiation fee. Since that income alone could hardly sustain their program, the association looked for money elsewhere and received some from the Manchester School Committee. Its support tipped the association even more in the direction of art labor, for the school committee saw the association as an extension of their courses in drawing in the public schools.

Less than a year after Walter Smith arrived in Boston and began putting some muscle behind the Massachusetts Drawing Act of 1870, Manchester set about following Boston's model. Manchester's proud citizens could not witness Boston's preoccupation with art without admiration, envy, and the desire to imitate. Massachusetts's act had two parts. One pertained to the instruction of children under age fifteen in the public schools, and the other concerned the instruction of students over age fifteen regardless of whether or not they attended school. Manchester wanted both programs. As a mill city, it valued art as a way of counteracting the growing tendency of American boys to feel too proud to learn a trade and work with their hands and as a way of elevating adults to a new, much-desired class of skilled art laborers. The school committee made its intentions clear:

We do not expect to make finished artists of the pupils, but we can give them such training . . . as will be of use to them in the various mechanical pursuits in which they engage; we do not regard this as an ornamental branch but one of the most useful, especially in a city like ours. . . . When we consider that in a city like ours, most of the children . . . will earn their living by manual labor, we should . . . provide them with the instruction best suited to their wants in after life. The complaint is frequently made that foreign workmen occupy the best places in our workshops and factories, and it is said that every branch of manufacturing interests is suffering from the lack of such training as the schools ought to give.[18]

The adults' evening drawing classes had the same priorities. On

January 18, 1872, the *Manchester Daily Mirror & American* gave notice of the city's plan to institute evening drawing classes to afford "instruction in mechanical drawing to a large class of young men from the mills and the shops, the benefit of which must be felt in all industrial pursuits."[19] Unlike John Rogers' evening drafting classes in 1855, these evening drawing classes were offered in public schools and paid for out of school budgets. The Manchester Evening School had its first organizational meeting in the lecture hall at the new high school to introduce the new teacher and explain the purposes of the classes. Manchester's symbol of art, the person they considered the one real artist in their midst, Henry Walker Herrick, was invited to remark on "practical benefits of artistic culture."[20] Herrick greeted an audience of twice the anticipated number, including twenty schoolteachers and eighty others from the general public—machinists, carpenters, and photographers. Mr. Edgerly, superintendent of schools, reminded them that this new skill would give them refinement and would improve their social standing.

"The lavish expenditures of Massachusetts upon this class of schools suggests the benefits there supposed to be derived from them. . . . The one thing Manchester needs above all others is culture. We have brains, and energy, some wealth acquired and more in the process of acquisition, and an honest pride in the city. We want, besides, the finish of scholarship and the polish of art."[21]

In 1873, after a short period of running the classes under the guidance of one unpublicized local talent, Manchester sought someone deemed a more competent teacher to take charge of the free evening drawing classes. The city announced the job in the *Daily Mirror & American* of September 15, 1873, and shortly thereafter hired a teacher who probably never saw that announcement. Just as Boston felt it necessary to import a British teacher, so Manchester pinned its hopes on a Massachusetts teacher who could bring the status of Massachusetts and familiarity with its system. Mr. J. Warren Thyng had the ideal credentials. He was a New Hampshire native who had studied in Massachusetts and most recently served as a teacher in Salem, Massachusetts.

Manchester hired no drawing teachers other than Warren Thyng. The drawing education of children, following Walter Smith's policy,

was to be in the hands of classroom teachers who taught drawing along with reading, spelling, and arithmetic. Emma Cross, now a full teacher at Primary School No. 13, and any others with art experience adapted what they knew, combining the ways they were taught as children with the new mandate for industrial drawing. The only support the city provided to its untrained teachers was the purchase of textbooks. Generally, they ordered updated, revised issues of William Bartholemew's soft-cover oblong sketchbooks, dating back to 1855, which provided examples for the student to copy.

In January 1874, the Manchester School Committee established a standing committee on drawing, and it proposed switching to a different series of instruction books. Predictably, since Manchester wanted to follow Boston in every detail, there was prestige in switching to the Walter Smith drawing books. By September 1874, the Walter Smith approach had captured the art association's classes as well. Every aspect of Manchester life pressed the association toward an industrial, art labor orientation. The more the art association tended in that direction, the more willing the city was to support it. In September 1874, the city judged that the association had taken its mission and so cancelled its own evening drawing classes. Interested adults were referred to the art association. Herrick's efforts, so diametrically opposed to Walter Smith's, were gradually being transformed.

Herrick still did things in his own way. In April 1875, the association's exhibition was organized differently and reached a new high in public acclaim. In the painting gallery, a portrait by Samuel Morse was side by side with watercolors by Emma and Henry Cross and several British painters. Allan Herrick and Carl Johnson, a twelve-year-old Norwegian boy who attended the Manchester public schools, showed pencil drawings. The high school's art class drawings were also exhibited. Foster Cross and Allan Herrick exhibited wood engravings of the Amoskeag steamers and of the mills where they were made. Henry Herrick and Henry Cross also showed their wood engravings alongside Herrick's pen illustrations for *Stories for the Young.* One whole room was devoted to mechanical drawings, architectural plans, rough illustrations of fibers of wool, flax, and linen, plans for the waterworks, plans for a marine engine and a locomotive, and a gigantic gingham pattern book that was contributed by the

Amoskeag Corporation itself. With this exhibition, Manchester was revving up for the nation's centennial. Here were exhibited all of the best work from which the cream would be selected and sent on to the state fair to end all state fairs—the Centennial Exposition in Philadelphia.

The 1875 New Hampshire State Agricultural Fair, with its cows and sheep, boasted having the most ambitious of the art association's exhibitions. Acknowledging the success of the art developments in Boston, the Manchester Art Association borrowed Boston's schoolwork to display it before the citizenry of New Hampshire. Twenty large framed drawings from the Massachusetts Normal Art School, the Harvard of art schools, were exhibited in order to demonstrate the methods and results of study at this public institution. The exhibition also included a twenty-nine-by-nine-foot display of the lithographic work of L. Prang and Company. Art developments in Boston were the big news of that year's state fair in New Hampshire.

In September, just as the New Hampshire state fair opened, the school committee voted the recommendation of its standing committee on drawing, that the high school adopt Walter Smith's industrial drawing textbooks. The school committee's decision was bolstered no doubt by the prominence of Boston art at the state fair. Lest there be any doubt about how the association and the school committee coordinated their efforts, the press announced that the art association sought more rooms at the courthouse "so it may have some Massachusetts Art instructors come up here and lecture."[22] The Manchester Art Association and the public schools had become a showcase for Walter Smith and Louis Prang, and through them, Charles Callahan Perkins was beginning to realize his vision of his academy spreading its word throughout the nation.

Walter Smith and Louis Prang knew an opportunity when they saw one. Selling to schools in the cities and towns of Massachusetts was indeed very profitable, but when cities outside the state were calling in orders for Walter Smith textbooks, their best dreams were confirmed. The collaboration of Prang as publisher and Smith as author assured each just what he wanted.

Prang deserves credit for having been interested in art education even prior to the Massachusetts drawing legislation. As early as

Drawing School for Beginners, Louis Prang's earliest art instruction product,
was a series of tiny volumes with white on black, suggesting chalk drawing on
a blackboard. 1863.

1863, Prang staked out the territory of drawing instruction when he published *Slate Pictures, Drawing School for Beginners*, a series of small green booklets whose black pages displayed white line illustrations suggestive of chalk on a blackboard. Less well known, but also published at this time, were Magic Cards. These provided an artistic problem requiring a solution and never failed "to give pleasure and delight" to adults and children.[23] At that time, however, when war maps and album cards demanded his attention, drawing was hardly Prang's priority.

But by 1874, when Manchester voted to switch from William Bartholemew's to Walter Smith's instruction books, Prang realized he was sitting on a gold mine. Cities and towns across the country would follow the trend. It was at this time that Prang moved to larger quarters on Roxbury Street, mortgaging its woodcuts, electrotype plates, lithographic stones, tools, and machinery, and even the drawings on stones to gain more capital for expanding his business. James R. Osgood and Company, Walter Smith's initial publisher, lost not only Smith's books to Prang, but also John S. Clarke, its manager of educational publications, who resigned to join Prang. Together Prang and Clarke masterminded art education's mass distribution.

Prang settled into his new quarters and prepared to provide the nation with everything of which Walter Smith could possibly dream. Prang and Smith's first collaboration was the American Drawing Cards, twenty-four miniature slate drawings to copy, originally entered into the Library of Congress by Osgood in 1873. Following these cards and the accompanying teacher's manual came an unending stream of books. The title of the series, American Textbooks of Art Education, revealed the ambitions of the collaborators. They also sold American Drawing Models, geometrical solids that were to be useful to common schools, private drawing classes, and schools of art and science. The solids—designed, of course, by Professor Walter Smith, "whose position will be sufficient guarantee of their quality and arrangement,"[24]—came in four different sets, one of which was composed of ten wooden replicas of Greek vases. Prang products with Smith's imprimatur spread the gospel to New Hampshire and throughout the land.

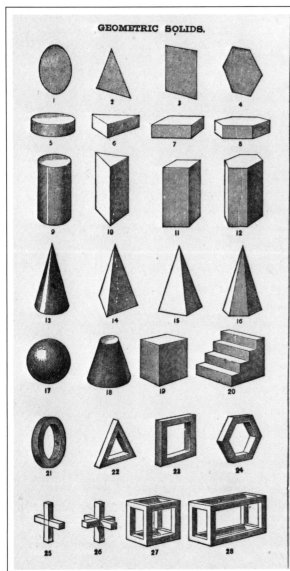

THE
AMERICAN DRAWING-MODELS

FOR THE USE OF

Common Schools, Drawing Classes, and Schools of Art and Science.

Manufactured at the Washburn Machine-Shop, connected with the Free Institute of Industrial Science, Worcester, Mass.

FROM DESIGNS BY

PROF. WALTER SMITH,

STATE DIRECTOR OF ART EDUCATION FOR MASSACHUSETTS.

THE increasing demand for ART EDUCATION, and its general adoption as a branch of common-school instruction by the Legislature of Massachusetts, has rendered it necessary that a supply of proper models with which to convey this instruction should be produced. The managers of the Worcester Technical School, having all the facilities for producing such works, and anxious to aid the cause of Artistic and Scientific Education, have obtained designs for a complete set of models, from PROF. WALTER SMITH, Director of Art Education for the State of Massachusetts, whose position will be a sufficient guaranty of their quality and arrangement.

The models are made from the best materials, in a perfect and workmanlike manner; and by reason of extensive machinery specially fitted up for this work, the models are produced with accuracy, at a much less price than would be possible otherwise. Each model being made to dimensions, these sets are equally suited to all kinds of Free-Hand, Instrumental, and Perspective Drawing.

Set No. 1

Consists of thirty pieces, selected from the most useful and beautiful geometrical figures and curved forms, and includes the NEW ADJUSTABLE MODEL-STAND. Price, with box $ 20

Set No. 2

Consists of ten wooden vases, duplicated from the Greek originals. Price, with box $ 10

Set No. 3

Consists of four large models for lectures and instructions to classes :—
1. CUBE, fifteen inches side.
2. CONE, with base twelve inches, altitude eighteen inches.
3. CYLINDER, base twelve inches, altitude eighteen inches.
4. HEXAGONAL PRISM, base twelve inches, length twenty-four inches.
Price, with box $ 15

Set No. 4

Is intended for Primary Schools, and consists of twelve pieces, which comprise the common geometrical figures. Price, with box . . $ 10
The above prices are all net prices.

Messrs. L. Prang and Company, the Publishers of these Books, are the Sole Agents for these Models.

Geometrical solids produced by students of the Free Institute of Industrial Science, Worcester, Mass. Back cover detail from *American Textbooks of Art Education*, by Walter Smith. L. Prang announced itself as sole agents for these American drawing models. 1875.

Boston Much as the engraver cuts his image into the block, anticipating the
many prints that will come from a single design, so travelers from
Boston to New Hampshire could anticipate how the life formed in
Boston would be repeated in multiples in outlying areas. Boston set
the standard that was printed over and over again on cities and towns
first in New England and ultimately across the states.

When Foster and Henry Cross originally left for Boston in the very
end of 1860s, Manchester had little or no interest in art. However
startling it was for them to see art that had been so private an affair in
their family's childhood become so public in their adult years in
Boston, it must have been even more peculiar as they traveled back
and forth between Boston and Manchester to find all the Boston art
ideas reverberating in their hometown.

Though it may not have been apparent to the brothers, what they
were seeing was the spreading fame of Massachusetts. Henry and
Foster's arrival in Boston put them in a perfect position to watch the
entire plan unfold. Charles Callahan Perkins's vision of his art acad-
emy and all its attendant developments served as a grand plan for
magnifying Massachusetts's prestige among the states as the nation's
centennial approached. Perkins persuaded various powers that were
in Massachusetts that art education offered a solution to a problem:
The commonwealth's industry was engaged in a struggle for suprem-
acy with a growing number of western and southern states whose
manufacturing ambitions threatened New England. Massachusetts'
preeminence could be assured if its industry produced a finer, more
artistic product than any other state's. Perkins was convincing, and
he won support to mastermind a sequence of backstage preparations
to achieve their goal.

It was no coincidence that on March 3, 1871, an Act of Congress
established the Centennial Exhibition to celebrate "the Arts, Manu-
factures, and Products of the Soil and the Mine,"[25] and on June 1,
1871, Walter Smith was appointed to the dual post of city and state art
director, explicitly to import British art labor to the United States.
A *pas de deux* followed in which the nation's preoccupation with in-
dustrial competition partnered Massachusetts's quest for prominence.
Perkins prepared the backdrop, readied the audience, and provided
the cues. His aim was that by 1876 a number of spectacular, highly

visible achievements would have taken place that would spotlight Massachusetts's contribution to the centennial.

From the moment he accepted the appointment, Smith's goal was to design extravaganzas. As director of drawing for the city of Boston, he started as early as May 1872 a series of drawing exhibitions at the hall of the Horticultural Society. The huge membership included some of the Boston's most prominent citizens. Smith could have made no better choice than to show this growing field of art in the home of a society renowned for its exhibitions of plants, flowers, and fruits. Each year thereafter he enticed crowds to gather.

Since the master plan stressed that proper art education had to begin at the level of children, children's drawings were Smith's best demonstration. Each annual exhibition was a prelude to the major exhibition of March 1876, which included the much-touted artwork of children of the schools of Boston along with that of their elders from the Boston evening drawing classes and from a third leg of Perkins's tripod, Massachusetts Normal Art School. For this exhibition, thirty thousand people jammed into Boston's Horticultural Hall. Thousands more had to be turned away, as in the 1850s when many who patiently waited in line were turned away from Frederick Church's displays. Even a hall as vast as this one could not contain all the curious spectators, and news of the numbers not admitted only incited further interest. After the closing date, the drawings were packed up for shipment to Philadelphia, where they were to be shown there at the Centennial Exhibition's main building. Those who could not satisfy their curiosity at home in Boston could follow the collection to Philadelphia to see it on view at the centennial.

The Massachusetts Normal Art School itself was an artifact of the centennial. If art instruction were to survive in America, the nation needed an institution that could produce teachers to train its multitudes. Only with a wealth of trained teachers might American workers realize the true scope of their powers, so an institution to train teachers was viewed as essential. No matter how many laws were passed and classes set up, they would come to naught without properly prepared teachers.

Walter Smith first mentioned a normal art school in 1871 in his first annual report, in which he referred to it as the logical home for his

traveling museum. Inspired by Perkins and his colleagues in public affairs, Smith proposed what was then called the National School of Design, which would be to art what Harvard and Yale were to a classical education. The Massachusetts Board of Education requested only ten thousand dollars to support the start of a state-supported art school. Though that small amount was denied, the legislature did not reject the notion outright. Perhaps the refusal of funds even intensified interest in forming such a school. The national academy of which Perkins dreamed years before now took the form of a huge complex of different but related institutions, each helping and benefiting the others. The National School of Design was to be combined with the Institute of Technology, the Museum of Natural History, a geological museum, horticultural gardens, and schools of architecture, anatomy, and medicine. The Boston Museum of Fine Arts, then under construction, was part of the grand scheme, but its success depended on the National School of Design. "A Museum however rich its contents . . . is just a show unless it combines with its wealth of art, the active, educational agencies in the classroom which are to transmute this wealth into currency."[26]

The scheme was grand in scale. The National School of Design should have students who prepared for entry during their earliest years of schooling. Art instruction had to start in common schools and continue in the high schools to enable a student to enter the proposed national school. Lest he be judged prematurely, Smith reminded the legislature that the true influence of art education "'upon the industries of the state can never be properly tested until the school receives pupils into its lowest classes, as thoroughly prepared for its course of study as are the freshmen who enter the halls of Harvard and Yale, in the studies there required.'"[27]

Smith's reference to Harvard and Yale was no coincidence. He knew to whom he must speak. He acknowledged:

The movement in favor of art education in Massachusetts is distinctly traceable to the influence of a few men, who, from European experience, saw that their country and state were behind the times in the promotion of art.[28]

He talked directly to "the few men" and promised them that Boston could "be at once the Athens and the Venice of the New World."[29]

The men he addressed had studied at Harvard and Yale, and he flattered them by saying that only they and other Americans who had been to Europe knew what they were missing. They would understand what he meant when he said, "Just as drawing is the only universal language, so art is an almost universal currency and amongst civilized races *is* universal."[30] As a result of Smith's gifts of persuasion and his identification with Boston's patricians, the normal school, the academy of which Perkins dreamed, was founded by 1873. Smith was appointed its principal in addition to his other responsibilities as state director of art education and head of the Department of Drawing for the city of Boston. Just as when he was at Leeds a decade before, he simply piled one job on top of the others.

The Massachusetts Normal Art School's stated aim was to produce drawing teachers for the public schools in the shortest possible time. Its unstated aim was to capture public attention by 1876. Students were selected by Smith who, in order to assure his success, went directly to the studios of some eager Boston artists and invited those he judged best to be pupils in his first class. "'The experiment must succeed, we must have an appropriation for carrying out the work a second year.'"[31] The artists came; the plan worked; and the school continued to be funded by the legislature.

How could a society that was believed to be culturally deprived create a school of art? Who could be its teachers? It was agreed that Walter Smith would be a professor of theory and practice of art education and of sculpture. Other professors were borrowed from prestigious nearby institutions. Massachusetts Institute of Technology offered its Professor William R. Ware, who lectured on architecture, building, and construction, as well as S. Edward Warren, who taught isometric projection and projection of shadows. Tufts College loaned C. D. Bray, who lectured on machine drawing and orthographic projection. An instructor from the Boston public schools, L. Baker, taught geometric drawing and perspective. The staff was completed by two more instructors, G. H. Bartlett and Mary Carter, who were imported from England to teach freehand drawing, painting, and designing.

Americans' historical ties to England created mixed feelings about this whole endeavor. Walter Smith, well aware of this, used or denied

his Britishness as was convenient. His gifts of persuasion involved not only finding the right word or the right phrase; he also relied on confusing his hearer. Smith would speak of "our" past and "our" history, although everyone was well aware that he was an Englishman and was exempt from the cultural deprivation he attributed to Americans. Smith's strategy was to reinforce that sense of deprivation in order to build a demand for salvation through his system of art education. He told his listeners that he was not sure America could be saved: "It remains to be demonstrated how much the study of principles and their applications by teachers can compensate for the absence of museums and galleries."[32] Walter Smith's rhetoric played into the low esteem that Americans had for themselves.

Smith reinforced Americans' deeply held beliefs that they were without culture. Americans appreciated being told that theirs was "a civilization which had no past history, no cathedrals to hand down to us the refinement of architectural expression, nor museums forming storehouses of power in fine industrial art, the product of our race in years gone by."[33] Each of Smith's words was gauged for its effect. When he called museums "storehouses of power" he fed the fantasies of American industrialists. If art were a vehicle for establishing international power, then certainly Americans should have art. Half a century later, it became the task of John Dewey to blow the whistle on the use of art as nationalistic competition.

Just as the city of Boston and the state of Massachusetts had their public display at Horticultural Hall along with the Normal Art School, the heart of the whole plan required that the fledgling art school have its own special media event, too. The best event possible was a first graduation that could take place while the centennial was underway, in the spring of 1876. Little did it matter that the four-year school had been in existence for only three years. A ceremony was scheduled for June 23, 1876.

The Normal Art School commencement of 1876 was billed as the event that would launch the nation's next century. It is difficult to exaggerate the importance attributed to it by the country as a whole. The commencement speaker was Massachusetts Governor Alexander H. Rice. He assured those concerned:

"We have attained to a state of social progress where art of some kind enters almost everything that concerns us in life . . . correct knowledge of its principles and their proper application is no longer the privilege and luxury of the few, but the necessity of the multitude. . . . Wherever science has carried her torch, art has followed with her hammers; and both the methods of production and the markets of the world have changed. Our competitors are mankind and our markets are the world." [34]

The students who sat in the audience at this graduation felt themselves to be part of a great art army. One student, B. F. Putnam, addressing his peers from the stage, said:

"The demand of the new century . . . is for recruits in that army that is being raised to do service in that 'peaceful battle of form' and skill and taste, a battle that is to be fought with ignorance, crudity, even barbarity, a contest that must be waged." [35]

In sum, these students were ready to do battle against those very qualities that Americans most feared in themselves.

Such ambition hardly seems appropriate to the facts. Students were admitted who perhaps could neither read nor write, so long as they could pass an examination in freehand drawing. Ninety percent were at the start of, rather than continuing, their art education, and none of the graduates had completed the whole program.

Since no student could have by 1876 completed the four-year curriculum, the school instituted a certificate that could be awarded to the students who completed any of the four years. The device of the certificate solved two problems; it legitimized the event of the graduation itself, and it disguised the fact that few students remained at the school for more than two years. Yet Putnam, speaking for all his fellow students, told the governor:

"You have now conferred on us the official commission to the state, testifying to our fitness to do service to this cause. . . . In accepting these [certificates] the first ever granted on this side of the Atlantic, we are ready to pledge ourselves to go forth, to the contest wherever and whenever duty calls us to the field." [36]

Completed artwork as well as graduating students were necessary to attest to the school's achievement. Smith had to plan well before June 1876 so that students completing the first-year program, Class A, could enroll in any subsequent ones, Classes B, C, or D, in any

order, to be assured that by the time of the centennial, samples would be available of all four years' art curriculum. It must have taken some maneuvering to get strong enough students into each of the levels:

CLASS A: Elementary Drawing, Foundation Year

CLASS B: Form, Color, and Industrial Design

CLASS C: Constructive Arts, including descriptive geometry, architectural design, machine drawing, and ship drafting

CLASS D: Sculpture and Design in the Round, including modelling and casting procedures.

Smith succeeded. A leather-bound volume of exemplary student work was proudly displayed in Philadelphia.

Smith's mission "'to devise the most comprehensive system of art instruction the world has ever seen in ancient or modern days'"[37] was glorified, and the audience was assured that the students' exhibition in the main building at Philadelphia's Centennial Exhibition would testify to Smith's success. Putnam's remarks captured that spirit which Smith wanted to carry on to Philadelphia:

"And now with gratitude . . . we are ready to go forth and plant in this state, and here and there all over this land, the seeds of art instruction we have gathered. . . . May we not believe that the historian of the next century as his eyes sweep down the long vista of a hundred years, searching for the glory of the cause of the Republic, will speak of this day and this hour as the beginning of better things. . . ."[38]

If the interest of the crowds in the children's art exhibition the previous March was not enough to propel them to Philadelphia, this graduation of the Normal Art School, with all its rhetoric and political upstaging, would surely do so.

CHAPTER 11

CENTENNIAL

By the midseventies, Henry Cross was traveling more than
ever. We know this from his art diaries, in which each
drawing is dated and labeled by site, as was customary for
landscape artists. In the fall of 1874, returning from a trip to New
York, Henry went to Merrimack, the New Hampshire town west of
Manchester on the western shore of the Merrimack River between
Bedford and Nashua, to see the farm his parents and sister were plan-
ning to move to. The farmhouse and barn there would remain the cen-
ter of his family's life for the rest of the century and become home to
the family's descendants for the next hundred years. (It was the sale
of this property in 1982 that brought to light the family papers that
gave rise to this book.)

The farm was located on the old Daniel Webster Highway, now
Loop Road, whose narrowness even today shows its age. At the time
the Crosses acquired their place, houses on either side dated back to
the eighteenth century. Their neighbor to the north, Samuel McConihe,
had already been there some fifty years. He had acquired his property
from John Clapp, who purchased it in 1808 from a family that had
owned it for two generations. The houses to the south are believed to
have been millhouses back in the 1700s.

Moving and
Traveling

No documents or journals state explicitly the family's motive for moving. Presumably, they found city life spiritually and financially unrewarding, particularly since these years were tough economically. In the years 1873 and 1874, a severe business depression left many in the city without employment. Crime and poverty increased. In retrospect, the in-town Manchester years turned out to be only an interim period that permitted the family to restore their financial and emotional resources after the draining years at City Farm. They could prepare to reinvest in every sense in a new farm that, like Shady Nook, would be their very own.

The Merrimack farmhouse suited the life that Joseph and Deborah Cross, both in their late fifties, wanted for their remaining years. Its two-story wooden structure had only a modest doorway approached by a couple of steps. Friends and family would be expected to use the kitchen doorway, off the long porch that bridged the house to the barn and ran parallel to the kitchen. From the kitchen door, looking out toward the white-picket-fenced front yard, Deborah Cross already could envision her beloved flower garden. Almost one-half of the porch was sheltered by trellises, planned to support climbing roses. The aging Crosses must have wanted this large house to entice their sons back for long visits and perhaps to stay. This was hardly a house built for two or even three. If Emma ever married, there was room here for more.

The land around this house was to have as powerful a hold on the adult Henry's aesthetic imagination as City Farm had had in his adolescence. He was to draw and paint Baboosic Brook, three hundred feet behind the house, from every angle in its minutest detail. Henry loved water, and here he could enjoy its sounds and light. As Henry made a path along the brook, stepping over roots, studying the speckles of light that broke through masses of leaves, he met the subject that was to be a magnet to him for the balance of his years.

As both parents and twenty-five-year-old Emma busied themselves with preparing the house and the animals that they acquired for food and profit, Henry meandered down to the brook, where the trees seemed in even greater focus reflected on the water's surface and the blinding sun more brilliant down here than it appeared in the sky. Depending on the clusters of rocks and branches, the water's rush

was either smooth or disrupted. All this variety delighted Henry, nourished on the ideas of Ruskin, and he made his drawing pages, like the water's surface, the retentive mirrors of nature around him.

Eighteen seventy-five was the year of moves. The family moved into its Merrimack home by the end of that year, which meant Emma had to relinquish her job in Manchester. Samuel Kilburn also was moving, leaving 96 Washington Street for expanded business quarters at 242 Washington. The two Cross brothers changed their Boston residence as well. Rather than boarding separately as they had been, they agreed to take one place together and moved into 52 Greene Street.

After all these changes, the Cross family enjoyed, in September, that too-rare occasion—a reunion with all three children. The occasion was the 1876 New Hampshire State Agricultural Fair. Thanks to Henry Herrick's efforts and the contributions of Emma, Foster, Henry, and others of the art association, that year's art exhibition at the state fair was acclaimed as the best yet. The proud agricultural society once again fitted the artist's work in with the produce of farmers, as the category of needlework and fancy articles was displayed alongside vegetables, swine, fruit, flowers, and machinery.

No drawing books of Henry's survive from the year 1875, perhaps because everyone was moving. But beginning with January 1876, we know that, despite the cold of winter, Henry worked at drawing outside. That January, perhaps on one of those freak, mild winter-thaw days, he drew *Our Boat House* and *Airing Day at our Shanty* out at Point of Pines. In March, he returned to Merrimack and drew nearby Atherton Falls. Baboosic Brook became his subject again in April of that year. By May 1876, Henry started a new art diary. On July 9, around the time of his twenty-fourth birthday, he was in Concord, the state capital, drawing subjects quite unusual for him: church steeples and housefronts. From Concord, he traveled on farther north, drawing the Pemigewasset River and the White Mountains. This book included other unusual subjects: a rough sketch of a peacock, the first animal to appear in his drawing since his adolescence; a large group of people in Concord enjoying a clam chowder picnic; and a man drawing out of doors under the customary umbrella. He also drew that natural illusion of art at Franconia discovered early in the nineteenth

Left: Copper medal designed by Henry Walker Herrick for the New Hampshire Agricultural Society. This medal was awarded to Joel Foster Cross in 1873. Size: 2″ in diameter, ¼″ thick.

Below: Reverse of the Herrick Medal.

century: The Old Man of the Mountains, a jagged edge of rock protruding from a high cliff that appears to be a man's profile.

In the midst of his travels, on August 7, 1875, Mr. Herrick's widowed mother, Martha Trow Herrick, died. Presumably, Henry attended the funeral, held the next day at the Russell Street house.

That year Henry's sketchbooks did not peter out with the end of summer, as they often did before and afterward. Drawings continue through October, recording his move from New Hampshire back to Massachusetts, where he drew Arlington's Spy Pond, Cambridge's Fresh Pond, and his beloved beach shanty at Point of Pines.

In October, Henry continued his travels, heading farther south to New York. One river landscape in his art diary, entitled *Approaching New York*, may well have been drawn from the train as he passed down the eastern edge of the Hudson River toward New York City. From New York, Henry continued his train journey south through Newark, Princeton, and Trenton, New Jersey, and on to Philadelphia, where he joined the multitude attending the Centennial Exhibition in Philadelphia. Celebrating the nation's centennial in Boston the previous spring enticed him and many others to think the trip worthwhile. October 12, 1876, was officially designated as New Hampshire Day at the centennial, which probably influenced Henry's decision to come at that time.

At the Centennial Exposition

Were Henry Cross living today, this journey would have been considered entirely tax deductible. Here he was, an artist in a field that was barely considered art—wood engraving—in a country that could hardly believe that it could produce any art, of a family that might have preferred that he remain a farmer, among many people who believed that art was only for those with wealth, culture, and a classical education, off to his nation's celebration of completion of its first one hundred years, and the exhibition was devoted to Art. Most of the displays had direct connection with Henry's work. Just as with the Massachusetts's centennial events, art education, art and industry, and industrial art, were the hot topics at Philadelphia.

Henry Cross would have arrived at the fairground via the Pennsylvania Railroad's special train just as millions of other Americans did. His train, passing across the Girard Avenue Bridge over the Schuylkill River, offered an excellent view of the exposition and then deposited

This wood engraving depicts October 12, 1876, New Hampshire Day. Crowds from the Granite State gathered before Governor Cheney, who addressed his constituency from a podium on the porch of the New Hampshire State Building.

Source: *Frank Leslie's Historical Register* (New York: Frank Leslie's Publishing House, 1877), p. 200.

him right at the gate of Fairmount Park. There, he and all the other visitors faced fifty acres of buildings and a nightmare of stalled carriages and horsecars, crowded sidewalks, and people waiting to get into shops, restaurants, and hotels. A special railroad formed a ring around the fairgrounds so that visitors could be deposited along the way at different starting points. The buildings were set on 236 acres of landscaped grounds, the final result of five years of planning and an expenditure of over ten million dollars by federal, state, and foreign governments.

Just having passed his twenty-fourth birthday, Henry was feeling quite adult. He had a sense of himself and his own purposes. He was who he had wanted to become: an artist who drew landscapes for his own pleasure and who made wood engravings to earn his living. He was an artist salaried by Samuel Kilburn to produce illustrations of just about everything, even of the newfangled machinery that he heard was on display here.

Though Henry's sense of himself may have been becoming clear, the concept of art that he was to meet at the centennial certainly was not. As he looked through his red clothbound official guide to the exhibition, so much was called art that he was not sure where to begin. The following description of his tour of the fair is based on best guesses on my part, aided only by the evidence of his interests and his own copy of the official guidebook with his red paper place markers still in it.

The guidebook explained what was where. In the Main Building were three major departments. Department one was devoted to mining and metallurgy, department two to manufactures, and department three to science and education. The manufactures called art exhibited in department two were ceramics, glass, furniture, and textiles. The science and education department also displayed its "art": drawings, art instruction methods, maps, and architectural plans. Another building, Memorial Hall, also had art exhibits; it filled its acre and a half with galleries of paintings and sculpture. The Women's Pavilion also had its own art department.

Perplexed by this diversity, Henry had to figure out where to start, and while he wandered, he tried to decipher what art had come to mean here. Had this art any relation to what he had learned years back from Henry Herrick, or was it more like the industrial art that

One of many art exhibits at the centennial. The masses of images on the walls suited the crowds of observers. This wood engraving shows viewers of the Art Department of the Woman's Pavilion.

Source: *Frank Leslie's Historical Register of the United States Centennial Exposition*, ed. by Frank H. Norton (New York: Frank Leslie's Publishing House, 1877), p. 208.

was being taught in the schools? Was art what he was doing at Mr. Kilburn's offices and what Mr. Prang and others were producing in the burgeoning Boston printing business? Back in Boston, artists and printers had barroom battles over the question of what art was, and now, in full view of the world, the controversies, contradictions, and conflicts were on display.

Even without the question of art, the sheer scale of the exhibition was confusing. In addition to those buildings that announced that they exhibited art, there were yet others. Machinery Hall alone covered fourteen acres. Agricultural Hall extended for ten. Horticultural Hall was the same size as the art gallery in Memorial Hall—an acre and a half. In addition to these major structures, a total of 180 other buildings and special exhibits dotted the landscape, including those of the individual states, foreign governments, and special facilities such as a kindergarten, restaurants in the style of foreign nations, and a butter and cheese factory. Drinking fountains were provided, including one called The Catholic Total Abstinence Union Fountain, which hoped to replace the temptation of alcohol with its own free libations. Of course, "houses of public comfort" were located throughout.

Nothing in Henry's sketchbooks indicates what he saw there. There was undoubtedly neither time nor space for him to stop and draw what was before him, but even if there had been, this fair was hardly his subject. In his art diaries, he rarely drew architectural forms, fabricated objects, or people, and these were what commanded his attention at the fair.

His first stop was Memorial Hall, the art gallery and its annex, conceived originally as a self-contained structure to survive the fair. It was intended to become the permanent home for the proposed Pennsylvania Art Museum and School of Industrial Art, inspired by London's South Kensington School, whence Walter Smith had come— another bow to Massachusetts's leadership in the field of art, but in the end that plan was not carried out. Memorial Hall's exhibitions were organized by the chief of the art department, John Sartain. An artist-illustrator, he came not from the South Kensington tradition, but from America's own Pennsylvania Academy of Fine Art. Sartain himself must have felt the conflict between the fine arts and the industrial arts missions within the fair.

Memorial Hall was described as a modern Renaissance structure. Two outdoor sculptures of Pegasus, one with a symbolic figure of Music and the other with a representation of History, ornamented its exterior. Entering Memorial Hall, Henry found himself among crowds of people with widely varying experiences of art. Elegantly dressed, sophisticated men and women from New York City, habitual gallery-goers, stood side by side with people who had never seen a painting or sculpture before. European works alone filled seventy-one rooms: sculpture, oil and watercolor painting, as well as a sampling of porcelains, tapestries, and engravings.

These works, representing the traditions of the contributing nations, were unlike anything made in America in terms of what was depicted as well as the form they took. Henry stared at paintings of the Holy Family, of the great saints, of royalty and ornate palaces, of beggar boys and emperors, and he walked around sculptures of Bacchus, Neapolitan water sellers, and dancing fauns. These signs of European culture, affluence, and aristocracy were what Americans, severed from their European roots, had sought to reject. Yet it was their absence that made people like Walter Smith accuse Americans of ignorance, crudity, and even barbarism. The exhibition compelled Henry to figure out how these objects and their traditions related to him.

In the sixteen rooms of American art, Henry had an easier time. The American paintings there were very different from those in the European section. Though some Americans may have admired European art and even bought quantities of it, American painters created their own images with special qualities designed to suit the democratic nation. The forms of painting exhibited here were the results of a deliberate search for an acceptable American way to make art.

One direction came from Thomas Cole's "American Scenery," published forty years before: the national cultivation of a taste for scenery. American painters found they could be distinct from Europeans by depicting their own homegrown landscape. By the time of the centennial, American landscape had become "the rich and delightful"[1] banquet Cole envisioned.

Asher B. Durand encouraged American painters in the same vein. In 1855, he wrote for the American art periodical the *Crayon*: "Go

not abroad then in search of material for the exercise of the pencil, while the virgin charms of our native land have claims on your deepest affections."[2] These urgings gave rise to the American landscape paintings that Henry saw in the centennial's art gallery. In rooms adjacent to the European galleries with their beggar boys and fauns, he contemplated scenes of Massachusetts's Housatonic River, Rhode Island's Narragansett coast, New Hampshire's Keene Valley (where Henry's maternal grandparents had settled), and New York's Adirondack Mountains.

Here Henry saw confirmation of what he believed. American painters need not feel they betrayed their nation by becoming artists. Indeed, they could see the painting of landscape as promoting the love of the American soil, as being absolutely patriotic. The American art galleries proved to everyone that painting need not be foreign, aristocratic, and un-American. Henry, who treasured the landscape in his own backyard, used drawing as an expression of love of nation. Henry was prepared to relish the art exhibited here.

But Henry's interest in Memorial Hall's American paintings was not restricted to landscape. He also wanted to see Henry Herrick's paintings here. He put a red place marker, printed with a Chinese character, in his official guidebook so that he could easily find Herrick's five historical watercolor paintings in gallery no. forty-four. Herrick's series of paintings celebrated General Stark, revolutionary war hero and native of Manchester: *Stark's Last Charge at Bennington*, *Stark's Grave*, *Stark at Bunker Hill*, *Stark as Trapper Captured by the Indians*, and *Stark at Trenton*. Herrick's five paintings hung just above those of his good friend Ulysses Dow Tenney in the same gallery with historical portraits of generals and commodores painted by Benjamin West, William Dunlap, Samuel Morse, and John Trumbull. The grouping of these paintings proved that history painting, like landscape, had become a legitimate pursuit for American painters. Both promoted nationalistic feelings.

Years back, on Christmas Day of 1826, John Trumbull wrote a letter to President John Quincy Adams suggesting a

"plan for the permanent encouragement of fine arts in the United States. . . . I would propose that whenever an event, political, naval, or military, shall occur, which shall be regarded by the government as of sufficient impor-

tance to be recorded as a matter of history, the most eminent painter of the time, be ordered to paint a picture of the same, to be placed in some of the national buildings."[3]

Historical painting, Trumbull believed, might help Americans overcome their suspicion of art and could redeem the fine arts from "being only the base and flattering instruments of royal and aristocratic luxury and vice."[4]

American paintings at the centennial were the results of decades of efforts to adapt European notions of art to an American set of values and fears about the morality of art. Whereas some viewed the task of democratization of art as the very heart of being an artist in America, others like William Morris Hunt of Boston felt that had they not been born in America they could have spent less time defending art and more time making it. Hunt was one of the artists listed at the other red place marker in Henry's guidebook. Here were the Boston painters, including Frederick Shapleigh, J. Foxcroft Cole, John Joseph Enneking, Benjamin Champney, Theodore Robinson, Elizabeth Boott, Fanny Alexander, and Ellen Hale, as well as Samuel L. Gerry, the wry chronicler of the Boston Art Club; Edward Mitchell Bannister, the distinguished black painter; and Henry T. Tuckerman, whose chronicles of this period enable us to know the lives of the artists whose works hung beside his.

Compared with any other American city, Boston had, by far, the largest number of exhibited painters. Being on view here, rather than at the Boston Art Club or at galleries or what they called art stores, put Boston and all its artists, including Henry, in a new light. It made Boston seem to be a very important place.

The exhibition could have prompted Henry to two extremes: to wish that his own landscapes were shown here or to doubt whether he had a right to consider himself an artist at all. He, too, was a landscape painter who depicted local scenery and that made him identify with the other artists whose works were here. But he also was a wood engraver, and despite the large representation of Boston artists, there were no works by any of Boston's wood engravers. In fact, were it not for examples by Philadelphia's Frederick Fass, official engraver of the Centennial Exhibition catalogue, not one American wood engraver would have been exhibited at the fair.

Henry was not the only one perplexed by what was going on here.

After the exhibition, art department chief John Sartain published a report in which he admitted his amazement at the crowds that gathered in his department's hall and his curiosity about what everyone was looking for. Sartain had expected the wealthy, sophisticated art aficionados to come, but he never expected the masses, whom everyone believed had little preparation for what they were seeing. What attracted them all? Had the boom in art reproduction through chromolithography made people curious to see the original paintings, just as Louis Prang had predicted they would? Were the viewers, many of them immigrants from different nations, simply eager to see bits of the culture they left behind? Perhaps the crowds included residents of those New England towns that already offered evening drawing classes, people who, despite the industrial orientation of the instruction they received had become intrigued with the possibilities of making pictures. Some may have been curiosity seekers drawn by the rumored value of these paintings. Whatever their reasons, many with much less apparent cause than Henry Cross crowded into Memorial Hall to look at art.

After passing through room after room of paintings, Henry might have had enough for one day, but since he probably could take little time away from work, he needed to squeeze in as much as he could in that single day. So he rested his eyes a bit in Fairmount Park, planning his next move, then directed his steps to the Main Building, just opposite Memorial Hall. Walking toward it, he faced a twenty-foot-tall granite sculpture of a uniformed soldier. He passed by it to enter the Main Building's north central doorway. Once inside, he found himself in a secular shrine. The sections of the building were labeled as if they were parts of a church—naves and transepts—but even without reference to a church, this structure in its sheer size would have proved awesome. It was 1800 feet long and 464 feet wide.

After getting accustomed to the scale and layout, Henry might have found the Main Building quite comfortable and familiar. Its contents were not unlike those of the New Hampshire state fairs, where machinery was displayed next to new inventions and prize livestock, vegetables and artworks. In fact, many spectators best understood their experience here in terms of their local state fairs, for here in the Main Building, agricultural samples, gems, machines for farming, weaving, and printing were all shown together. Though inspired by

London's industrial exposition and subsequent international exhibitions, this was in the eyes of most Americans just as a New Hampshire newspaper described it, "The State Fair of All State Fairs."

For Americans, generally, the Main Building represented American potential and power. Here were symbols of vast natural resources waiting to be made into things. The wealth of United States displays occupied as much space as was devoted to displays from the entire rest of the world, and the effect produced an American euphoria. As one government report described it:

In walking through the aisles of that immense building known as the Main Building . . . in which all the world set out their best displays of artistic manufactures, there came to the thoughtful observer, a sudden revelation of the relative importance, power and destiny of the white, English-speaking Protestant races of the earth.[5]

For Henry Cross, who had known the quiet side of Manchester through most of his young life and had only recently immersed himself in the business of Boston, it must have been startling to consider himself now in relation to other nations of the world. Here, he could not avoid seeing himself as part of a mighty power too rich and too productive to be ignored.

In his recent years in Boston—in fact, since the close of the Civil War—the artist was increasingly considered the person critical to American economy. The person who could draw would transform ideas into machinery and raw materials into finished products, and could increase sales through illustrated advertisements. For Mr. Kilburn's commissions, for example, Henry already had had to scrutinize brand-new machinery, such as a mechanical printer's brayer, and new inventions, such as the bicycle, in order to render his precise wood-engraved illustrated advertisements for their manufacturers. "Art applied to industry," the latest word throughout the Main Building, was in fact proving profitable for many artists. Laboring for industry provided an alternative to the unhappy fortune of so many artists, who could complain as Benjamin West did when he arrived in London, "I've come a great way to starve."[6] Henry quite unwittingly found himself in a central, powerful position within the society of his time.

The economic importance of art to the nation at this moment was indicated even by the choice of location for the centennial. J. S. Ingram, who wrote the comprehensive history of the Centennial Exposition, explained that one reason Philadelphia was chosen as its site was because the city already had an artistic tradition. Philadelphia's Pennsylvania Academy of Fine Art, established in 1805 to improve and refine the public taste, needed only a slight push to get in step with the times. Rather than encourage "works of genius by providing elegant and improved specimens of the arts for imitation," as stated in its charter, it could inspire improved specimens of plows, diamond-stone saws, brick machines, perforated chair seats, ice crushers, and gold pens.[7]

Sensitive to this shifting spirit well before 1876, Charles Callahan Perkins had predicted that Walter Smith would become one of the heroes of the centennial. Indeed, he did become America's symbol of artistic self-improvement. In the Main Building, Henry Cross could view, alongside numerous framed individual pieces, huge leather-bound volumes of the artwork of Walter Smith's students from the Massachusetts Normal Art School. Henry could compare his own adolescent art with the student work here and reflect on his education in relation to this system of instruction.

Walter Smith's display thrilled many Americans, particularly because it won the praise of foreign judges. The French commissioner of education praised it, saying that it was "extremely remarkable," and he predicted "a brilliant future for the industrial arts in Massachusetts."[8] The Canadian deputy judged Smith's exhibit a "complete success" and "recommended the adoption of the Massachusetts system in the British provinces."[9] The United States government report applauded the Massachusetts Normal Art School and praised it for spreading its thorough and effective training throughout the nation. The young art school won a medal for excellence in its work from the centennial's award committee.

It took a visit to the Main Building for Henry Cross to see why everyone back in Boston had been so excited about Walter Smith. All the plans to transplant British art education to America began to fit into place. Ever since the abolition of slavery, the quality of labor was a pressing subject. Every workplace wanted the most highly skilled

labor possible. People were needed who could work carefully with complex tools and deliver products of the highest quality, whether on farms or in shops and industries. The stampede was on to improve the tools, the equipment, and the visual appearance of products. The artist was deemed essential for all three.

Another motive for importing Walter Smith to America also became clear. Americans had always deferred to Britain in matters of production. This attitude was formed when the colonies were young. For years Americans had been sending their raw materials to England for fabrication and transformation into salable goods. From the start the British were attracted to the New World for its raw materials. Its relationship to the states was defined to ensure its continued benefits from these resources.

Although America was the home of the beaver from whose fur men's hats were made, the colonists were rigorously prevented from making their own hats; the skins [had to be] sent to England and made there and then bought at high prices by the Americans who trapped the beavers.[10]

For years, Americans had tacitly agreed that the British knew best. Rousing from their passivity, Americans were at once wary and envious of the British. In order to emulate their methods they needed an Englishman to show them the way. Walter Smith became their way of getting what they wanted.

The Main Building showed not only Walter Smith's instructional system and his students' work, it also included his publications. Because of Perkins's and Smith's passion for art education, tremendous energy was devoted to spreading the word, not only in Massachusetts but across the states. The mass distribution of American Textbooks of Art Education, first by Osgood and then by Louis Prang, was just the beginning. However well marketing of these publications served the new ideas, the Centennial Exposition assured them even greater visibility.

That only slightly less recent Boston arrival, Louis Prang, astutely perceived the importance of the centennial and became an inseparable part of the plan. Prang, already Smith's publisher, was well aware that the fair could make Smith a hero, and he wanted his name, as much as that of Walter Smith, before the eyes of the world. For this reason, Prang financed and prepared his own exhibition for the Main

Building to accompany the Massachusetts Normal Art School display, enticing people to purchase "the appliances used in the schools for giving instruction in drawing . . . solid models, casts, drawing books and cards, and teachers' manuals, large studies in light and shade and sepia and studies from nature in watercolor."[11]

Both Smith and Prang were sharp businessmen. Each knew at that moment that they needed each other. The notion of art applied to industry gained a momentum at the centennial that would inevitably continue long afterwards. Both men realized they were launching a collaboration that could be profitable for years to come. Prang, who had been nourishing the American appetite for art through his art reproductions, greeting cards, and album cards, now broadened his markets through schools and school-related studies. He had the same success in selling Walter Smith to the schools as he had in selling chromolithography to the home. By allying himself with Smith in the most visible arena available, the Centennial Exposition, Prang reinforced his preeminence in selling art to America.

By the time Henry Cross was ready to leave Philadelphia, he had a better sense of his nation's priorities. The consuming passion for art that seemed to have taken possession of almost everyone left a lasting impression. If the question of what *art* meant was never sorted out— and it really could not be—at least he had seen everything that his culture decided to call art in all its many manifestations.

When Henry left the Centennial Exposition at Fairmount Park, his eyes had done enough looking for a while. Stimulated and exhausted by the barrage of new sights and new information, he was ready to rest. Boston, which had only recently seemed so busy and demanding, must have seemed calm by comparison, permitting him much needed time just to close his eyes, to allow those experiences that were important to him to sink in.

Had Henry kept a journal of his thoughts and feelings at the Centennial Exposition, it would have been most useful to us here. Contradictory messages had been cast before him, some insulting, others encouraging, and he needed to sort these out. He had every reason to feel confused, angry, and insulted. We may hope he was less bruised than he had reason to be.

Aftermath

The paintings in Memorial Hall could have encouraged and in-spired him, but Walter Smith's approach to drawing was the antithesis of Henry's in both purpose and appearance. Nowhere in all of Henry's practice sheets through childhood and adolescence is there a single page of circles, squares, cones, and cylinders, the bases of Smith's teaching. Henry's art training involved only patient drawing from nature and from storybook pictures. Now, more than ever, after years of painting, drawing, and engraving, he needed someone in addition to Henry Herrick, to protect him from Walter Smith's condemnation of American aesthetics. Ironically, it probably was another Englishman, John Ruskin, who helped. Ruskin, who believed that observational drawing was useful precisely because it destroyed the possibility of any system for drawing, had been battling the British schools of de-sign long before Walter Smith ever hit American soil. Ruskin's point of view might have comforted Henry, now back home, integrating all these recent experiences while he worked in his art diaries.

In his young life, Henry had already adapted to much change. He was born into a city at the vortex of physical, social, and economic change that offered him and his siblings the benefits of schools, li-braries, and public speakers. Having change as the norm also helped Henry understand people's differences and consider unfamiliar ideas that came in the form of improved printed picture books, art repro-ductions, and art instruction books. Awareness of change stirred him to leave the familiar path of farming to become an artist and wood engraver.

The change of city, the move to Boston, shocked him again. He thought he was an isolated outlander, but soon found himself part of a crowd of artists. The centennial was another shock. The exhibition presented new demands. Henry found himself in the midst of a con-test in which he had never enlisted: Armies of different nations waged war through their art products, and the soldiers in these armies were artists. With the Civil War barely a decade past, it must have been stunning to find oneself engaged in a war of art applied to industry.

Until the time of the exhibition, Henry's life consisted of small-scale personal aesthetic choices, not only in his art, but in every as-pect of his life. He and his family provided for their needs as they saw them, preserving their old rocker, old books, and many other things

from earlier generations that they saw as well-made and beautiful. For Henry, drawing landscape was a personal act, capturing spiritual and even nationalistic feelings. Deeply, he knew the value of removing himself to some isolated country spot to draw the twigs and the grasses in front of him.

Henry, trained by the illustrated press and his artist neighbor, innocently attended the exhibition proud of his personal mission as an artist. After the centennial, nothing was the same. The cherished old books and the family rocker became, overnight, signs of America's aesthetic inferiority. Art, other than perforated veneer chair seats and ornate marble soda fountains, had become almost irrelevant in the exaltation of Walter Smith and his system of industrial art education. The Centennial Exposition fostered a new struggle. The Manchester School Committee already recognized it, even in 1875:

The time is not far in the future when the question of the supremacy among nations is to be a question, not of armies and of battles but of art, industry and skilled labor. . . . In this country, the foundation of this art education must be laid in our common schools and must begin with drawing. . . . Whosoever attends the Centennial Exposition at Philadelphia will behold the results of such [art] education, not only in France, but in other European countries, where drawing is made the foundation of all manufactures and of all art.[12]

The exhibition did, in fact, reveal some of the secrets by which the French, and indeed other nations, trained their art armies. The Department of Education and Science in the Main Building disclosed different nations' methods of education in art. Americans perceived that inferiority led people to identify with England and Russia because both nations had felt themselves to be inferior in art and deliberately established a plan for improvement.

Russia's exhibit was the result of its conscious efforts to recreate a national art, motivated by the patronage of the czar. From Russia's exhibit, Americans learned that "definite instruction in the fine arts . . . and in mechanical arts can both be successfully given, and that it is possible for a ruler or for a community to train both artists and artisans."[13]

England's display stirred Americans because it showed the success of a deliberate movement to improve a nation's manufactures. Well before her Great Exhibition in 1851, England was possessed with the

will to overcome the stigma of aesthetic inferiority when compared with the nations on the continent. From England's exhibit, Americans learned that it was possible to improve a whole nation aesthetically and that from this improvement would come wealth. Americans, seeing that the British had improved themselves, heard Walter Smith say: "It used to be the monopoly of England to stand lowest in the visible evidences of civilization, as seen in her manufacturing industries. I am sorry to be obliged to say today we, in America, have inherited the reputation which England has lost."[14] Americans were embarrassed into action.

Since the international judges approved the art of the Normal Art School, it appeared that America could rise from its lowly position in the world. Acknowledging America's inferiority, Smith admitted that "by the verdict of the most patriotic Americans, America stands today at the very bottom of the column of art, manufacture and industrial taste."[15] But there was hope. "Other countries have delivered themselves from a low state of taste and barbaric conditions of manufacture. . . ."[16] Given even twenty-five years, Smith was sure the Normal Art School would be seen as "a little leaven, leavening the whole lump."[17] That was enough to make Americans euphoric.

The shock of the centennial was felt not only in international terms. Rivalry between the states, which so fiercely expressed itself in the Civil War, again manifested itself in competition for priority in manufacturing:

Every New England man who stood amongst the magnificent contributions of natural wealth from the Southern and Western States saw more distinctly than ever, our [New England's] place as a manufacturing district. It was evident too, that other sections of this country are successfully manufacturing what were once exclusive products of New England. No lesson of the Centennial is plainer than that New England must eventually change the character of her manufactures from the coarse and the plain to the finer and richer, requiring more elaborate processes and more skill and design—such goods as come to us from the old world. The center of fine and artistic manufacture has long been in Europe and naturally belongs to New England.[18]

The new struggle could not but provoke reflection upon the war just passed: "Like thunderstorms, wars may be necessary convulsions; and in their issue . . . the fierce and deadly contests of hostile rivalry may ultimately prove beneficial."[19]

Despite all the talk about art, the great lesson of the centennial was an economic one. Governments supported the industrial orientation of art in elementary and secondary schools, and in evening drawing classes, as well as in normal school art classes for teachers, while artists with another vision were relegated to the sidelines. Despite its apparent concern with art, the centennial was a massive blitz to create new appetites, to increase American spending. Artists were needed only to create a generation of wanters and consumers who would condemn objects they had owned and loved and buy new things. People were caught unaware. They were susceptible even if they did not want to be. "Look into the shop windows of our great cities, mark there how many beautiful objects you see that you first saw at the Centennial."[20] The first aim was to get people to admire these objects; the second was to get them to make these objects in the United States rather than importing them from everywhere else; the third was to get them to buy them.

Try though he may have to find comfort in the values of his childhood, Henry Cross could not escape the commercial pressures. Back in Boston, Henry had to fit himself to all these new demands. In Boston, everyone wanted to be on the art bandwagon. Walter Smith, who always had to court the legislature in order to secure his annual budget, now also approached business and academic institutions, and everyone wanted to support him. The Massachusetts Normal Art School became a cause célèbre. The Boston Museum of Fine Arts promised free admission to all Walter Smith's students. Mr. Henry Durant sent the choicest flowers and foliage from Wellesley College conservatories so that the Normal Art School might have the best specimens for the use of the freehand drawing and flower painting classes. Everyone wanted to help in this process that seemed so refining and, simultaneously, so supportive of the national economy.

The academic year 1877–78 proved to have peak enrollment: 265 men and women. These numbers that seem small to us today had a huge impact. Graduates of the Massachusetts Normal Art School were eagerly hired to teach in evening drawing classes in Worcester, Lawrence, Lowell, indeed throughout the state as well as in cities and towns across the country. Their success spread the word; the art army was in the making.

With new economic priorities, the role of artist had changed. Whether he liked it or not, he was in the eye of the storm. The centennial was a critical dividing point. Artists trained after it would think entirely differently than those schooled earlier. Henry Cross and other artists, substantially formed before the centennial, were in an ideal and enviable position. Henry had been taught before any system became rigidified in public schools. He benefited from a private, family-based experience of art making with Henry Herrick and a rich and unusual grammar school experience with Col. Francis Wayland Parker. His now mature mastery of the marketable skills of wood engraving opened to him a field that, because it was not called art, left him free rein to use his skills as needed. By the time of the stimulating and intimidating experience of the centennial, Henry already was set. The criticism and denigration of American visual culture that shaped younger people just starting their training may well have sounded to him somewhat like a cranky, troubled relative to whom one need not pay too much heed.

Despite all the faultfinding, the centennial did embody the preoccupation with the American dream of art. Art represented opportunity. Young people like Henry who were just launching their art careers had to feel energized by it. The artist, the citizen with some aesthetic skills, inevitably gained a certain social prestige in the course of the six months of the centennial exposition. Artists of all varieties were eagerly absorbed into the economy. They sold their products, they advertised other people's products, and they taught other people to follow their lead. Henry, who mastered landscape painting and commercial advertising, seemed to have it all!

At the same time, everyone felt some pressure to change. Both Charles Callahan Perkins and Henry Walker Herrick, who started their art work from personal preoccupations, underwent a change of goals. Perkins had spent years painting in Europe, whereas Herrick spent years engraving in New York City. In time, their commitments to their communities led them to return home and address their energies to those who knew less about art. They both worked to spread the knowledge of art, and neither could have succeeded had there not been the desperate hunger for improvement among the citizens themselves. Had people not been impressed by the opportunities for art

labor and uncomfortable because of their alleged lack of culture, the efforts of these two men would have accomplished naught.

Perkins and Herrick each made the most of the tide they perceived in political, cultural, and economic affairs. They started to influence their respective communities at exactly the same time. Each built an organization involving many people, public displays, and massing of financial support. They gathered their respective forces so that by 1876 their efforts could fuse with the goals of that grand art educational event, the centennial, in one big crescendo. They were the advance guard. Once the fair was over, everybody followed them.

Self-improvement was all the rage. The students who sought an art education after 1876 were quite unlike Henry Cross and the assorted country kids who quite privately sensed their desire to be artists and humbly approached the cities seeking employment and art instruction. Those who came after 1876 were filled not so much with personal or private motives as with a public mission. In the fall of 1876, when the Boston Museum of Fine Arts opened its own school to teach drawing from casts, still life, and the human figure, it felt obliged to teach commercial printing processes, too.

Those who would not go so far as to take art classes wanted books. The exhibition in Philadelphia was acknowledged as a great teacher. To preserve its lessons for those who could not attend or who had not yet been born, books were needed. Authors and publishers encapsulated the exhibition in books that were commemorative museums. One lavish three-volume leather-bound set, *Masterpieces of the International Exhibition*, published by Philadelphia's Gebbie and Barrie, proudly announced that Walter Smith prepared its volume two, entitled *Industrial Arts*.

The centennial proved to be not only an educator of taste, but also a process of consciousness-raising for the public, the rank and file who were to become America's principal patrons of art. This new role required that special attention be given to the needs of the people so that they could assume their new role intelligibly:

Nothing appears more directly calculated to raise the character of modern painting . . . than the promotion of sound art education among the masses of the people. . . . To know a good picture from an indifferent one is not a natural gift. . . . It must be acquired and cultivated by study of good pictures.[21]

Just as Walter Smith and Louis Prang predicted, the exhibition made people hungry to know and to buy anything and everything concerning art. Art information itself became a most salable product. People wanted to know the history of many arts, specifically the materials and actual procedures for making objects in the fine, industrial, and mechanical arts. The exhibition had led viewers to crave information, perhaps because it underestimated this appetite and printed only a few meager pamphlets. The lack of information only increased the demand. Harper & Brothers published two compendia immediately following the exhibition: *Art Education Applied to Industry*, by George Ward Nichols, and *Pottery and Porcelain from Early Times Down to the Philadelphia Exhibition*, by Wallis Elliot.

But these volumes did not suffice. Again, like the flood of computer magazines a century later, handbooks and journals proliferated for a newly discovered audience. New York's *Art Amateur*, a family journal, and Boston's *American Art Review*, published by Estes and Lauriat, were two such publications.

Henry subscribed to as many journals as he could get. Though much of the magazine collection was sold before I ever saw the Cross family boxes, some issues did survive along with the artwork. These included the New York edition of London's *Art Journal*, with its meticulous steel-engraved reproductions of paintings and its articles such as "Studio Life in New York," "Prize Designs for Art Manufacture," and "American Painters." It claimed to be a "record of Progress in the Arts . . . that affords instruction to amateurs and students, furnishes designers with innumerable suggestions, and gives examples of what is doing in Europe and America in the different arts."[22] *American Art and Art Collections of America*, published by E. W. Walker and Company in Boston, was also in Henry's stash. In sixty-two serialized parts, it offered an original steel engraving by each of the sixty-two American artists to whom an issue was devoted. The list is a *Who's Who* of American art for its time.

The lavish publications fed a curiosity about both art and Europe. New York's Appleton and Company, in its publisher's series Picturesque Europe, offered Henry examples of ideals of landscape composition in wood engraving executed in the best of European tech-

niques. Henry saved these along with his copies of *Art Journal* and *American Art Review*.

Great results were anticipated from all these efforts.

[The Centennial was] one vast art educational enterprise . . . [that] could set American taste aright. The Artist, the Manufacturer, and the Artisan learned the valuable lessons that are derived from *comparison* in actual and practical schools; they saw and no doubt, studied the perfections and defects they are required to imitate and avoid. . . . Already there is evidence that such teachings were not in vain; and, with time, out of this exhibition, will issue immense results. . . .[23]

The centennial taught Americans how much they did not know. George Ward Nichols gave the following critique of the educational influences of the Centennial Exposition in his *Art Education Applied to Industry*:

Art is not the privilege of a class; it is essentially human and is both individual and universal. How can it be developed? . . . By technical education . . . in schools; by the study of great works of art; by the establishment of museums, which shall be open to the public; by the organization of societies in the interests of special industries; by expositions of pictures, statuary, objects of ancient art, and of all the products into whose composition art may enter.[24]

So far, Nichols's view elaborates only the general view of the time, but he does not stop there. He speaks of the clients, the consumers, of his grand educational program:

If this want were confined to children, the matter could easily be arranged . . . but other classes need instruction and the trouble in America is, that many of the masterworkmen, the manufacturers, and the capitalists are all as uninformed and indifferent as the men they employ.[25]

America's aesthetic inferiority became a matter of public policy. By 1881, the United States government report on the progress of art education concluded:

It by no means follows in the United States, as yet, that the possession of wealth necessarily implies any form of culture; least of all, art culture. Nor ought lack to be held . . . as a reproach to the individual, because this country has heretofore, the Centennial Exhibition alone excepted, been absolutely destitute of opportunities for the acquisition of art knowledge.[26]

Henry Cross and anyone else who would consider himself an American artist were in an impossible position. Those who did not aspire to

make art or study art were considered boors; but the existence of those who believed they were artists—and indeed there were many— was denied by public rhetoric. Exceptions, such as the 1881 exhibition of 500 works of American engraving on wood at Boston's Museum of Fine Arts, must have been encouraging. One journalist, trying to be sympathetic to the artist's peculiar position, wrote a couple of years earlier:

When the lives of the artists of America shall be written by some future Vasari, it will be seen that most of them labored under greater disadvantages than beset their brethren abroad, and that there is little or nothing in their ancestry and surroundings to account for their determination toward Art. A large number will be found to have come from the people—that is to say, from those to whom Art is as if it didn't exist—farmers, tradesmen, and the like—and to have struggled harder for that very reason.[27]

In this rush for artistic improvement, Henry Cross must have felt very odd. His ties to Herrick and Kilburn and to his artist colleagues in Boston, as well as a few sympathetic writers served as ballast against the storms of rhetoric that said he and other American artists did not exist.

CHAPTER 12

THE DREAM AND THE AWAKENING

In the 1880s, the couple who themselves broke away from their hometowns in their youth now found themselves lonely when their three children each likewise left the nest. On July 1, 1883, Deborah Cross, who usually wrote to both sons together, composed a letter for Henry that she promised would be exclusively his. She told him that Emma was away and Foster had delighted Joseph and her with a surprise visit. No sooner had Foster arrived, she noted, than he had made a beautiful picture. "He thinks it's the best he has done."[1] Deborah tempted Henry to come too with an offer of fritters, strawberries, and cream, and mention of her enjoyable visits to friends in Manchester: "Friday we took Gyp [the horse] and drove to Manchester and took our dinner over the hill to the Poor Farm [City Farm]. Enjoyed the day ever so much, called at Mr. Herrick's on our way back."[2] By then, Mr. Herrick was about sixty. Well she knew what would entice Henry to "drop in for a visit" or "spend a good long vacation."[3] She wrote Henry that she wondered what he would do on the Fourth of July. "It seems odd to know our three children are separated. You have lived so long together."[4]

One photograph survives from about this time that embodies her wish to gather the family together. It is a stereopticon card showing all the Crosses sometime in the early 1880s. Henry seems to have

Achieved

231

Foster, Deborah, Emma, Joseph, and Henry Cross, all carefully composed
around exposed roots of a tree stump. Half of a stereopticon card.
Cross Family Collection.

had his personal photographs printed in the commercial format of stereopticon cards. With ready-made stereopticon cards popularized by the Kilbourne Brothers of Littleton, New Hampshire, Henry stored away his own informal shots of family, schools, neighbors, mills in construction, even their brown-and-white spaniel, Dick. The stereopticon card of the reunited family, though not so posed as that daguerreotype of the 1850s, was hardly a candid snapshot. The family appears to have chosen to have themselves photographed behind their new home in Merrimack, down by Baboosic Brook. They are propped in various positions on an uneven slope of land leading down to the water. The autumn earth is thickly laden with dead leaves, and the trees are mostly bare.

The photograph has no center. People are positioned so that the eye of the viewer travels smoothly from one to the other and stops and settles on no one. Closest to the center is the aging Deborah Perry Cross, shown almost in full figure. She wears a floor-length long-sleeved black dress gathered tightly at the bodice and intricately pleated at the hem. Her hands, clasped at her waist, hold a dark straw hat that conceals her stomach and much of the draped fabric of her skirt. Her white ruffled collar is fixed high at the neck with a brooch. Through wire-rimmed eyeglasses, perhaps recently acquired, she is gazing off toward the lower right corner of the photograph. Filling the whole left side of the photograph is Joel Foster Cross, the only figure visible from head to toe, standing to his mother's right. He is leaning ever so slightly against a tree stump or mound of ground that props him up. Some bit of nature provides an armrest, making his precarious position appear a bit more stable. His bow tie and white shirt, dark vest, and long dark jacket with a hem down to the mid-thigh of his gray trousers, make him look quite debonair. The whole elegant look is finished off by the bowler hat in his hand.

Between Foster and his mother is a shape that looks nothing like trees, bushes, rocks, or stumps, but rather like fur. This is probably the family dog, Dick, beside Emma, who is posed elegantly on the ground like a clothed odalisque. A high-collared dark blouse with white buttons and a velvet bodice shows off Emma's small waist, below which she holds a magazine that conceals her hips. The rest of her long skirt is masked by her mother, who is standing in front of

her. Emma's left arm is propped on a tree stump, a branch of which holds her flowered dark hat as if it were on a stand in a millinery shop window. The thick flat top of that same tree stump provides the now white-bearded Joseph Cross a lectern against which to lean. Though he looks down toward the lower left corner of the photograph, his interest seems to be in the rock he is holding in his left hand. With his right hand he is reaching into the pocket of his dark jacket, as if for a pocket knife or some tool with which he could poke at the rock. Draped next to Emma's hat and under Joseph Cross's arms is a heavy textile, perhaps a coat brought along in case the weather turned cool.

Everyone in the photograph seems to be sporting a symbol, an attribute, like the saints in the paintings of the seventeenth century. Foster has his bowler hat; Deborah Cross, her straw one. Emma has reading material and her flowered bonnet; and Joseph Cross has his rock. Henry, seated down beneath them all on the ground at the foot of the slope, is also holding his attribute—one of the treasured oblong sketchbooks, his art diary. The self-consciousness of his pose persuades me that he set up this whole photograph and that he enjoyed doing so. Henry is photographed in the lower right-hand corner of the image, seated on the ground, studying the distant landscape while his pencil is poised on his drawing book page—an indication that he was a landscape artist who must look out to nature as he draws. He had become the person he longed to be. He wears a citified gray suit and a full dark long tie. His costume, less formal than Foster's, is nevertheless more urbane than his father's tieless garb.

Someone must have wanted this photograph of this rare reunion. Stereopticon cards have two images, one for each eye, that merge into one when observed through the viewer. All the other cards have survived with their two parts, except this one. It is fortunate that one-half remained with the Cross family's possessions.

Luckily, also, the family still owned boxes full of prints by the brothers from the Kilburn Company's and Kilburn & Cross's wood engravings. Test proofs and final runs were salvaged from the office files for the family's safekeeping. A comic dialogue between a woman and the sun on behalf of Hood's sarsaparilla, "that purifies the blood and makes the weak strong," was stored along with advertisements for Golding's Automatic Brayer (a printer's inking machine), Burney's ele-

gant cast-iron stoves, fancy marble Arctic soda apparatuses, finely ornamented silver samovars—all suggesting the technical virtuosity of the firm during the 1880s and 1890s. Wood engravings of all the presidents, of historical houses and ships, book illustrations after works of artists such as Childe Hassam, himself a wood engraver, pleased Kilburn's clients and advertised the firm's skill at the same time.

By the 1880s, the Cross brothers were reaping the harvest of their hard-earned skills. They had become masters of this painstaking art. Each nest of lines with spacing calculated to create illusions of a specific degree of gray cost hours and hours of undivided attention and offers clues, like Persian rugs, of an entirely different sense of time.

The superb quality of the work earned the Kilburn firm a reputation that extended well outside of Boston. Commissions came from Page Belting of Concord, New Hampshire; Campbell Printing Press and Manufacturing Company of New York and Chicago; Wilmot and Hobbs steel brass tubing manufacturers of Bridgeport, Connecticut; C. I. Hood of Lowell, Massachusetts; as well as Boston firms: Reversible Collar Company, Emerson Piano Company, and Ivers and Pond Piano, among others.

At this time, the art of the wood engraver was art labor's best testimony. All the effort and passion for detail so important to industry was preserved in the fine lines cut into the wood block. As Governor Hartranft of Pennsylvania said in introducing Walter Smith before an 1877 joint meeting of his state's house and senate, "Minerals are of little value compared with the great amount of work represented in them after they have assumed a shapeful use."[5] The wood engraver's advertising illustration could best capture that shapeful use in infinitesimal detail. When the Arctic Soda Apparatus Company lavished its four-tiered soda dispenser with marble, glass, mirror, and brass as a backdrop for a diminutive ornamental silver female sculpture, the wood engraver's medium was ideal for showing it off. Each glimmer of surface reflection, the varied darks of its recesses, and even the letters etched in their silver signs—Ale, Vichy, Ottawa Beer, and Seltzer—could be read with satisfying clarity. Engravers rose to each occasion, exploiting the qualities of each product, the rich wood grain of a piano and the lush fibers of carpeting, for lines they could create in their wood blocks.

The celebration of progress sold Page's Belting, a client from New Hampshire. By the time this advertisement was engraved the firm was probably known as Kilburn & Cross. Circa 1891.

In the 1880s the Kilburn firm's work was well-known for its ingenuity and compositional invention. Its wood engraving enabled everyone to see America's progress in artistic manufacturing. Page Belting Company advertised its Eureka Dynamo belting through an image in which one of its belts wraps the earth in orbit with the sun and another smaller belt encloses the earth with the moon. If Eureka Dynamo belting could keep these mighty orbs on their course, certainly it was strong enough to support gaslights and run industrial machinery. Surrounding the smiling belted sun, the atmosphere glowed with the bright wood-engraved letters spelling Progress.

In the later 1880s, the firm got a commission to illustrate landmarks in the city of Manchester. The Cross brothers now had the opportunity to look back at what had been built since their infancy. Their set of engravings include all Manchester's schoolhouses, those constructed early as well as the fancier ones built well after the Crosses were of school age. One engraving shows the Spring Street

School No. 13, where Emma taught, and another the high school from which Emma graduated and where Henry barely got started. One wide wood-block print pictured City Farm with its barn and the house where the family was last to live all together. The set of engravings was completed with buildings less personally connected to the Crosses: the firehouse, Massebesic Hose Company; the city library; and the Court House. These engravings appeared in City of Manchester Annual Reports. As Joseph and Deborah Cross regretted the absence of their sons, they could at least enjoy their presence visible through the work they did in and about their old hometown.

In these years, Henry increased the time he spent painting. Perhaps inspired by the publication of Henry Herrick's book, *Water Color Painting*, in 1882, Henry produced watercolors wherever he went: Newburyport, Nantucket, Martha's Vineyard, and at the Baboosic. From his prolific production, he selected those he wished to exhibit at the Boston Art Club. Henry's work hung in the 1886 and 1888 juried annual watercolor exhibitions at the art club's gallery, where the walls were draped with cloth, divided by elegant Corinthian columns, and crowded with three tiers of gold-framed watercolors. Henry, who had worked, traveled, and enjoyed drinks with club members, now showed his work with them.

Shortly after that letter with which Deborah Cross tried to lure Henry back home with strawberries and fritters, Emma decided that she, too, wanted to live in Boston. Having given up her teaching job in Manchester in 1876 and assisted her parents in getting started on their new farm, she had, predictably, become restless. It was unusual for a woman to take off to the big city, but she decided to do it. To avoid being entirely alone, she took a room in Malden, the same town just north of Boston where her brothers were now living. As neighbors, they sometimes drew together. Like other artists who came to the city from the provinces, Emma tried to make her living there as a photo-retoucher. But unlike those artists who arrived in Boston a decade before, she could not benefit from the anatomy classes of William Rimmer, who had died in 1879. Emma set her own program of Rimmer studies, tracing more than thirty of his ten-by-fourteen-inch drawing-filled pages of *Art Anatomy*, published in 1877. For Emma, this was the next best way to study with Boston's revered artist-teacher.

Her arrival coincided with the construction of Malden's architectural treasure, the last of five small Boston-area public libraries built by Henry Hobson Richardson. Emma could watch the library being built. She wrote in her letters of her delight in walks to and from the library that, even in the 1880s, had become the repository of all she loved in literature and art. Today that library proudly displays the art collection begun in this period. It includes local Malden artists Albion Bicknell, Horace Burdick, and George Loring Brown, as well as beloved artists who were not Malden residents: Americans George Inness, Winslow Homer, Thomas Hill, and Frank Benson, and Europeans John Constable, Joseph M. W. Turner, and Jean Léon Gérôme.

It was a small world. On September 30, 1885, Thomas Lang, a prominent Malden citizen, donated a painting by Henry Herrick to the library, writing to its mayor, Lorin L. Fuller:

Wishing to add my tribute to the purposes of the founders of the public library building, and to the treasures of the Art Gallery, and learning that the departments of Sculpture and Oil Painting were to be well represented, it occurred to me that a picture from one of the masters of Watercolor Painting would be of value in many ways. I therefore desire through you to present "Summer Vacation" by Mr. Henry Walker Herrick of Manchester, New Hampshire.[6]

Lang, a native of Candia, New Hampshire, was the son of a blacksmith. He, like many others who came to Boston for the benefit of a commercial high school education, succeeded in his work. He worked for Malden's Boston Rubber Shoe Company, compiled a history of his native Candia, and became founder of the Malden Historical Society. Lang had arrived in Malden more than twenty years before the Crosses and, coincidentally, also developed a lasting interest in art.

In the years 1884–86, Emma attended Boston's Evening Drawing Classes, where she produced highly skilled renderings of the assignments in the curriculum. Since the work of all students was the same, we cannot tell if any of the work was hers that was shown in Massachusetts's display at the World's Columbian Exposition of 1893 in Chicago, but her portfolio is identical to that pictured in its catalogue.

Emma's experience in the Boston classes was different than in Walter Smith's day. By the time she arrived, Smith was gone. His in-

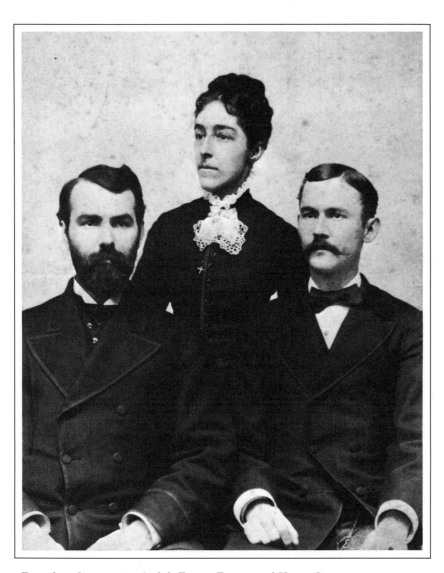

Formal studio portrait of adult Foster, Emma, and Henry Cross.

fluence had become too powerful to go unchallenged. By July 6, 1882, not rehired to any of his three positions, Walter Smith returned to England. Except for mention of a disruption of friendly relations, records are almost silent about why. Through Walter Smith, Americans had an informer who disclosed British know-how, and it seems inevitable that despite any particulars, Americans would have had to make him disappear. Walter Smith's very Englishness had become abrasive. An Englishman could no longer be credible as the symbol of America's route to economic and aesthetic independence. That British voice, however charismatic, could no longer acceptably denigrate American resources and abilities.

As art education became big business, this irritation became an opportunity. Fortunes were to be made on the orders coming in from all the states for Walter Smith's books, drawing cards, and drawing models, and up to 1882, Smith had a virtual monopoly, shared only with his publisher. Louis Prang, no more an American but less a public voice, perhaps foresaw his own advantage in Smith's departure. The many surviving textbooks attest to the fact that, begining in 1879, Prang printed his name larger and larger on the book covers, and gradually dropped Smith's name entirely; fueling the rumor that Prang himself may have played a part in the politics that forced Smith out.

With his wife and eight of their children (three married and remained in the States), an embittered, forty-four-year-old Walter Smith returned to his native soil. Directorship of a newly established technical college at Bradford became his. There he spent four sour years resenting his fate in America and disparaging the decline of British art education in the twelve years of his absence. Just at the start of a new school year, in September 1886, Smith died of tetanus contracted while gardening. His despair and sense of drama are indicated by his wish that his gravestone read: "Died of a Broken Heart."

After Smith's departure, one student of those first Normal Art School classes, Henry Hitching, who had become Smith's protégé, assumed the position as director of the evening drawing classes. It was he who supervised Emma's work. Since he was prominent in the Boston Art Club, serving at this time as one of its vice-presidents, Hitching also would have been known by Henry. By the time Emma enrolled, the evening drawing classes had been offered for eleven

years. Rigidly fixed exercises were assigned, and students obediently completed them if they wished to continue in the course. "No other drawings but those named on the list [were] permitted to be drawn in the classes."[7] Every drawing was deemed completed only when approved by the director. He indicated his approval with a rubber stamp that had a line for his initials. Henry Hitching's name is on each one of Emma's class drawings. Emma wrote:

I stay right in my room day times and work and go to the drawing school evenings. . . . I like it all for I feel that I am gaining something by it. I never get lonesome for when I get tired of work I have lots of nice friends at my right hand in my books and I am always happy with them. Am feeling first rate and take a little walk everyday before dinner—walked up to the library this noon in ten minutes. I got the "Lives of the Queens of England" to read.[8]

Emma's classes ran from 7:30 to 9:30 P.M. every Monday, Wednesday, and Friday from the third Monday in October through the third Monday in March. She started with the general elementary introductory year, required of all. For her second year, she chose, rather than machine drawing or building and ship construction, the program in freehand designing.

Her artwork and school certificates were stored for safekeeping with the other family treasures in the attic. The work, still in pristine condition, is evidence of the type and standard of work in her classes. Charcoal studies after plaster casts show how smoothly she could graduate tones of grays to give the illusion of shadows, second nature to a woman who already had spent years forming subtle gray tones through wood engraving. Whether drawing a portrait bust, a whole figure, or a piece of architectural ornament, the student faced the same problem: He or she was simply expected to modulate and control the grays to create an illusion of form in space. Other assignments required just the opposite. Emma had to draw and paint flat pattern borders that might have trimmed wallpapers as they met the room's ceiling. Each technique Emma learned was justified in the curriculum because of its contribution to the student's commercial employability. That last week in March 1886, Emma took and satisfactorily completed her drawing examinations. In acknowledgment of her success, she received a lavishly ornamented diploma certifying her completion of this highly regarded course of study.

Emma Cross's diploma for completing two years of Free-hand Drawing classes at Boston's Warren Avenue Free Evening Drawing School. Awarded in May 1886 and signed by Henry Hitching, Director. Note: Art and Industry are celebrated in roundels in the bottom corners.

Though Emma had joined her brothers in Malden, she remained quite separate while the brothers' lives drew more tightly together. Life seemed paired for the two brothers. Since their departure from Manchester, they worked together for Samuel Kilburn. In Boston, they boarded together. Each move they made, they made together, first to Malden and then on to the adjacent town of Melrose in 1891. These two adjacent towns grew rapidly in this period, and both were welcoming places for artists. To this day, both towns are known for their libraries' art holdings, acquired during this era. They were even married within the same period: Foster married first, on July 22, 1889, to Christine MacPherson. Just over a year later, on October 9, 1890, Henry married Elizabeth M. Eames.

But not quite everything happened in tandem. One development was likely to irritate a relationship that otherwise remained so equal. Just after the men's marriages, Henry Cross was invited by Sam Kilburn to become a partner in the firm. Only Richard Mallory before him had held that position (1852–1865). In 1891, when Henry accepted, the firm became known as Kilburn & Cross, and the city directory made clear which Mr. Cross it was. Foster remained with the firm as a staff engraver, but their unequal roles had to be a source of strain. Years back, in 1883, there had been some ambiguous and bitter letters from Foster to Henry suggesting other tensions between these two close brothers. At that time Foster had written Henry, on Kilburn stationery:

I cannot listen to sympathy from anyone. Don't worry for me but go for business and let that take your attention.

Sometime I will only be too happy to have a good long talk with you and I think you will know me better than you ever did before and I hope we can come together again as brothers and thoroughly understand each other. I believe we will all be happy yet.[9]

Henry responded to Foster, also on Kilburn stationery, with the 433 Washington Street address:

My dear Brother Foster,

I leave this note for you with the love of a Brother and a determination to do all that comes within my power to make life a happy one for you.

You need our help and sympathy and you have my kindest feelings that you may succeed in any honorable undertaking in life.

Keep up a manly courage and by the Grace of God you will come out all right. I can't say anything more, only that perhaps some day we may understand each other better than we ["do now and have for sometime past" is a passage Henry scratched out, substituting with less feeling, the following words] have along back.

Your loving brother, Henry. [10]

No details of the conflict survive despite the existence of these letters because of the brothers' careful omission of the facts. Other correspondence has the writing paper removed, leaving only empty envelopes.

At the times of their marriages, the two brothers were middle-aged. They married at just about the age their parents had. Foster was forty-four and his wife, Christine, was only twenty-one. Henry married just after his fortieth birthday, when his wife, Elizabeth, was then twenty-seven. Both couples must have felt pressure to produce offspring. After two years of marriage, Foster and Christine had their first child, Robert Laurence Cross, on April 15, 1891. He survived only nine months. Though infant mortality had decreased greatly in that century, infants were less likely to survive than they are today. The next year, both wives delivered sons. Henry and Elizabeth named theirs, born September 6, 1892, Julian Richard, probably after Richard Mallory, who had only recently died. Foster and Christine named their boy Edward Adrian at his birth on October 29, 1892.

Much of the paired quality of the brothers' lives could be attributed to convenience. Perhaps even the coincidence of their marriages could be explained by a decision that it was time to marry. But that both brothers also lost their young wives early in their marriages could hardly be attributed to plan. Henry's wife, Elizabeth, died when Julian was not quite two, on June 4, 1894. Christine, Foster's wife, died on September 6, 1897, when her son, Edward, was about to turn five. By 1897, the two brothers were left alone with two young children in the city, and with work they had to continue to do. Despite the fact that both were far older than their wives, it was they who survived and had to cope with the care of the children as well as changes in their family and business.

In 1894, another family photograph fills in some details. In this picture the children have become the elders and stand behind their

Elderly Joseph and Deborah Cross in the last of their family photographs,
circa 1892.

Cross Family Collection.

seated aged parents. Henry, who had just recently lost his wife after barely three years of marriage, stands on the left in three-quarter view. He sports an elegant beard and wears a high-collared shirt under his dark jacket. Emma stands next to Henry, watching his mother-in-law, Mrs. Eames, who shares the grief over the loss of Elizabeth. Mrs. Eames, seated below Emma, prods Foster's son Edward in the hope that this little boy, all decked out in a navy blue sailor suit, would produce an agreeable expression for posterity. Two-year-old Edward, unstirred by her efforts, looks sulkily toward the camera. Both children, Edward and Julian, are enclosed in the arms of their loving grandfather, Joseph Cross, hunched a bit in his large wicker armchair. By now Joseph is in his seventies, with white hair a bit grown out and a white moustache and beard. Emma's hands are clasped at the edge of his chair, close to his head, as if she were reaching out to this man who was not to remain with them much longer. Deborah Cross, close to her husband, tries to make herself low, on the level of the grandchildren on Joseph's lap, curving her back in toward them and her husband. Behind Joseph and Deborah stands beautiful Christine MacPherson in an elegant leg-of-mutton-sleeved dress, next to her husband, Foster. As in the early family daguerreotype, the young command the interest and are in the central position. But here, the aging parents, holding the youngest to them tightly, share the center.

The expressiveness of this photograph may well be due to changes in the process of photography itself. Unlike the formal daguerreotype for which people had to sit immobile and wait, or even the stereopticon card, which also required holding the pose, here the family could chat and prod, joke and hug one another. Whatever moment the camera clicked would be preserved.

Shortly after that day, on December 5, 1895, Deborah Cross died. Her obituary celebrated her success in floriculture and announced that she was to be buried in Manchester where the family still considered itself at home. Joseph Cross, who appeared in the photograph the more fragile of the two, survived her by only another nine months. He died on September 6, 1896, and was buried alongside his wife, almost exactly a year to the day before his daughter-in-law Christine would die.

The family was devastated by the chain of deaths that besieged them between 1892 and 1897. When Joseph Cross was away during the war, Henry Herrick filled in as a surrogate father, albeit remote. Now again, for the next ten years, Herrick could assume an important role at least psychologically for all three Cross siblings. Fortunately, he lived well on to the ripe age of eighty-two. A lecture read years later to the Manchester Historical Association, which he helped found, captured his qualities in these years:

Rather inclined to obesity with keen blue eyes peering out from rather heavy overhanging eyelids, firm mouth and chin, rather prominent straight nose, wearing his hair which was almost white of a length that permitted it to rest on the collar of his black broadcloth coat. . . . His manner of walking was quite different than that of people in the present day who are always in a rush to get nowhere. His was a moderate gait, accented by an occasional shuffling around at the heels of his shoes, as though they fitted none too closely but were exceedingly comfortable. Holbein, the great painter of the Renaissance, could have used the head of this patriarch as a model for one of his drawings, without deviating from the original in the least.[11]

In the 1890s, Kilburn & Cross thrived at its quarters at 433 Washington Street, but the success was short-lived. By the late 1890s, the firm had moved to 185 Franklin Street, presumably smaller quarters. Kilburn & Cross, now calling themselves general designers, illustrators, and engravers, busily tried to adapt their business to technological improvements that were rapidly making wood engravings obsolete. By 1899, Samuel Kilburn was compelled to release both Cross brothers. The firm was then called only S. S. Kilburn, and neither brother is listed as even residing in Boston. On March 30, 1901, Henry shipped eleven boxes of books, two boxes of pictures, and his bookcases back home to Merrimack via the Boston and Maine Railroad. By the following year, the long-lived Kilburn company appears to have been permanently dissolved.

Henry had no home address after 1900. When Foster went off to California seeking gold, Henry followed him for a time, stopping to paint at Yosemite along the way. Traces of Henry remained in the Boston city directory only as "moved to Copley, California." He meandered from place to place. Many envelopes, often without their contents, give his addresses in these years, sometimes in Somerville's Brastow Avenue, sometimes at his mother-in-law's address in Melrose,

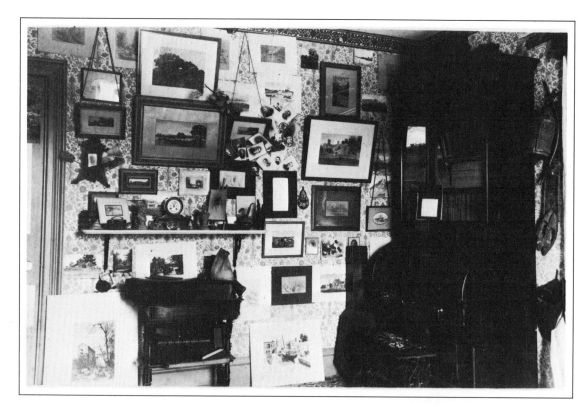

Somerville, Massachusetts, apartment where over fifty images are displayed on a single wall, many of which are included in this book. Note: Photograph of the Loop Road house is on mantle behind clock. Other photographs of family, friends, and the dog Dick are stuck in the scarce empty spaces between the paintings. Henry's beloved guitar is beside his rolltop desk.

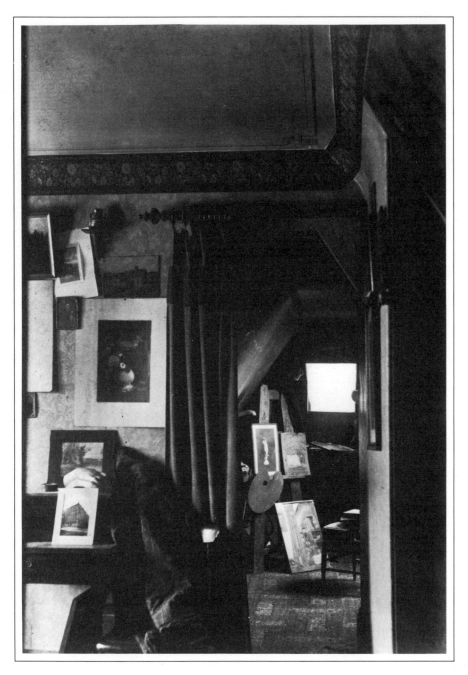

Somerville, Massachusetts, studio, photographed by Henry Cross and filled with his artwork. Painting at the foot of the easel depicts the composition framed in this photograph, evidence of Henry's deliberate composition of elements to be photographed. The Kilburn & Cross advertisement is matted and beneath plaster cast of hand, symbolizing both worlds of his art.

then at Ashland, Massachusetts. Some envelopes were addressed to him in care of the different firms for which he produced artwork. Henry is recalled as having made his home with Emma when he was not away on painting trips.

Emma became the mainstay of the family. She returned to Merrimack and made the farmhouse the temporary home for her two nephews and her often traveling brothers. She never married. Her friend, Marguerite Bushee, later Henderson, helped her establish Merrimack's first public library. With funds budgeted to the library from local taxes, Emma and Marguerite built a collection of books that they made available to people in Emma's farmhouse living room. A long table in the center of the room was for display of the books. On the surrounding walls were hung pictures of famous poets and paintings of artists Emma probably knew. Children came to the house to hear Emma tell stories and to see her favorite pictures. When Marguerite married, her children became like Emma's own. They treasured the time spent with her in the library. Emma's extended family also included a retarded young woman, Mary Frain, who was a neglected, frail daughter of alcoholic parents in Boston. Emma adopted her—perhaps informally—and together, the two maintained the farmhouse as the family center. Emma cared for her until Mary died.

In time, the town provided funds for the library to move out of "Aunt Emma's" house and into a more public place just up the road called the Birdhouse Tearoom. Emma continued as town librarian and met the neighbors there on Wednesdays and Saturdays between two and five o'clock in the afternoon, and between seven and nine o'clock in the evening. Years later, the town built its own proper library and appointed her its director. Emma, an experienced teacher, became a member of Merrimack's school board. She interviewed all applicants for teaching positions in the town, and her decision about a prospective teacher's qualifications to serve the local children was trusted.

All three Crosses must have welcomed time with Henry Herrick who, until his last day, July 30, 1906, actively contributed to Manchester life. Remembering him walking slowly in his heavy black broadcloth coat, leaning on his gold cane, the Reverend Thomas Chalmers, officiating at Herrick's funeral in the First Congregational

Church, said, "'It was a wonder to me during these last years as I have seen him moving slowly along the streets that he could find time to accomplish so much. But he was working as he walked, with his mind, imagination, and soul.'"[12] Even in his last years, Herrick maintained strong, deep ties to many parts of Manchester. He was its artist and he had the interest and political savvy to anchor his art in the life of his town. His funeral celebrated his achievements even in this location at the First Congregational Church, for which he had served as deacon. Here, the Missionary Society, the Art Association, the Historical Society, and the by now innumerable students and friends, like Foster, Emma, and Henry, gathered.

All people lose loved ones, so we can imagine something of how the family's personal losses felt, but few people except perhaps in our own time have watched the work that they perfected with diligence and faith in its future totally vanish before their eyes. On top of all their personal losses, the Crosses lost the wood-engraving profession that had excited them ever since childhood. One Boston art dealer, whose family has been in the business for generations, told me that his father remembered an experienced, middle-aged wood engraver who used to hang around his gallery staring at the paintings, trying to learn how to paint. His wood-engraving jobs had disappeared, and he had no notion of what to do with what he knew.

A new tool had replaced the old. A perfect photographic copy of a drawing was preferred to the explanatory power in the wood engraver's art. Significantly, it was the personal touch of the wood engraving that critics began to feel was out of place. Political figures and monuments, it was argued, should be recorded without any human interference. Harper's publishing firm, so well known as the "museum" of the best engraving in the 1860s, 1870s, and 1880s, by 1890 was reproducing 95 percent of its illustrations by photomechanical blocks.

The demise of wood engraving was at least as much a function of economics as aesthetics. Paradoxically, the great technological advances in America were being portrayed in a costly and labor-intensive medium. The craft of wood engraving had long been anachronistic, and its decline was inevitable, sped by the technological improvements in photographic halftone or screen printing processes. A pseud-

onymous author, Process Crank, wrote in one of the magazines to which Henry subscribed, the *Zepho*: "By their aid any kind of drawing can be translated into a printing block with such success that it is often hardly possible to tell the original from the copy." [13]

Though few among the wood engravers were willing and ready to read it, the handwriting was on the wall as early as 1890. Halftone illustrations were already common, and at the school where Henry Herrick had taught wood engraving—a school long since incorporated into Cooper Union—wood-engraving classes were to be discontinued and replaced with classes for pen-and-ink drawing for process work. [14]

In 1896, Herrick gave a lecture entitled "The Art of Illustrating" at Gentlemen's Night at the Manchester Press Club. He reviewed the history of wood engraving from its use in England to Dr. Alexander Anderson in America, and spoke of the many opportunities offered by *Harper's* and *Leslie's*. Although he showed examples of the new halftone and pen-and-ink processs, Herrick said these "could never entirely supplant wood engraving." [15] He, too, was unwilling to face the facts.

"The grave *was* dug, but it took about ten years to drop in." [16] A certain inertia in the wood-engraving business postponed its immediate death. Many survivors of the trade did as Henry apparently did and adapted their craft to the hand finishing of halftone plates. It seems some engravers still found work. Their medium still was sought for machinery advertisements and sales catalogues.

The truth was told in a periodical, *Harper's Young People*, which, as late as July 31, 1894, described wood engraving as an occupation for its young readers. After explaining that the engraver must have all the "talent of the artist and the control of the graver besides," the article's author, engraver Hiram Merrill, concluded, "the chance for the engraver has been much narrowed of late years by the introduction of half-tone reproductions which have the advantage of lower cost and quick production. The future of wood engraving considered as a business at which one may gain a livelihood and perhaps lay up a small sum for a rainy day is dark indeed." [17]

Those were the dark days. Written information by and about the Cross family virtually dries up for these years. Nothing in all those

boxes was helpful, and everything I learned through interviews was cloudy and ambiguous, and even a bit unsavory. Depression is said to have plagued the two brothers. Perhaps the most interesting bit of light comes from an interview I had with the son of Marguerite Bushee Henderson, who knew Foster and Emma but unfortunately never even saw Henry, who died in 1913. Lawrence Henderson recalls the dextrous hands with which Foster, an elected Merrimack Selectman, worked his own knitting machine to make socks. He also recollected Foster's love of animals. When Foster's horse, Jerry, was accidentally strangled by a rope in his barn stall, he invited the neighbors in to the funeral. Lawrence Henderson admired Foster, whom some faulted for lacking ambition.

But Henderson especially brightened when he spoke of "Aunt Emma," who made mittens for him and his sister for those cold days in New Hampshire. She took him on walks and taught him about the stars and flowers and gave him quizzes on specific wild flowers she had asked him to pick, to see if he had retained what she taught him. He loved what he learned from her and reflected that, above all, she taught him to respect the privilege of learning. Emma taught Lawrence about pictures. She showed him her original set of Audubon birds and gave him three paintings to take with him when he went off to college, one by each of the three Cross artists. The one by Foster was of the woods behind the Merrimack house; Henry's was of the Souhegan River; and Emma's was of rowboats in Nantucket. Though Emma occasionally stayed in the Henderson home during her last years, she died on November 7, 1933 in her own Loop Road home.

Despite the fact that Emma had given him paintings and talked so much about pictures, Lawrence Henderson was astonished to see the quantities of paintings that emerged from the Cross family barn at the time of the auction in 1981. "I didn't know they had so many paintings. I wasn't prepared for that," he told me. The family's history in art had become a secret. Their vast productivity and intense interests were buried with the objects stored in boxes. Henderson recalled the family as poor, always doing the best they could. They always had two or three growing pigs and vegetables as a source for their meals. It was almost as if art had become a sort of skeleton in the closet.

Then as now, this era provoked confusion. Some saw it as Amer-

ica's nadir, others as its zenith. Even Lewis Mumford, who made this period the subject of his book, *The Brown Decades*, changed his view. In 1931, Mumford quoted the great French sculptor Rodin as saying, "America is having a Renaissance, only America doesn't know it."[18] Unable to fulfill my request for a citation for this quote, Mumford wrote me: "Cheer up! I'm not even sure Rodin was right."[19]

It must have been difficult for Foster, who lived until 1925, and Emma, who survived to 1933, both devastated by losses of people and the world for which they were trained, to know how to interpret the fever for drawing that had possessed them in their younger years. Nourished by an early faith in the value of pictures for education, for employment, and for improving their nation, they now saw their American dream and their fellow believers in ruins. Art had come to mean either craft—that is, art labor, fancywork for industrial workers—or a bauble or accoutrement for the rich. The private, nourishing personal opportunity for making and viewing art that sustained the Cross children in their youth and early adult years was gone.

There was secrecy about the Cross family, Henderson told me. You got the feeling that there were some things about which you just should not ask. Foster did not seem proud of himself or who he had been. I wonder if he felt a betrayal, that folks like him never should have been coaxed into the world of art. Perhaps Foster, and even Emma, remained a bit embarrassed, or at least ambivalent, about the attic full of art.

Art had promised fulfillment of all those dreams, and it had let them down. By the turn of the century, art in America had become something entirely different from what it had been in the children's formative years. No one for a minute believed any longer in the dream that had motivated Foster, Emma, and Henry along with others.

Perhaps because people expected drawing to deliver so much they were doomed to be disappointed by it. I agree with Neil Harris: "In the deepest sense, art's ultimate legitimization—its ability to exist without one—was never achieved in nineteenth century America. . . . Art did become a part of national life but as one of many mercenary agents on an errand of moralizing."[20]

If we can bear to look, we will see that Americans have had great difficulty with art. All the dreams, fantasies, and justifications dis-

guised the fact that even now Americans do not feel themselves en-
titled to art. Perhaps it is because of this view—that Americans were
so sure they had no art or should have no art—that generations of
nineteenth-century artists are becoming known to us only today.

In the course of doing the Cross family research, I looked back at
all those nineteenth-century trade cards depicting artists that I had
collected at flea markets. The palette-shaped or rectangular chromo-
lithographed cards, never exceeding three-by-five inches, showed
people either seated on stools before easels in an open landscape,
standing painting an image on a wall, or working in a studio sur-
rounded by professional paraphernalia. Regardless of the setting, the
artist was always posed in front of some empty surface on which was
inserted the name of a product or service, such as Babbit's soap, J. & P.
Coats' threads, Hoyt's German cologne, or John Hancock Insurance.
The image of the artist on the trade card could be used to sell any-
thing. The eventual frustration of the dream of learning to draw left us
with these pathetic caricatures in which the artist shows people what
to buy. The mass appeal of these cards suggests that people knew that
artists were, or had been, important, but had forgotten why.

POSTSCRIPT

There was a time when there were no places to start. Many poor European immigrants found themselves where there were no museums or art schools, where imported paint boxes were jewels too dear for them to afford. Without Henry Herrick, Walter Smith, the printshops, and all the unknown devoted teachers who nourished Henry Cross and his friends and counterparts across the states, few Americans would ever have grown up to draw, paint, or engrave their thoughts.

Today, the institutions that these artist-teachers created provide a heritage far more substantial than the image of the artist on those trade cards I have spoken of. The nineteenth-century dreams that appeared to die did not. They became new beginnings. Art schools, art publications housed in art libraries, and most broadly, the nationwide system of public-school art classes all continued into our century and produced undreamed of opportunities.

Although these art institutions had roots in American soil, we have never quite accepted them as homegrown. Since the start of the twentieth century, each decade in its uneasiness has generated new defenses for its art and a predictable rejection and disdain for past practices.

257

With the turn of the century and the burgeoning interest in psychology, art instruction was transformed from a skill or trade to a way of organizing and expressing thoughts and feelings. Americans following German psychologists studied preschoolers' drawings to understand how and why people draw at all. "Spontaneous, natural drawing" became the revelation of the twentieth century. With it spread the Child Study movement, from Clark University in the East to Stanford University in the West. Art expression came to be seen as normal and innate.

The Armory Show in 1913 introduced the latest ideas of European and American modern art to New Yorkers and unleashed unending debates about what was and was not art. Ironically, "Any child could do that!" became the most hostile way to voice criticism of modern art. Everyone had something to say about art and every region in the United States developed its own artists. The established art schools and academies continued to spew forth painters and sculptors. New schools like Minnesota's Federal Art Schools, Inc., organized home-study methods in 1914 to teach people to make what was called salable art: cartooning, fashion illustration, packaging labels, and billboards, under the guidance of such famous artists as Charles Dana Gibson, Joseph Leyendecker, Maxfield Parrish, Frederic Remington, and Norman Rockwell.

Pictures, it was now assumed, persuaded and informed people differently than words. Through the 1920s and 1930s, John Dewey's followers put Colonel Parker's ideas into common practice. Most schoolchildren made drawings as part of their social studies and science homework and used clay to form relief maps for geography.

As Charles Callahan Perkins and Walter Smith had created the first wave of popular art education, the 1930s saw the second great wave. Rudolf Arnheim, Henry Schaefer-Simmern, and Victor Lowenfeld, fleeing the political crisis in Europe, brought with them to America their well-crafted, humanistic ideas on artistic expression. The Works Progress Administration (WPA) of the depression era embodied their values in a resurgence of the idea of art for social reconstruction. Art sustained a hungry, ill-sheltered, economically devastated nation. Through relief sculptures and murals at sites such as a sewage dis-

posal plant and a women's house of detention, new audiences became art viewers.

But the public did more than merely view art. Free art classes sprung forth across the country. Black artist Lawrence Jones, having served as waiter at Jane Addams's pioneering Hull House, in Chicago, at which art classes were offered, moved on to New Orleans. There, through art teaching, he aimed "to create a more democratic America. . . . The country as a whole may well use New Orleans as an example of what the WPA/FAP [Works Progress Administration's Federal Art Program] can do for the cultural advancement of the Negro."[1] Art classes at the Negro Art Gallery in Jacksonville, Florida, at the Community Art Center in Phoenix, Arizona, and at the Puppet Guild in Greenville, North Carolina, each rediscovered the value of art and the necessity of its equitable distribution. Art education, which originated on the East Coast, strained to make new roots across the growing nation.

Photography projected art education even into nooks and crannies where it was not sought. Beginning in 1935, the Farm Security Administration employed photographers Walker Evans, Ben Shahn, Dorothea Lange, Russell Lee, and others, who captured images of rural poverty and raised new questions about the purpose of art—among other things—in America. Like the wood engravers of the nineteenth-century Harper's magazines, the FSA photographers created their era's indelible pictures. *Look* magazine brought their images into astounded households all over America. Their social realism, which permeated painting and sculpture as well, defined what was American about our art for the time. By the 1940s, abstract expressionism obscured explicit pathos and diverted viewers from pain to paint. Artists' subjects were shapes and substances and the thoughts and feelings these provoked, and again, as with the armory show, debates about art raged.

The twentieth century's strivings and shiftings in art should not distract us from the extraordinary position that art has gained in American life. Even today people continue to scurry to become ever more educated about art, much in the spirit in which George Ward Nichols wrote in 1877:

If this want [art instruction] were confined alone to children, the matter would easily be arranged. . . . But other classes need instruction; and the trouble in America is, that many of the master workmen, the manufacturers, and the capitalists are as uninformed and indifferent as the men they employ.[2]

That unquenchable quest for improvement, whetted back in the nineteenth century, motivates us still.

NOTES AND INDEX

NOTES

Introduction

1. George Kubler, *The Shape of Time: Remarks on the History of Things* (New Haven: Yale University Press, 1962), 7.

Chapter 1. New Mills

1. *Manchester* (New Hampshire) *Daily Mirror & American*, December 9, 1895.
2. J. Parton, *Life of Horace Greeley* (New York: Mason Brothers, 1855), 39–40.
3. Ibid., 51.
4. Henry Clay, quoted in Calvin Colton, *The Last Seven Years of the Life of Henry Clay* (New York: A. S. Barnes & Co., 1856), 347.
5. Harriet Martineau, *Society in America*, 2 vols. (New York: Saunders & Otley, 1837), 2:40.
6. Frederick G. Stark, quoted in Grace Holbrook Blood, *Manchester on the Merrimack* (Manchester, NH: Lew A. Cummings, 1948; Manchester Historical Association, 1975), 113.
7. C. E. Potter, *History of Manchester* (Manchester, NH: C. E. Potter, 1856), 720.
8. Ibid., 737.
9. Parton, Op. cit., 36.
10. Ibid., 52.
11. Robert B. Thomas, *The (Old) Farmer's Almanac* (Boston: Jenks, Kickling & Swan, 1852), 3.
12. Ralph Waldo Emerson, "Art," in *Self-Reliance and Other Essays* (Boston: H. M. Caldwell Co., n.d.), 306–7.
13. Thomas Cole, entry in 1828 sketchbook (Detroit Institute of the Arts, microfilm #D-39, in Archives of American Art, Smithsonian Institution, Washington, D.C.)
14. Thomas Cole, "American Scenery," *American Monthly Magazine*, January 1836, 4.
15. Ibid., 1.
16. Ibid., 12.
17. Ibid., 1.
18. Ibid., 12.
19. David Huntington, *The Landscapes of Frederick Edwin Church* (New York: George Braziller, 1966), 24.
20. Ibid., 27.
21. Blood, Op. cit., 83.
22. William Minifie, *Popular Lectures on Drawing and Design Delivered at the Public Meetings of the School of Design of the Maryland Institute* (Baltimore: William Minifie, 1854), 57.
23. B. Silliman and C. R. Goodrich, *The World of Science, Art and Industry Illustrated* (New York: G. P. Putnam & Company, 1854), 101.
24. Ibid.
25. Ibid., 105.
26. John Rogers, letter, March 5, 1854, New-York Historical Society.

27. David H. Wallace, *John Rogers, The People's Sculptor* (Middletown, CT: Wesleyan University Press, 1967). 25.

28. Silliman and Goodrich, Op. cit., 7.

29. Ibid.

Chapter 2. First People

1. *Parents Magazine*, June 1841, 1, 10: 218.

2. Ibid., 220.

3. Huntington, Op. cit., ix.

4. John Ruskin, *The Elements of Drawing* (London: Smith, Elder & Co., 1857) 9–10.

5. *Parents Magazine*, August 1841, 1, no. 12: 276–77.

6. Huntington, Op. cit., 24.

7. Benjamin H. Coe, *Drawing For Schools: Second Series. A Method by which All Members of a Large Class Are Taught to Draw at once with Neatness, Uniformity, and Accuracy*, in six parts; Landscapes; Foliage (New York: George P. Putnam, 1852), 5.

8. Ibid.

9. William Dunlap, *The History of the Rise and Progress of the Arts of Design in the United States* (New York: George P. Scott, 1834), 1:245.

10. Ibid., 1:250.

11. Parton, Op. cit., 50.

12. John Rubens Smith, quoted in Peter C. Marzio, *The Art Crusade: An Analysis of American Drawing Manuals 1820–1860* (Washington, D.C.: Smithsonian Institution Press, 1976), 54.

Chapter 3. In and Out of School

1. John G. Chapman, *The American Drawing-Book: A Manual for the Amateur, and Basis of Study for the Professional Artist* (New York: J. S. Redfield, 1847), 29–30.

2. Ibid., 4. 3. Ibid., 22.

4. Ibid., 19. 5. Ibid., 27.

6. Joseph Cross to Foster Cross, no. 24, February 12, 1863, Cross family collection.

7. David Lane Perkins, *Manchester Up to Date, Story of the City 1846–1896* (Manchester, NH: George F. Willey, 1896), 18.

8. Isaac Edwards Clarke, *Art and Industry, Education in the Industrial and Fine Arts in the United States, Part I: Drawing in the Public Schools* (Washington, D.C.: Government Printing Office, 1885), c.

9. Horace Burdick, "My Experience of Life," MS, (Malden, MA: Malden Historical Society, n.d.), 4.

10. *A Descriptive Catalogue of Books, Maps, and Charts and School Apparatus* (Boston: Ide & Dutton, 1855), 63–64.

11. William B. Fowle, *Principles of Linear and Perspective Drawing for the Training of the Eye and Hand* (New York: A. S. Barnes & Co., 1866), 3.

12. William Bartholomew, *Drawing Book No. 3* (1855), inside cover.

13. Minifie, Op. cit., 57.

14. "Frederick Edwin Church," *Harper's Weekly*, June 8, 1867, 11: 364.

15. Chapman, Op. cit., 29.

Chapter 4. Reading and Writing Through the War Years

1. Blood, Op. cit., 193–94.

2. Ibid., 195.

3. *Manchester* (New Hampshire) *Union Democrat*, October 13, 1852, scrapbook 2: 123.

4. Joseph Cross to Deborah Cross, no. 3, November 14, 1862, Cross family collection.

5. Ibid., no. 42, July 6, 1863, Cross family collection.

6. "Making the Magazine," *Harper's New Monthly Magazine*, December 1865, 23, no. 187: 30.

7. Joseph Cross to Deborah Cross, no. 8, November 1, 1862, Cross family collection. (all Cross letters hereafter from Cross family collection unless otherwise noted).

8. Ibid., no. 44, August 2, 1863.

9. Joseph Cross to Henry Cross, no. 21, February 4, 1863.

10. Joseph Cross to Deborah Cross, no. 25, March 1, 1863.

11. Joseph Cross to Emma Cross, no. 21, February 4, 1863.

12. Ibid., no. 71, February 21, 1864.

13. Joseph Cross to Foster Cross, no. 27, March 15, 1863.

14. Ibid.

15. Ibid.

16. Ibid.

17. Ibid. Joseph Cross to Deborah Cross, no. 16, December 28, 1862.

18. Ibid., no. 34, May 3, 1863.

19. Ibid., no. 38, May 31, 1863.

20. Ibid., no. 45, August 10, 1863.

21. Ibid., no. 40, June 2, 1863.

22. Ibid., no. 94, September 4, 1864.

23. Ibid., no. 68, January 31, 1864.

24. Ibid.

25. Ibid., no. 17, January 4, 1863.

26. Ibid., no. 38, May 31, 1863.

27. Ibid.

28. Ibid., no. 44, August 2, 1863.

29. Ibid.

30. Ibid., no. 48, August 30, 1863.

31. Ibid., no. 18, January 11, 1863.

32. Ibid., no. 9, November 6, 1862.

33. Ibid., no. 69, February 6, 1864.

34. Ibid.

35. Ibid., no. 75, April 8, 1864.

36. Ibid., no. 79, May 20, 1864.

37. Ibid., no. 81, June 10, 1864.

38. Ibid., no. 95, September 11, 1864.

39. Ibid., no. 109, December 18, 1864.

40. Ibid., no. 111, January 1, 1865.

41. Ibid., no. 115, January 22, 1865.

42. Horace Mann, "Schools in Prussia," *Common School Journal*, 1840, 2: 71–72.

43. Parton, Op. cit., 38.

Chapter 5. Opportunity of a Century

1. Joseph Cross to Henry Cross, no. 31, April 1863 (no day indicated).

2. Ibid.

3. Joseph Cross to Deborah Cross, no. 82, June 19, 1864.

4. Joseph Cross to Foster Cross, no. 40, June 2, 1863.

5. Ibid.

6. Manchester (New Hampshire) *Daily Mirror & American*, January 19, 1865, scrapbook 7:111.

7. Joseph Cross to Foster Cross, no. 46, August 16, 1863.

8. Ibid., no. 73, March 11, 1864.

9. Ibid., no. 113, January 8, 1865.

10. Joseph Cross to Deborah Cross and children, no. 78, May 1, 1864.

11. Joseph Cross to Deborah Cross, no. 115, January 22, 1865.

12. Ibid., no. 92, August 25, 1864.

13. Ibid., no. 105, November 20, 1864.

14. Ibid., no. 84, July 4, 1864.

15. Ibid., no. 113, January 8, 1865.

16. Ibid., no. 41, July 19, 1863.

17. Ibid.

18. Ibid., no. 55, October 18, 1863.

19. Ibid., no. 59, November 15, 1863.

20. Ibid.

21. Ibid.

22. Joseph Cross to Deborah Cross and Emma Cross, no. 40, June 2, 1863.

23. Ibid., no. 44, August 2, 1863.

24. Joseph Cross to Deborah Cross, no. 43, July 26, 1863.

25. Ibid.

26. Silliman and Goodrich, Op. cit., 179–80.

27. Philip Gilbert Hamerton, *The Graphic Arts, A Treatise on the Varieties of Drawing*,

Painting and Engraving in Comparison with Each Other and with Nature (Boston: Roberts Brothers, 1886), 42.

28. *Parents Magazine*, May 1841, 1, no. 9: 194.

29. *Harper's New Monthly Magazine*, December 1865, 32, no. 187: 2.

30. Ibid., 11.

31. Hamerton, Op. cit., 1.

32. W. J. Linton, *The History of Wood-Engraving in America* (Boston: Estes & Lauriat, 1882), 3.

33. Ibid., 26.

Chapter 6. Influences

1. Joseph Cross to Foster Cross, no. 73, March 11, 1864.

2. Ibid., no. 64, December, 1863.

3. Ibid., no. 86, July 20, 1864.

4. Ibid., no. 88, July 26, 1864.

5. Joseph Cross to Deborah Cross, no. 91, August 14, 1864.

6. Ibid. 7. Ibid., no. 119, February 19, 1865.

8. Ibid., no. 43, July 26, 1863. 9. Ibid.

10. Ibid. 11. Ibid.

12. Joseph Cross to Foster Cross, no. 46, August 16, 1863.

13. Joseph Cross to Deborah Cross, no. 127, April 30, 1865.

14. Ibid., no. 129, May 7, 1865.

15. Ibid., no. 130, May 20, 1865.

16. Joseph Cross to Foster Cross, no. 73, March 11, 1864.

17. Joseph Cross to Deborah Cross, no. 8, November 1, 1862.

18. Ibid., no. 57, November 3, 1863.

19. Ibid., no. 119, February 19, 1865.

20. *Cosmopolitan Art Journal*, March 1859, 2: 85.

21. Huntington, Op. cit., 24.

22. Ibid., 2.

23. *The Autobiography of Worthington Whittredge 1820–1910*, John I. Baur, ed. (New York: Arno Press, 1969), 43.

24. Elbridge Kingsley, papers (Northhampton, MA: Forbes Library, Washington, D.C.: microfilm roll #48 in Archives of American Art, Smithsonian Institution).

25. *Putnam's Monthly Magazine*, June 1853, 1: 70.

26. M. L. Kellogg to Professor R. S. Smith, 1861, Cooper Union. Cooper Union Archives, New York.

27. *Crayon*, May, 1859, 6: 160.

28. Elbridge Kingsley, Op. cit.

29. George Perkins Marsh, *Man and Nature: Or Physical Geography as Modified by Human Action* (New York: Scribner, 1864), 1.

Chapter 7. Homecoming

1. Joseph Cross to Deborah Cross, no. 110, December 24, 1864.

2. Ibid. no. 71, February 21, 1864.

3. Alice Ekern Interview, with author, November 1, 1981.

4. Margaret Haller to author, July 29, 1981.

5. Ibid.

6. John Foster, "Henry W. Herrick," *Granite State Monthly*, March 1906, 2: 137.

7. Blood, Op. cit., 219.

8. Neil Harris, *The Artist in American Society: The Formative Years, 1790–1860*, (New York: George Braziller, 1966; Chicago: University of Chicago Press, Phoenix Books, 1982), 273.

9. "Memoir of Henry Walker Herrick" 1910–11 (Manchester NH: Manchester Historical Association Collections, vol. IV), 278.

10. George Waldo Brown, 1910–11 (Manchester, NH: Manchester Historical Association).

11. *Manchester* (New Hampshire) *Daily Mirror & American*, October 21, 1863, scrapbook 7, 187.

12. Ibid., January 7, 1865, scrapbook 7, 106.

13. Ibid., February 28, 1865; Manchester, New Hampshire, 126.

14. Ruskin, Op. cit., viii.

15. *The Fables of Aesop with a Life of the Author*, illustrated with one hundred and eleven engravings from original designs by Henry Walker Herrick (New York: Hurd & Houghton; Cambridge, MA: Riverside Press, 1872).

16. Ruskin, Op. cit., xii.

17. Ibid., xi.

18. Donaldson album of engravings, 1868, author's collection.

19. Cole, "American Scenery," 1–2. 20. Ibid.

21. Ibid. 22. Ibid., 12.

23. Daniel Huntington, quoted in Barbara Novak, *Next to Nature* (New York: National Academy of Design, 1980), 42.

24. Catherine H. Campbell, *White Mountains, Places and Perceptions* (Hanover, NH: University Press of New England, 1980), 44.

25. Cole, "American Scenery," 12.

26. Asher B. Durand, quoted in Novak, Op. cit., 62.

27. Maud Briggs Knowlton, unpublished lecture, Nov. 21, 1947 (Manchester, NH: Manchester Historical Association), 5.

28. *Manchester* (New Hampshire) *Daily Mirror & American*, Nov. 13, 1865, scrapbook 7, 209.

29. Ibid., June 31, 1914; scrapbook D, 36–37.

30. Ibid., Nov. 8, 1913, scrapbook B, 176.

31. Francis Wayland Parker, *Talks on Pedagogics* (New York: E. L. Kellogg & Co., 1894), 14.

32. Ibid., 23.

33. Ibid., 161.

34. Ibid., 23.

35. John Dewey, "How Much Freedom in New Schools?" *New Republic*, July 9, 1930, reprinted in John Dewey, *Education Today*, Joseph Ratner, ed. (New York: G. P. Putnam's sons, 1940), p. 217.

36. John Foster, "Henry W. Herrick," *Granite State Monthly*, 1906, 2: 144.

37. Harris, Op. cit., 312.

38. Eighteenth Annual Report, Manchester Missionary Society (Manchester, NH: Henry A. Gage, 1869), 7.

39. Ibid., 4.

40. Ibid., 10.

41. Harris, Op. cit., 303.

Chapter 8. Preparing to Leave

1. Ruskin, Op. cit., 32. 2. Ibid.

3. Ibid., xi. 4. Ibid., xviii.

5. School Committee Report of 1871 (Manchester, NH, 1872), 53.

6. *Manchester* (New Hampshire) *Daily Union*, January 11, 1869, scrapbook 9, 141.

7. Ibid.

8. Ibid., February 10, 1869, scrapbook 9, 152.

9. *Manchester* (New Hampshire) *Daily Mirror & American*, July 15, 1869, scrapbook 9, 218.

10. Ibid.

11. Joel Foster Cross to Henry Cross, March 26, 1869. Cross collection.

12. Ibid.

13. Kevin Lynch, *The Image of the City* (Cambridge, MA: MIT Press, 1960), 1.

14. Henry T. Tuckerman, *Book of the Artists, American Artist Life* (New York: G. P. Putnam & Son, 1870), 29.

15. *Every Saturday* (Boston: Fields, Osgood & Co., May 6, 1871), 426.

16. Charles Callahan Perkins, quoted in Samuel Eliot, "Memoir of C. C. Perkins," *Proceedings of the Massachusetts Historical Society* (Cambridge, MA: John Wilson & Sons, 1887), 6.

17. Ibid., 7.

18. Eliot, 10.

19. Charles Callahan Perkins, "On Drawing as a Branch of General Education," lecture, 1871 (Fitchburg, MA), 3.

20. Ibid., 7.

21. Ibid., 8.

22. Augustus Thorndike Perkins, *Losses to Literature and Art by the Great Fire in Boston*, prepared for the New England Historic, Geneological Society (Boston: David Clapp & Son, 1873), 2.

23. Ibid., 10.

24. Ibid., 9–10.

Chapter 9. Artistic Improvement

1. Burdick, Op. cit., 29.

2. Ibid., 46. 3. Ibid., 47.

4. Ibid., 35. 5. Tuckerman, Op. cit., 28.

6. Samuel Lancaster Gerry, *Reminiscences of the Boston Art Club*, MS, 1885 (Boston: Boston Athenaeum), 44.

7. Ibid., 47. 8. Ibid., 167.

9. Ibid., 102. 10. Ibid., 116½.

11. *Every Saturday*, May 6, 1871 (Boston: Fields, Osgood & Co.), 426.

12. Ibid.

13. Tuckerman, Op. cit., 33–34.

14. *Every Saturday*, May 6, 1871, 416.

15. S. R. Koehler, "Memorial Lecture for Joseph Andrews," May 17, 1873, (Boston: Boston Art Club, 1873), 14.

16. Ibid., 9. 17. Ibid., 13.

18. Clarke, Op. cit., 39. 19. Ibid.

20. Secretary of the Commonwealth, editor; *Acts and Resolves of Massachusetts 1870–71*, chapter 248 (Boston: Wright & Potter, 1871), 183–84.

21. Clarke, Op. cit., 41.

22. Ibid., 42.

23. Ibid., 51.

24. Walter Smith, quoted in Nora C. C. Sheath, *Some Events in the Life of Walter Smith* (Chesham, England: Chesham Church Printing, 1982), 2.

25. Walter Smith, diary entry, July 20, 1855, (J. E. Gilbert, private collection).

26. Walter Smith, *Proceedings at a Convention of the House and Senate of the State of Pennsylvania; Industrial Art Education Considered Economically* (Boston: Lockwood, Brooks & Co., 1877), 19.

27. Walter Smith quoted in Clarke, Op. cit., 76.

28. Smith, *Proceedings at a Convention*, 12.

29. Ibid., 7.

30. Walter Smith quoted in Clarke, Op. cit., 82.

31. Prang Company salesman, quoted in Peter C. Marzio, "The Democratic Art of

Chromolithography in America: An Overview," *Art and Commerce, American Prints in the Nineteenth Century* (Boston: Museum of Fine Arts, 1978), 77.

32. Edward A. Rushford, "Lewis [*sic*] Prang Engraver on Wood," *Hobbies*, April 1940, 189.

33. Louis Prang, quoted in Rushford, Op. cit., 189.

34. "Quarter Centennial Ode," anniversary announcement, L. Prang & Co., 1885 (Boston: Armstrong Collection, Print Department, Boston Public Library).

35. Kilburn & Cross, advertising card, circa 1891 (author's collection).

36. Boston Daily Advertiser, quoted in Marzio, Op. cit., 98.

Chapter 10. Building Institutions

1. Henry Walker Herrick, *Water Color Painting, Description of Materials with Directions for Their Use* (New York: F. W. Devoe & Co., 1882), 125.

2. Ibid.

3. Ibid., 114.

4. Ibid., 125.

5. Edwin M. Bacon, *King's Dictionary of Boston* (Cambridge, MA: Moses King, 1883), 18.

6. *Manchester* (New Hampshire) *Daily Mirror & American*, Dec. 28, 1872, scrapbook 12, 90.

7. Theodore E. Stebbins, *Master Drawings & Watercolors* (New York: Harper & Row, 1976), 155.

8. Ibid., 241–42.

9. *Manchester* (New Hampshire) *Daily Mirror & American*, Feb. 3, 1872, scrapbook 11, 170.

10. Mr. Coburn, quoted in Ibid., Feb. 21, 1872, scrapbook 11, 178.

11. Henry Walker Herrick, quoted in Ibid., Feb. 2, 1872, scrapbook 11, 169.

12. Ibid., Feb 21, 1872, scrapbook 11, 178.

13. Ibid.

14. Ibid., Mar. 25, 1872, scrapbook 11, 197.

15. Ibid.

16. Ibid., Sept. 29, 1873, scrapbook 12, 2.

17. "Manchester Art Association," pamphlet, 1875 (Manchester, NH: Manchester City Library, New Hampshire Room Collection).

18. "School Committee Report for 1871," in *Annual Report of the City of Manchester* (Manchester, NH: 1872), 261.

19. *Manchester* (New Hampshire) *Daily Mirror & American*, Jan. 18, 1872, scrapbook 11, 160.

20. Ibid., Oct. 15, 1873, scrapbook 13, 18.

21. Mr. Edgerly, quoted in Ibid.

22. Ibid., Oct. 4, 1875, scrapbook 14, 215.

23. Louis Prang, *Slate Pictures No. 2, Drawing School for Beginners* (Boston: L. Prang & Co., 1863), back cover.

24. Walter Smith, *Freehand Drawing #3 American Textbooks of Art Education* (Boston: L. Prang & Co., 1863), back cover.

25. *International Exhibition 1876 Official Catalogue* (Philadelphia: John R. Nagle & Co., 1876), 7.

26. Walter Smith, *Art Education* (Boston: James R. Osgood and Company, 1872), 22.

27. Walter Smith, quoted in May Smith Dean, *History of the Massachusetts Normal Art School 1873–4 to 1923–4* (Boston: Massachusetts Normal Art School Alumni Association, 1924), 9.

28. Smith, *Art Education*, v.

29. Ibid., 26.

30. Ibid., 19.

31. Walter Smith, quoted in Dean, *History of Massachusetts Normal Art School*, 7.

32. Walter Smith, "Industrial Drawing in Public Schools," address to Boston principals and teachers (Boston: L. Prang & Co., 1875), 54.

33. Ibid.

34. Gov. Alexander H. Rice, quoted in Clarke, Op.cit., 160–61.

35. B. F. Putnam, quoted in Ibid. 36. Putnam, quoted in Ibid.

37. Putnam, quoted in Ibid., 162. 38. Putnam, quoted in Ibid., 161.

Chapter 11. Centennial

1. Cole, "American Scenery," 12.

2. Asher B. Durand, quoted in Roger B. Stein, *John Ruskin and Aesthetic Thought in America 1840–1900* (Cambridge, MA: Harvard University Press, 1967), 14.

3. John Trumbull, quoted in William Dunlap, Op. cit., 384–87.

4. Ibid.

5. Clarke, Op. cit., cclll.

6. Tuckerman, Op. cit., 27–28.

7. J. S. Ingram, *The Centennial Exposition Described and Illustrated* (Philadelphia: Hubbard Brothers, 1876), 64.

8. Clarke, Op. cit., 280.

9. Dean, Op. cit., 10.

10. Clarke, Op. cit., cxcii.

11. Ibid., 658.

12. "School Committee Report for 1875," in *The Annual Report of The City of Manchester* (Manchester, NH: 1876), 13.

13. Clarke, Op. cit., xci.

14. Walter Smith, quoted in Ibid., xciii.

15. Clarke, Op.cit., 162.

16. Walter Smith, quoted in Ibid.

17. Walter Smith, quoted in Ibid.

18. "School Committee Report for 1875," 22.

19. Philip T. Sandhurst, *The Great Centennial Exhibition Illustrated* (Philadelphia: P. W. Ziegler and Co., 1876), 139.

20. Clarke, Op. cit., cxxix. 21. Sandhurst, Op. cit., 128.

22. *Art Journal*, n.s., 61 (January 1880): 1. 23. Sandhurst, Op. cit., 7.

24. George Ward Nichols, *Art Education Applied to Industry* (New York: Harper & Brothers, 1877), 21.

25. Ibid.

26. Clarke, Op. cit., clxxviii.

27. "John Rogers," *Aldine* (January 18, 1873), 1, no. 6:27.

Chapter 12. The Dream and the Awakening

1. Deborah Cross to Henry Cross, July 1, 1883, Merrimack (New Hampshire) Historical Society.

2. Ibid.

3. Ibid.

4. Ibid.

5. Gov. Hartranft, quoted in Smith, *Proceedings at a Convention*, 1.

6. Thomas Lang, quoted in *1885 Records of Donations*, Malden (Massachusetts) Public Library.

7. Clarke, Op. cit., 122.

8. Emma Cross to Joseph and Deborah Cross, January 16, 1884, Merrimack (New Hampshire) Historical Society.

9. Joel Foster Cross to Henry Cross, April 7, 1883, Cross family collection.

10. Henry Cross to Joel Foster Cross, 1883 (no day and month indicated), Cross family collection.

11. Knowlton, Op. cit., 1.

12. Reverend Thomas Chalmers, quoted in obituary, 1906 newspaper clipping file, Manchester (New Hampshire) Historical Association.

13. Process Crank, "Photographic Processes," *Zepho* (May 1890) 1, no. 1:28.

14. David Woodward, "The Decline of Commercial Woodengraving in Nineteenth Century America," *Journal of the Printing Historical Society*, 1974–75, 10: 69.

15. *Manchester* (New Hampshire) *Daily Mirror & American*, May 18, 1896, scrapbook 45, 106–7.

16. Woodward, Op. cit., 69.

17. Hiram Merrill, "Wood-engraving as a Life Occupation," *Harper's Young People* (July 31, 1894), 306.

18. Lewis Mumford, *The Brown Decades, A Study of the Arts in America 1865–1895*, 2d rev. ed. (New York: Dover Publications, 1955), 191.

19. Lewis Mumford to author, Feb. 12, 1982.

20. Harris, Op. cit., 315.

Postscript

1. Francis O'Connor, *Art for the Millions* (Boston: New York Graphic Society, 1975), 199.

2. Nichols, Op. cit., 22.

INDEX

Numbers in italics refer to pages with illustrations.